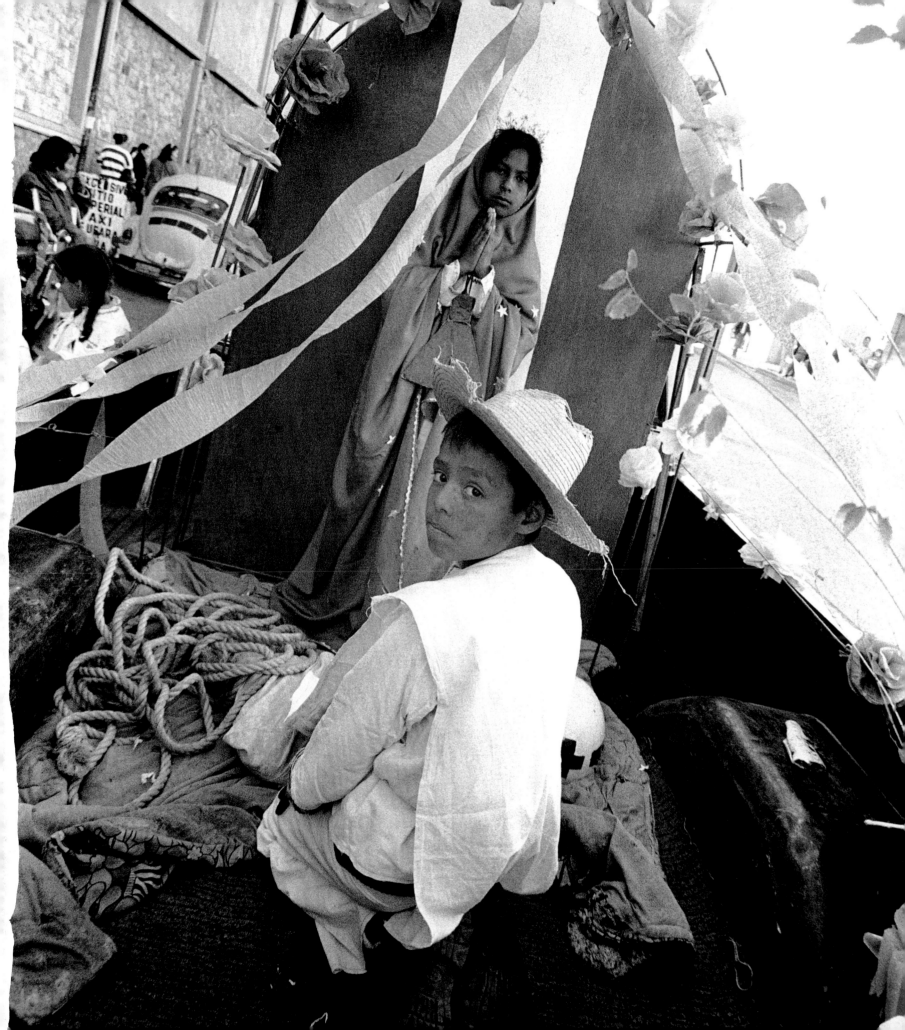

# Nuevo México Profundo

## *Rituals of an Indo-Hispano Homeland*

MUSEUM OF NEW MEXICO PRESS *Santa Fe*

NATIONAL HISPANIC CULTURAL CENTER OF NEW MEXICO *Albuquerque*

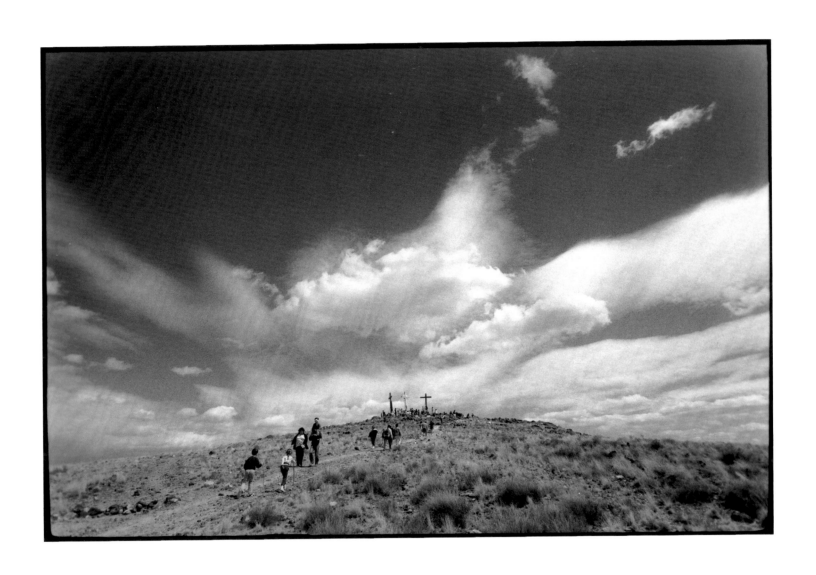

# PHOTOGRAPHS BY MIGUEL GANDERT

*Essays by Enrique R. Lamadrid, Ramón A. Gutiérrez, Lucy R. Lippard, and Chris Wilson*

Published by Museum of New Mexico Press in cooperation with the National Hispanic Cultural Center of New Mexico. Copyright © 2000 National Hispanic Cultural Center of New Mexico. Photographs copyright © 2000 Miguel Gandert. All rights reserved. No part of this book may be reproduced in any form or by any means whatsoever without the written consent of the publisher, with the exception of brief passages embodied in critical reviews.

Library of Congress Cataloging-in-Publication Data
Gandert, Miguel A.
Nuevo Mexico profundo : rituals of an indo-hispano homeland/
photographs by Miguel Gandert ; essays by Enrique Lamadrid . . . [et al.].
     p. cm.
Includes bibliographical references.
ISBN 0-89013-348-4 — ISBN 0-89013-349-2
1. Hispanic Americans—New Mexico—Social life and customs—Pictorial works.  2. Hispanic Americans
—Rio Grande Valley—Social life and customs--Pictorial works. 3. Indians of North America—
Mixed descent—New Mexico—Social life and customs—Pictorial works.  4. Indians of North America
—Mixed descent—Rio Grande Valley—Social life and customs—Pictorial works. 5. New Mexico—
Social life and customs—Pictorial works.  6. Rio Grande Valley—Social life and customs—Pictorial works.
7. Folklore—New Mexico. 8. Folklore—Rio Grande Valley.  I. Lamadrid, Enrique R.  II. Title.

F805.S75 G36 2000
978.9'00468--dc21                                                                                        00-056110

10 9 8 7 6 5 3 2 1

Museum of New Mexico Press, Post Office Box 2087, Santa Fe, New Mexico 87504
National Hispanic Cultural Center of New Mexico, 1701 4th Street sw, Albuquerque, New Mexico 87102

FRONTISPIECE (*preceding page*): Cerro de Tomé, Tomé, 1993

# C O N T E N T S

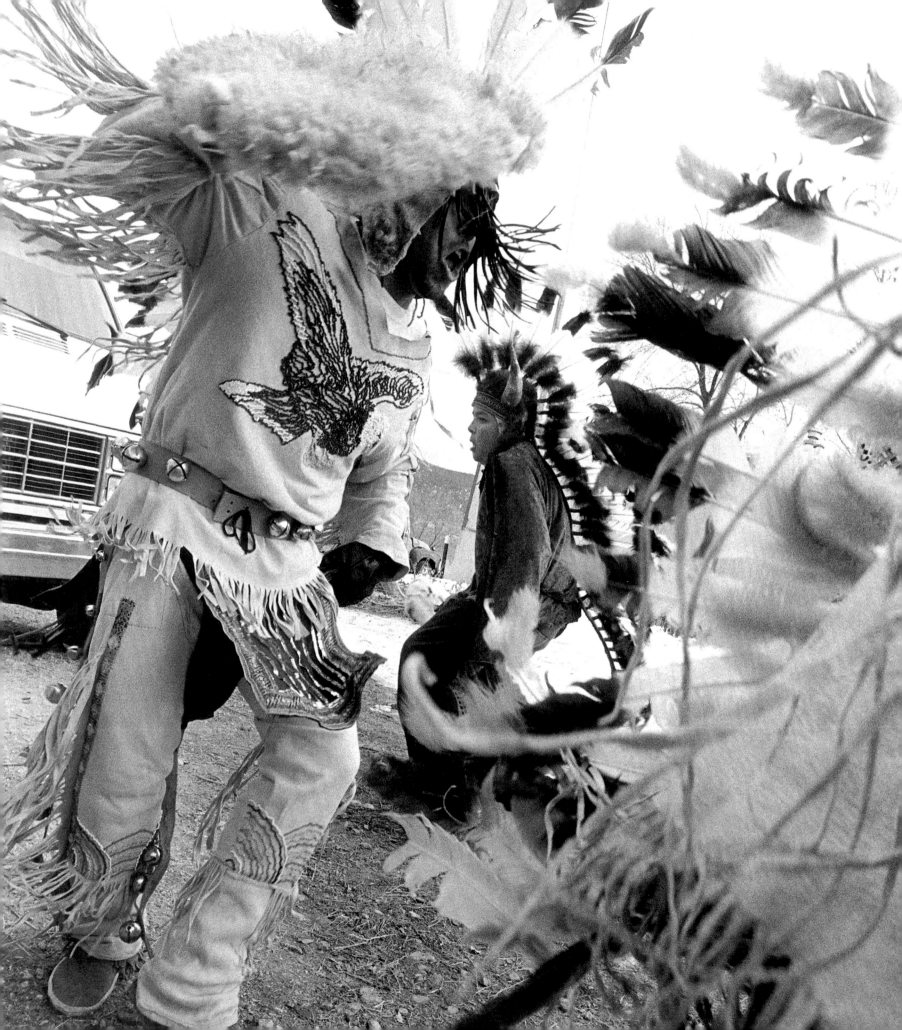

# FOREWORD

Well-known Mexican anthropologist Guillermo Bonfil Batalla refers to Mexico's Indian communities as *México profundo*. Mexico's "de-Indianized" rural *mestizo* and poor urban communities are rooted in indigenous civilizations that are governed by ancient cultural patterns and values not unlike those that regulate the lives of their northern kin—the Indo-Hispanos of *Nuevo México Profundo*. A unique way of life has endured in both Mexico and New Mexico, distinct from that of the Hispano population that identifies with a primarily European lineage.

In Mexico, Indian communities continue to resist outside forces of assimilation while at the same time appropriating useful elements from without to create a new blend of an older Mesoamerican civilization. The Nuevo Mexicano Indo-Hispanos who live along the Río Grande corridor, from the Colorado border in the north to the Mexican border in the south, also have adapted to a different way of life, dominated in this case by United States culture. Yet in spite of cultural conflict, compromise, and intermarriage, New Mexico's Indo-Hispanos have maintained a connection with their origins and developed a separate identity.

The struggle to retain elements of their indigenous cultural patterns has given the peoples of both Mexicos a profound and incredible will to survive. While the constantly evolving

third culture may be viewed by some as "impure," it is as much a genuine and legitimate culture as the root cultures from which it evolved. The rituals, processions, and social gatherings that internationally renowned photographer Miguel Gandert has documented over twenty years in *Nuevo México Profundo: Rituals of an Indo-Hispano Homeland* are important manifestations of the continuity and adaptation that comprise this survival.

Because of my long-standing friendship with Miguel Gandert, I was delighted to have inherited the *Nuevo México Profundo* project from Mariah Sacoman, my predecessor at the National Hispanic Cultural Center. This project has allowed Miguel and me to continue a collaboration that began in 1988, when we worked together on the Hispanic Culture Foundation's first publication, *Flow of the River*. Miguel, who was the principal photographer, and I pored over the collections storage area in the basement of the Museum of International Folk Art in Santa Fe, where I was a curator, in search of images to photograph. Years later, we traversed northern New Mexico taking photographs for my co-authored publication, *Chimayó Weaving: The Transformation of a Tradition*. Our personal and working relationship has continued to grow over the years. I am honored to have helped bring this project to fruition.

I wish to express my sincere gratitude to Miguel Gandert for allowing the new National Hispanic Cultural Center of New Mexico to open with his magnificent photographs of Nuevo Mexicano Indo-Hispano rituals. This inaugural exhibition will be on display at the Center from October 2000 through May 2001. It will live on through this book, which presents many of the images along with the insightful interpretations of four preeminent scholars.

HELEN R. LUCERO
*Director of Visual Arts*
*National Hispanic Cultural Center of New Mexico*
*Albuquerque, New Mexico*

# A C K N O W L E D G M E N T S

A book like this necessitates the cooperation of numerous communities, organizations, and individuals. All deserve to be acknowledged and thanked by the entities and individuals that collaborated on this project.

The Visual Arts Program of the National Hispanic Cultural Center of New Mexico thanks the Center's Board of Directors, the Hispanic Culture Foundation, the New Mexico Office of Cultural Affairs, and the state legislature. Thanks also are due to the Hispanic Cultural Center's staff, particularly executive director Eugene Matta. Joanne O'Hare, director of the Museum of New Mexico Press, and Kristina Kachele, this book's designer, deserve credit for transforming an idea into a beautiful reality. Chris Musello, Caren Cook, and Terry Bluhm at Sightworks are thanked for their courage and creativity and for undertaking the difficult task of designing an exhibition for an untested space. For his interpretive overview in the book and exhibit labels, Enrique Lamadrid receives special thanks.

Miguel Gandert wishes to thank the people in the many communities that allowed him to enter their lives and make his photographs. He also thanks the writers who contributed essays to this volume —Ramón Gutiérrez, Enrique Lamadrid, Lucy Lippard, and Chris Wilson—and all the other writers and photographers whose documentation of Indo-Hispano rituals has informed his work. At the University of New Mexico, Miguel extends

special thanks to the Southwest Hispanic Research Institute, Center for Regional Studies, and Department of Communication and Journalism for their long-term support of his work. He also thanks James Enyeart, director of the National Millennium Survey, National Endowment for the Arts. Because the years of work required to complete a project like this necessitate the sacrifice and support of those individuals who matter most, Miguel owes a huge debt of gratitude to his wife, Julie Newcomb, and his daughters, Sonja and Yvonne. He also says *"mil gracias"* to his parents, Cecilia and José Gandert.

Above all, most of the credit must go to the participants in the rituals, performances, and celebrations documented in these photographs. Their sometimes superhuman efforts have guaranteed the continuity of these complex rituals of an Indo-Hispano homeland in *Nuevo México Profundo*.

# Luz y Sombra

<div style="text-align: right">*Enrique R. Lamadrid*</div>

## THE POETICS OF MESTIZO IDENTITY

In Nuevo México, when we are born our mother literally gives us the light— *"Da luz,"* we say in the language of our Iberian forebears. As soon as our eyes are accustomed to the brilliance, we memorize the features of her face. As we rise to walk upon the earth, we transpose her profile to those first intimate horizons: a house, a road, cottonwoods by a river, a distant line of hills beyond. Because we are human, we see faces in the rocks and clouds. Thus is human love transposed onto landscape. *Querer* means to want, to desire, to be in a place, with its people. In folk terminology, *querencia* is such a place, the center space of desire, the root of belonging and yearning to belong, that vicinity where you first beheld the light. Querencia, in collective terms, is homeland.

With eyes opened wide, Miguel Gandert has been exploring and redefining his querencia for a new century. But the magnificent light that has attracted generations of artists to the Land of Enchantment is also the stark and mystified light of historical amnesia. For half of Mexico to become a region of the United States, it had to be naturalized, its history erased, its people obscured. These are the shadows Gandert's camera has illuminated, setting the scene for remembrance to replace oblivion and for a new vision of history and identity to be realized and reinscribed.

In Nuevo México, from the first decades of American commerce after independence from

Spain in 1821, a cultural dichotomy was cut between Indians and Hispanos to construct a persistent new paradigm of Indianism (idealization of Indian culture) and Hispanophobia (denigration of Hispano culture) that has lasted to the present day. This operation effectively severed an Indo-Hispano political, social, and economic alliance that evolved in the era between the great Pueblo Revolt of 1680 and the American Occupation of 1846. By the early nineteenth century, the Hispano colonists and Pueblo Indians were so close that in 1812 the wealthy rancher-diplomat, Pedro Pino, wrote in his report to the Cortes de Cádiz that the Pueblo Indians *"casi no se distinguen de nosotros"* (they are barely distinguishable from us)—unusual words for a conservative monarchist.

The wedge was set early by Anglo-American traders and travelers on the Santa Fe Trail, who expressed admiration for the exotic Pueblos and unmitigated disdain for the Nuevo Mexicanos. The wedge was driven deeper by the military occupation force, whose commanders, such as Colonel E. V. Summer, eloquently articulated their cultural blindness:

> The New Mexicans were thoroughly debased and totally incapable of self-government, and there is no latent quality about them that can *ever* make them respectable. They have more Indian blood than Spanish, and in some respects are below the Pueblo Indians; for they are not as honest or as industrious.

Of all the imagined character flaws of the Mexicanos, miscegenation was, and still is, the most primal and most indelible. In an often quoted passage, George Brewerton, a long-time associate of Kit Carson, captured the American conception of *mestizaje* when he wrote that the mixed bloods of New Mexico possessed "the cunning and deceit of the Indian, the politeness and the spirit of revenge of the Spaniard, and the imaginative temperament and fiery impulses of the Moor." *Mestizos,* or mixed bloods, are despised precisely because they bridge the gap between Indian and Hispano New Mexicans.

The military annexation of New Mexico was consolidated practically overnight, but its psychological annexation to the American imagination is still in progress. As the land was resurveyed to map the new American ownership, so the indigenous peoples' cultures were confined within the parameters of a new social order. American novels, historical treatises, ethnic humor, movies, fine art, and photography are not merely entertainments constructed around Indian and Mexican cultural others. Rather, they are components in a massive process that shifted the axis of cultural orientation and representation: "El Norte" was fast becoming "the Great Southwest."

The burgeoning Spanish language press in the territorial era reacted to insults, threats, and denigration in the public discourse. To nurture the ethnic pride of Nuevo Mexicanos

and inspire the respect of their Anglo-American neighbors, journalists responded not by representing the cultural complexity of their people, but by extolling the accomplishments of the original Spanish Mexican colonists and emphasizing their long history. To the south, the Mexican Revolution created a cultural agenda that honored the hybrid cultures of Mesoamerica and its people. In the north, the deeper mestizo story of "Nuevo México Profundo" would have to wait until the late twentieth century to be told and represented.

## Chosen People, Promised Land

Legends and epic poetry commemorate the heroic migration of people across a desert. The most ancient wanderings of Uto-Aztecan Natives from north to south can be traced in the dispersion of their languages. The historic quest of the Aztecs for a new homeland led them south from Aztlán to Lake Texcoco in the fourteenth century. Through prophecy and the portentous sign of an eagle perched on cactus devouring a serpent, they knew they were home. In 1521 Tenochtitlán, their fabled city on the lake, was razed by bearded Iberian marauders mounted on war horses and armed with steel and gunpowder. By the end of the sixteenth century, the descendants of the ambitious invaders headed north across the same vast wilderness, no longer as adventurers, but as families in search of a homeland.

In their chronicles, these children of the True Cross likened themselves to the children of Israel in their odyssey across the Sinai. Guided by the hand of the same God across the Mesoamerican desert, his chosen ones were delivered from suffering by his Mercy. When all seemed lost and the flocks were dying of thirst, clouds gathered, and blessed rain poured down in the desolate place named Socorro del Cielo, for heaven's deliverance. When the people joyfully crossed their own Jordan, the Río Grande del Norte, it was into their own promised land of Nuevo México, their new querencia. Starving, with no provisions, they reached the Piro village of Senecú, the southernmost Indian pueblo and a second Socorro, where they were delivered again, this time by human hands and the gift of corn.

To sanctify and spiritually claim the valleys and mountains, and to mark the places of sacrifice, death, and rebirth, like perpetual pilgrims, they planted crosses wherever they went. In every festivity and celebration, they reenacted with fervent zeal the folk drama of the Christian Reconquest of Spain. "Moros y Cristianos" is an exuberant equestrian display and mock battle between Moors and Christians, complete with horses, steel, and firearms. In 1598 it was enacted at the river crossing at El Paso del Norte and again four hundred miles up river at

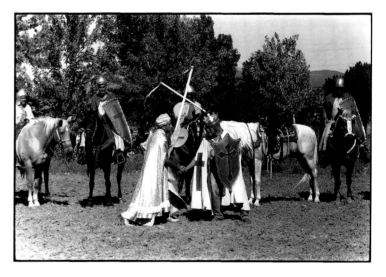

La Victoria del Rey Alfonso, Santa Cruz, 1993

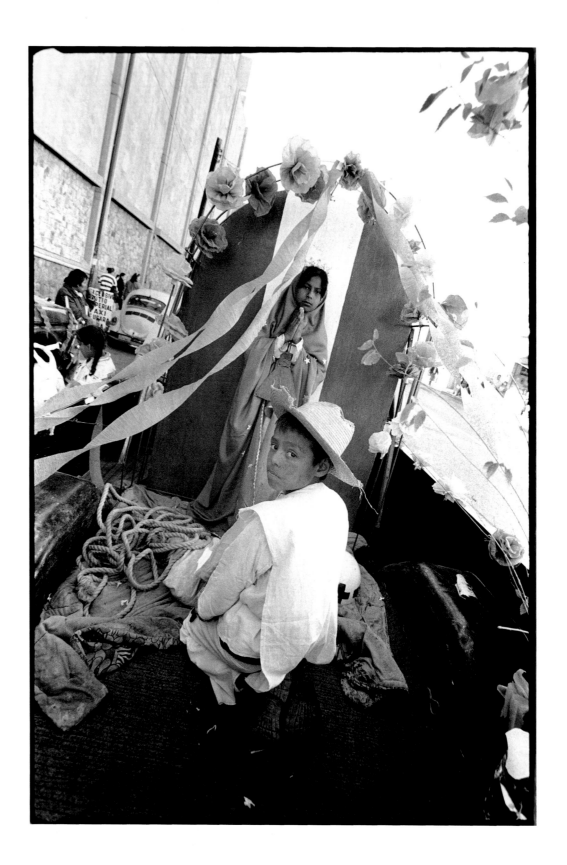

Juan Diego y su Reina,
Juárez, México, 1995

San Juan de los Caballeros, the Tewa pueblo of Oke Owingee, which played wary host to the settlers. As an ideological exercise, the play was meant to terrify and edify the Indian spectator even with no knowledge of Spanish. The pantomime is obvious: A powerful enemy steals the Santa Cruz, or Holy Cross, is vanquished in furious battle, then pardoned after converting to the Santa Fe, the Holy Christian Faith, and embracing its sacred symbol.

Other religious dramas and holy images were clear in their intent of putting a human face on divinity and eclipsing the universal cosmic symbols of sun and moon and the totem symbols of animals. A Holy Human Family was the new center of devotion. The Blessed Mother stands over the moon, and her Son shines more brilliantly than the sun. As a child with sandals, hat, and staff, he traverses the land like a little pilgrim, bringing deliverance to all. As a man, he is the sacrificial lamb, bleeding on the cross. All other horned animal spirits are demonized. Thus were the culture and religion of Spain brought to the banks of the Río Grande.

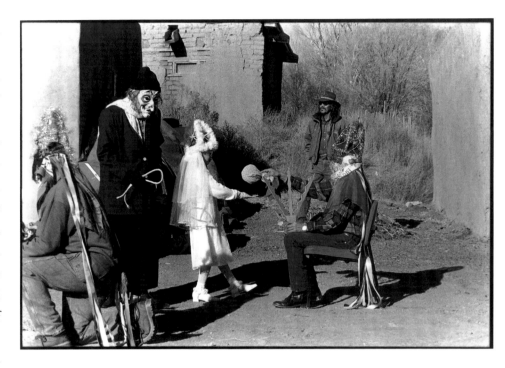

Conversión de Moctezuma,
Picurís, 1999

Concerned with caste and the *castizo* privilege of pallor, for a quixotic few, the cultural history of New Mexico is exemplified by the image of imperial Spain. Place names and family names are a bulwark of cultural pride, and the most honorable and unsullied names are put forward in royal petitions for grants of land. But the faith of all the people arose and enshrined itself in a string of graceful earthen churches like adobe beads along a rosary of precious desert waterways. As in the rest of the world, the catholic only becomes universal through its embrace of the local and the particular. By the end of the sixteenth century, castizo aspirations were immersed in the hybrid, mestizo realities of life and society in New Spain and Mexico. Even the leaders of the new colony were already calling themselves *Españoles Mexicanos,* Spanish Mexicans, already becoming indigenous to this place.

## Guadalupe Tonantzín: The Aztec Blessed Mother

To embody the spirit of a new people, a new mestiza Virgin had already found her place in their hearts. The folk play that celebrates the appearance of la Virgen de Guadalupe was

and is still performed by children. During his journey along the north shore of Lake Texcoco, the Indian Juan Diego hears a heavenly voice from the heights of Tepeyac, the ruined hilltop temple of Tonantzín, the Aztec Blessed Mother. The proof of her request for a new temple was a bouquet of roses, symbolic of Mary, and a wondrous image on a cactus-fiber cape. Instead of cold stone or wood, the image of Guadalupe has all the intimacy of cloth worn next to the skin. The miracle is that Mary is also an Indian woman and a mother to all peoples of the New World.

The devotion to Guadalupe began among the creole elite in the struggle for independence, and they took her image into the thick of battle. Soon she moved in from the cultural fringes of syncretism to the very center of the altar, the enduring and essential emblem of indigenous and mestizo identity and the emergence of Indo-Hispano culture. In Mexico and New Mexico, she is omnipresent, presiding over all religious feast days and cultural celebrations.

## Moctezuma, the Virgin, and the Bull

To dance for Guadalupe is an essential form of worship in Nuevo México, and no ritual dance expresses the complexity and depth of the Indo-Hispano experience more than the Matachines. According to Pueblo legend, long ago king Moctezuma himself flew north in the form of a bird with bad news and good advice. He warned that bearded foreigners were on their way north, but if the people mastered this dance, the strangers would learn to respect them, would join the dance and come to be just like them.

Eurocentric explanations of the dance drama stress the apparently Moorish elements of fringed face mask and sumptuous costumes, and the theme of Christian conversion. Americanists assert that the Matachines is an Aztec dance that portrays the spiritual conquest of Mexico. Whether the teachers of this tradition in Nuevo México were Franciscan priests or the Tlaxcalan servants of the Spanish Mexican colonists is only speculation.

What is clear is that for centuries, both Native and mestizo peoples have danced the Matachines. From Taos to Sonora, from Chihuahua to Laredo, they step in unison to the insistent but gentle music of drums and rattles, guitars and violins. The fluttering ribbons that hang from their crowns and shoulders are the colors of the rainbow. In proud formation they do battle against chaos and reenact the terms of their own capitulation. The totem bull of Spain runs wild through their lines. With three-pronged lightning swords, they invoke the Trinity and carve the wind in symmetrical arabesques.

Christian souls or Aztec spirits, they dance in graceful reconciliation, now in lines, now in crosses, now in circles. In their midst a great king receives the counsel of a little girl. She is Malinche. In the south her name is synonymous with betrayal, but she is no traitor

here. Her purity and ceremonial conversion of Monarca, the King, to Christianity identify her with the Virgin herself. She takes up his rattle and *palma,* or trident sword, and she weaves between and animates the rest of the dancers. At the edges of the fray, the grotesque *Abuelos* guard the dancers, make fun of the people, and ridicule the new order. These grandfathers of the mountains taunt and overpower the *toro,* killing and castrating him and casting his seed to the joyful crowd. Have they vanquished evil, as the people say, or has the savage bull of European empire met its consummation? *Gracias a Dios,* it is a mystery.

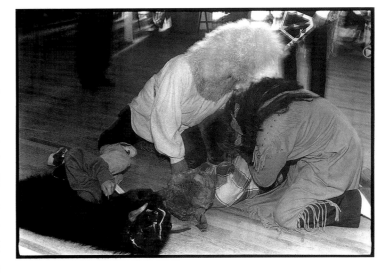

The Matachines dance drama is performed in both Pueblo and Hispano communities on key feast days such as Christmas, New Year's Day, San Antonio, San Lorenzo, and the Virgin of Guadalupe. Its allegorical characters reenact the spiritual drama of the conquest in a complex blend of Indian and European traditions. Some features are related to the reconquest themes of Moros y Cristianos. Other elements derive from combat dances of the Aztecs, which were Christianized and used for evangelization during colonial times.

Toritos Capados, Alcalde, 1999

The significance and details of Los Matachines can vary widely between regions and cultures. In Hispano communities it has a strong sacred character and is performed in devotion to Guadalupe and the saints; in Indian communities it is often a more secular celebration with strong burlesque components.

## The Cultural Legacy of Popay and Ecueracapa

The enduring symbols and vitality of Indo-Hispano culture stem directly from historical struggle and cultural resistance. Two Native figures emerged who held the future of Nuevo México in their hands: Popay, the Tewa priest who led the Pueblo Revolt of 1680, and Ecueracapa, the Comanche chieftain who unified his people and, with Governor Juan Bautista de Anza, forged the crucial peace treaty of 1786.

By targeting children in their evangelical campaign and subverting the influence of Native priests, Franciscan missionaries eventually achieved a measure of success in Christianizing the Pueblo peoples. The Holy Family and the saints were gradually added to the Native pantheon of kachina deities, and the new animals, plants, and technologies the padres introduced were accepted. But the religious zeal and intolerance of the Franciscans, coupled with the rapaciousness of the civil authorities, inevitably led to conflict and a well-coordinated rebellion that drove the Spanish colonists and their allies into exile in El Paso del Norte.

The genius behind the great Pueblo Revolt of 1680 was Popay, the religious leader from

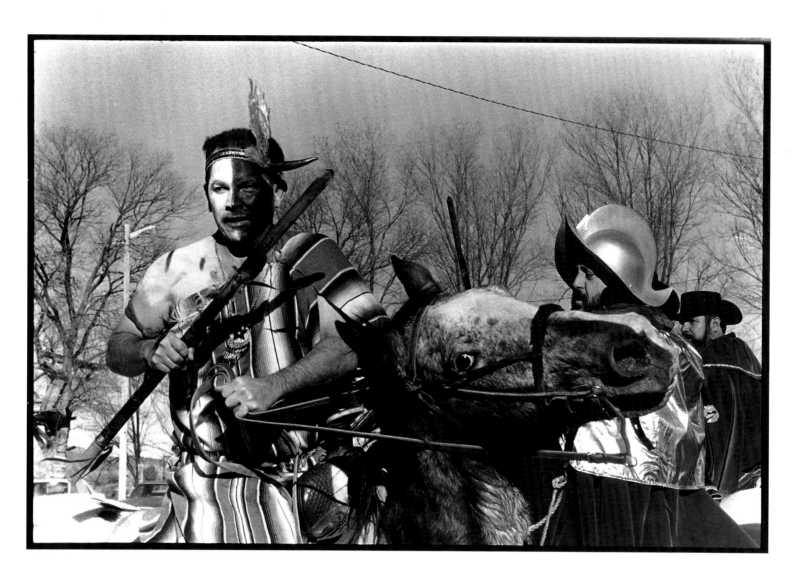

Cuerno Verde y Don Carlos Fernández,
Alcalde, 1999

the pueblo of Oke Owingee/San Juan, who planned and coordinated strategy in the kivas of Taos Pueblo in the north. He successfully framed the insurrection as a restoration of Native religion, thus ensuring its survival into modern times.

With the Reconquest of 1692, Spanish Mexican settlers and Pueblo Indians were obliged to recast their position as adversaries and gradually became trusted allies. They were surrounded on all sides by roving, generally hostile bands of Athabascan (Navajo and Apache) and Shoshonean (Ute and Comanche) peoples, creating a protracted siege that lasted throughout the eighteenth and nineteenth centuries. As the alliance of Pueblos and Hispanos strengthened, their cultural accommodation and mutual tolerance grew. The Pueblo villages, in consequence, were able to conserve many aboriginal cultural traits and religious practices that were obliterated forever in other areas of New Spain.

Needless to say, the enemy nomads resisted altogether the efforts of the twin majesties of Spanish state and church to bring them into the colonial fold. The numerous victims of this conflict, orphans, captives, and slaves, became known as *genízaros,* an emerging class of detribalized Indians. As *criados,* or servants, raised in the intimacy of Spanish households, they became more thoroughly Hispanicized than the Pueblos. As they moved into society to populate assigned military buffer zones, these New World janissaries evolved their own unique style of Hispanism and made a major contribution to the culture and folk Catholicism of the region.

The Hispano identification with non–Pueblo Indian cultures developed quickly, in part because of the intimate social relations that they experienced with nomadic Indian captives who joined Spanish households as criados or companions. Pueblo Indians were allies and trusted neighbors, but a genízaro with Comanche, Navajo, or Apache roots lived under the same roof, taking care of the children and singing them Native lullabies.

The theme of captive children and their travails dominates the folk music, oral history, and folk dramas of Nuevo México. Centuries after the conflicts subside, they are still remembered and honored.

## Los Comanches: Captivity and Redemption

The Nuhmuhnuh, or Comanches, made their first recorded appearance in Nuevo México in 1706, when they swept down from the southern Plains. When they acquired the horse, a new equestrian economy emerged, based on buffalo hunting, trading, and warfare. The Comanches' success created a dynamic cultural movement that galvanized, acculturated, and absorbed their neighboring Plains Indian tribes. On their annual visits to the Río Grande Valley, they brought horses, dried buffalo meat and robes, and captives to huge regional trade fairs. But conflicts developed, and by 1776 more than half of the settlements in the region lay in ruins. Every Comanche casualty that the militia managed to inflict was returned in kind five-fold. More than ever before, the future of Nuevo México was very much in doubt.

Named for his green horn headdress, the great Comanche chief Cuerno Verde liked to boast that he controlled the fate of Nuevo México. He had the warriors and firepower to destroy it at his whim, but he needed the Pueblo Indians to grow his corn for him and the Nuevo Mexicanos to take care of his horses. As soon as Juan Bautista de Anza assumed the governorship of New Mexico in 1778, he began making plans for a large military campaign to eliminate Cuerno Verde. With a sizeable army of over six hundred, including militiamen, Pueblo auxiliaries, and several hundred Utes, de Anza captured Cuerno Verde's winter camp above the Arkansas River in southern Colorado and defeated him soon after.

Nuevo Mexicanos were cynical about the victory and looked forward with trepidation to the reprisals that would follow. However, de Anza proved to be as capable a statesman as he was a soldier. He learned the Comanche custom of gift exchange and distributed tons of trade goods. Wagon loads of tobacco were smoked in the meetings in Santa Fe. After several years of negotiating, with the help of chief Ecueracapa, the diverse bands of Nuhmuh-nuh agreed to a peace treaty in 1786 that has lasted into modern times.

A dazzling range of intercultural celebrations commemorate the Comanche peace. After Matachines, the performance complex the people call *Los Comanches* comprises the second great regional tradition of ritual drama. At every major feast, Hispanos and Pueblos dressed and singing as Comanches may be found somewhere along the Río Grande del Norte. Hispano placitas and Indian pueblos alike come alive with colorful processions, heroic historical drama, religious morality plays, and boisterous ceremonial dancing, all in mixed defiance and emulation of a much admired friend and former foe. In the Indo-Hispano imagination, a compelling image of Comanches has animated a process of transculturation in New Mexico folk tradition, encompassing all points on the scale from cultural self to indigenous other.

Conflict has indeed preserved cultural differences, but it has also created a deep and complex mestizo tradition that serves as a fascinating register of cultural and historical relations. In Nuevo México, Indo-Hispano identity is not the result of reflection or contemplation. It is vigorously enacted in ritual settings, not for the tourist gaze (for there are virtually no tourists at these events), but rather to celebrate the historic survival of a community and its querencia.

## Sources

Lorin W. Brown, with Charles L. Briggs and Marta Weigle, *Hispano Folklife of New Mexico: The Lorin W. Brown Federal Writers' Project Manuscripts*. Albuquerque: University of New Mexico Press, 1978.

Arthur L. Campa, *Hispanic Culture in the Southwest*. Norman: University of Oklahoma Press, 1979.

Fray Angélico Chávez, *My Penitente Land: Reflections on Spanish New Mexico*. Albuquerque: University of New Mexico Press, 1974.

Aurelio M. Espinosa, in J. Manuel Espinosa, ed., *The Folklore of Spain in the American Southwest*. Norman: University of Oklahoma Press, 1976.

Ramón A. Gutiérrez, *When Jesus Came the Corn Mothers Went Away: Marriage, Sexuality, and Power in New Mexico, 1500–1846*. Stanford: Stanford University Press, 1991.

Enrique R. Lamadrid, "Los Comanches": Text, Performance, and Transculturation in an Eighteenth Century New Mexican Folk Drama, in *Recovering the U.S. Hispanic Literary Heritage,* vol. 3. Houston: Arte Público Press, 2000.

_____, *Pilgrimage to Chimayó: Contemporary Portrait of a Living Tradition*. Photographs by Sam Howarth, Miguel Gandert, Cary Herz, and Oscar Lozoya. Santa Fe: Museum of New Mexico Press, 1999.

_____, Entre Cíbolos Criado: Images of Native Americans in the Popular Culture of Colonial New Mexico, in María Herrera-Sobek, ed., *Reconstructing a Chicano/a Literary Heritage: Hispanic Colonial Literature of the Southwest*. Tucson: University of Arizona Press, 1993.

Stanley Noyes, *Los Comanches: The Horse People, 1751–1845*. Albuquerque: University of New Mexico Press, 1993.

Alan James Oppenheimer, *An Ethnological Study of Tortugas, New Mexico*. New York: Garland Publishing, 1974.

Alfonso Ortiz, *The Tewa World: Space, Time, Being, and Becoming in a Pueblo Society*. Chicago: University of Chicago Press, 1969.

Arthur G. Pettit, *Images of the Mexican American in Fiction and Film*. College Station: Texas A & M Press, 1980.

Pedro B. Pino, *Noticias Históricas y Estadísticas de la Antigua Provincia del Nuevo Méjico*. Cádiz 1812, adicionadas por Antonio Barreiro en 1839; y últimamente anotadas por el Lic. J.A. Escudero, Mexico, 1849.

Sylvia Rodríguez, *The Matachines Dance: Ritual Symbolism and Interethnic Relations in the Upper Río Grande Valley*. Albuquerque: University of New Mexico Press, 1996.

Alvin R. Sunseri, Anglo Attitudes toward Hispanos, 1846–1861, *Journal of Mexican American History* III (1973).

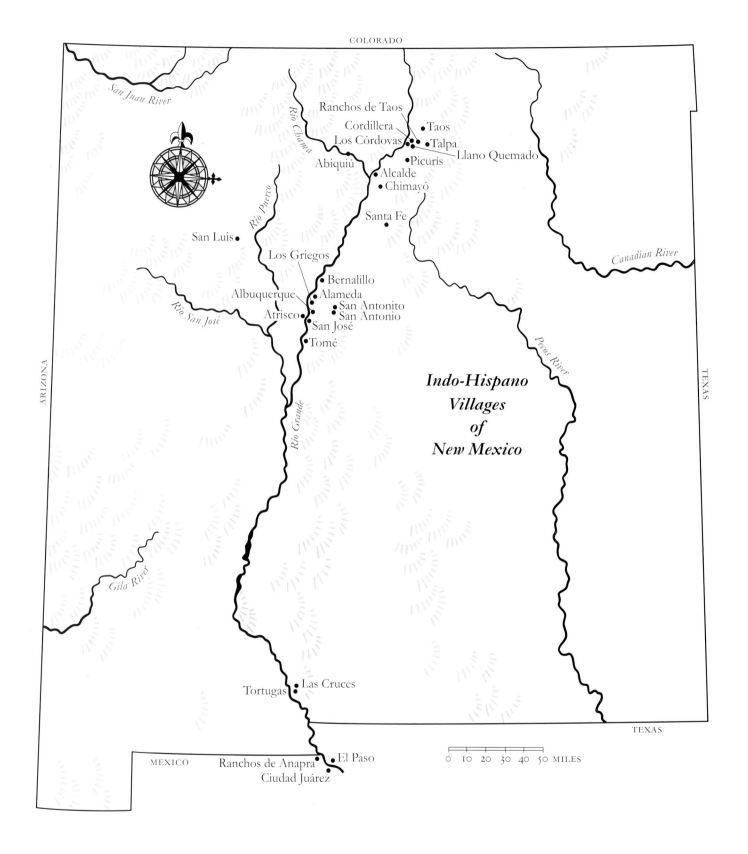

COLORADO

*San Juan River*

*Rio Chama*

Ranchos de Taos
Cordillera • Taos
Los Córdovas • • Talpa
Abiquiú • Picurís — Llano Quemado
• Alcalde
• Chimayó

*Rio Puerco*

• Santa Fe

*Canadian River*

San Luis •

Los Griegos

• Bernalillo
Albuquerque • Alameda
Atrisco • • • San Antonito
• • San Antonio
San José •
• Tomé

ARIZONA

*Rio San José*

*Gila River*

*Rio Grande*

*Pecos River*

*Indo-Hispano*
*Villages*
*of*
*New Mexico*

TEXAS

TEXAS

• Las Cruces
Tortugas •

Ranchos de Anapra • • El Paso

MEXICO

Ciudad Juárez

0  10  20  30  40  50 MILES

# Nuevo México Profundo

PHOTOGRAPHS BY MIGUEL GANDERT

TEXT BY ENRIQUE R. LAMADRID

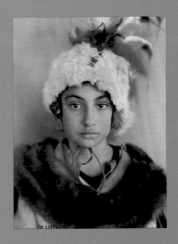

In 1598, the first domestic space shared by Spanish Mexican colonists and Pueblo Indians was Yunque Owingee, the place of the mockingbirds, directly across the Río Grande from Oke Owingee, or San Juan Pueblo. The settlers named it San Gabriel, the first capital of the kingdom of Nuevo México. Except for the new capital at Santa Fe, which was by itself in a protected valley, most Hispano settlements grew up in the vicinity of Indian pueblos. Settlers moved from the northern province of Río Arriba—literally, "up river"—to the southern province of Río Abajo, "down river," as the population grew.

In a similar way, this cultural survey of Nuevo México Profundo begins in the village of Alcalde, near the original colonial settlement, explores other northern villages, and proceeds south to El Paso del Norte, the modern border city of Juárez.

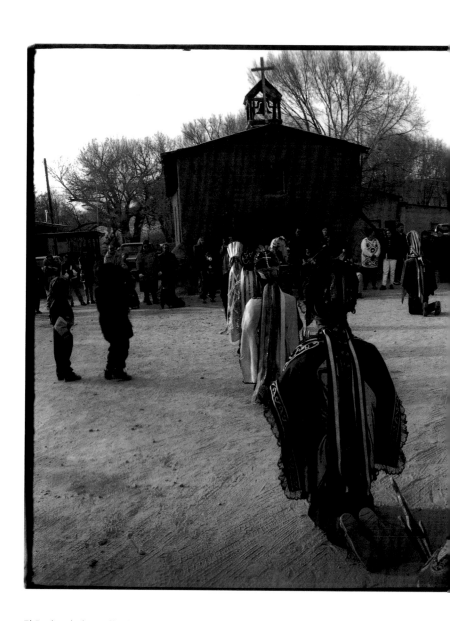

El Poder de la Malinche, Alcalde, 1996

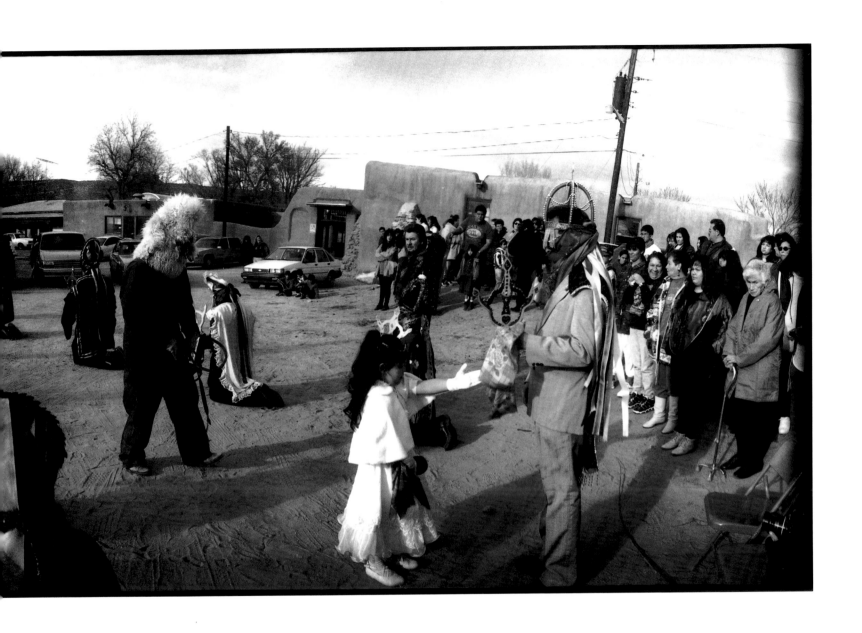

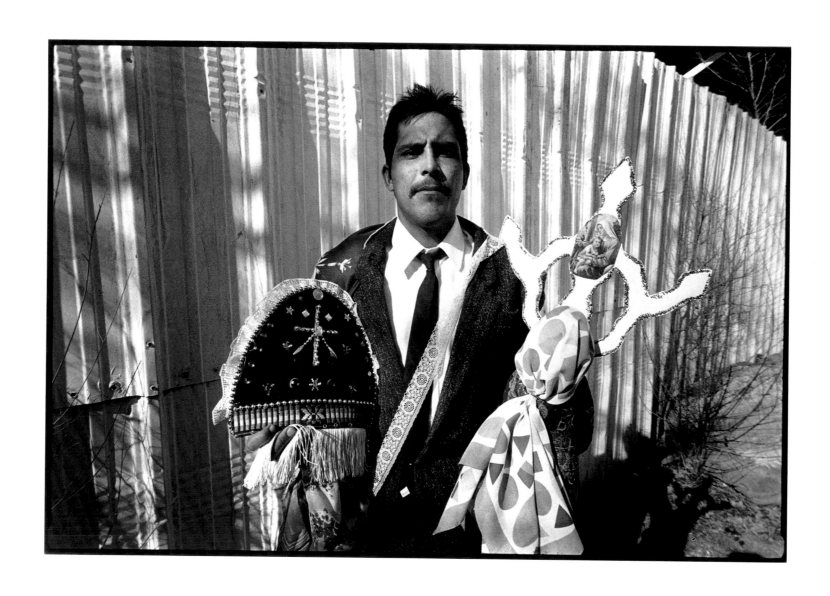

Orgullo del Matachín, Alcalde, 1995

**ALCALDE**   *Monarca and Cuerno Verde Share the Plaza*

Just three miles north of San Juan Pueblo, Alcalde gets its name from the magistrates who presided there during colonial times. One of the earliest land grants in New Mexico, the Sebastián Martín grant, had its headquarters nearby. The strategic and historic location of the village explains why all of the ritual dramas have been performed here, including Matachines and Comanches through the present, and Moros y Cristianos through the 1920s.

Although Alcalde historically observed the feasts of San Antonio (June 13) and Santa Ana and Santiago (July 25 and 26), the main community festivity is December 27 for San Juan Evangelista, when both Matachines and Comanches are celebrated in several locations around the village. The Alcalde Matachines share musical and choreographic similarities with the Matachines dancers at San Juan Pueblo. The main difference is in the costume details, such as the eagle feathers and moccasins used at the pueblo.

The dance consists of five sections, each with its separate tune played by two violinists and two guitarists. The first begins with Monarca weaving between two rows of kneeling dancers, who then arise. Malinche's dance is next and features the conversion scene in which she is given Monarca's rattle and trident, and a scene of submission in which a masked Abuelo strokes the leg of Monarca. In the third dance, *La Cruz,* the two lines of dancers combine to draw the figure of the cross. *El Toro* is the fourth dance, in which a boy dressed

in bull hide and horns challenges the Abuelos. The fifth dance features a complex series of exchange maneuvers and ends with the castration and killing of the bull by the Abuelos. There are often as many as three Abuelos, one of whom can be a "female" or Perijundia, who adds an erotic element to the clowning. After the Matachines dance ends, Los Comanches begins.

Written about 1780, Los Comanches is a heroic play commemorating the death of the great chief Cuerno Verde in the final campaigns of the Comanche wars. Until the 1940s, the play was staged all over New Mexico, as far north as Taos, as far east as Rainsville and Galisteo, and as far south as Socorro. Alcalde, the last community where it is still performed, was attacked by Cuerno Verde in the 1770s.

Structurally similar to the popular Moros y Cristianos plays, Los Comanches is performed on horseback, complete with frenzied harangues and battle scenes. The action alternates between the Comanche camp, where there are two captives known as *las Pecas* (Pecos Indian girls), and the Spanish camp, which has a *castillo*, or castle, made of branches. The action conflates elements from the campaigns of 1774 and 1779, when Cuerno Verde finally meets his fate. Governor de Anza, who actually led the final campaign, is omitted from the play as a statement of popular discontent with his initial military policies. Instead, the major Spanish protagonist is Don Carlos Fernández, a venerable officer who was married to one of the daughters of Sebastián Martín of Alcalde and was called out of retirement to lead the 1774 campaign. In the play, there is a dramatic tension between the wisdom of old age, embodied by Don Carlos, and the brashness of youth, personified by Cuerno Verde.

The spectacle begins with a stirring speech that many older Nuevo Mexicanos can still recite. Here, a young Cuerno Verde invokes the power of the four directions to inspire his warriors and intimidate his enemies:

| | |
|---|---|
| Desde el oriente al poniente, | From sunrise to sunset, |
| Desde el sur al norte frío | From the south to frigid north |
| Suena el brillante clarín | My shining trumpet sounds |
| Y reina el acero mío. | And my steel reigns. |

With calm resolve, a dignified Don Carlos taunts Cuerno Verde face to face, boasting that the imperial power of Spain encircles the entire globe:

| | |
|---|---|
| ¿Qué no sabes que en la España | Know you not that in Spain |
| El señor soberano | Is the Sovereign Lord |
| De los cielos y la tierra | Of the skies and the earth |

| Y todos los cuatro polos | And all four poles |
| Que este gran círculo encierra? | This great circle encloses? |

In the final scene, Cuerno Verde is vanquished and killed, bringing the Comanche wars to their conclusion. Absent are the touching scenes of repentance and forgiveness that characterize Moros y Cristianos. Here the defiant Comanches are soundly defeated, and the play is a victory celebration. Neither demon nor prince, Cuerno Verde appears as the haughty and formidable enemy that he was. In the contemporary Alcalde performance, the death scene of Cuerno Verde is eliminated, and he rides off with the other characters at the end.

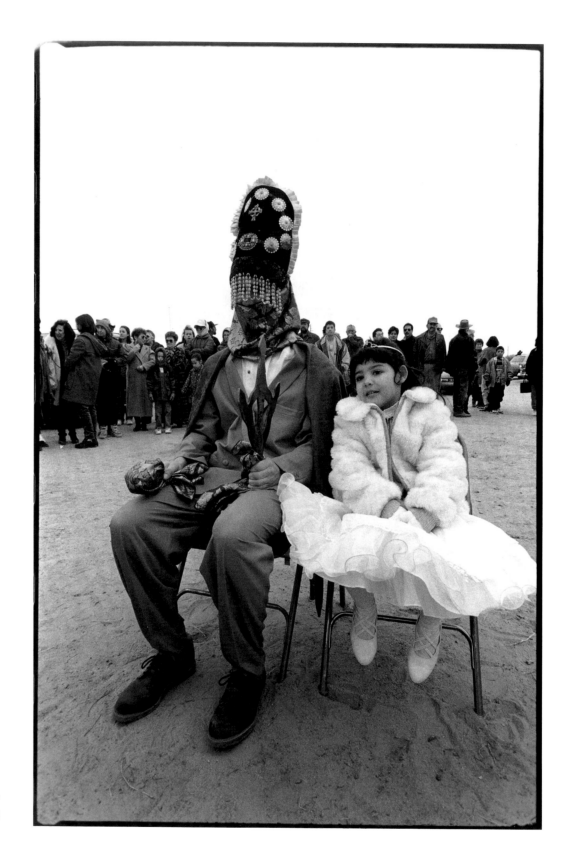

Monarca y su Malinche,
Alcalde, 1996

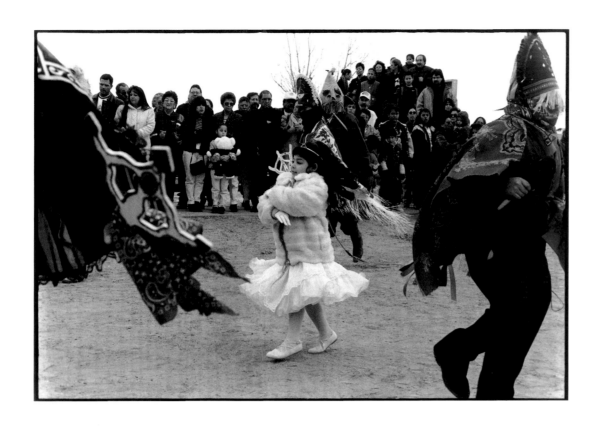

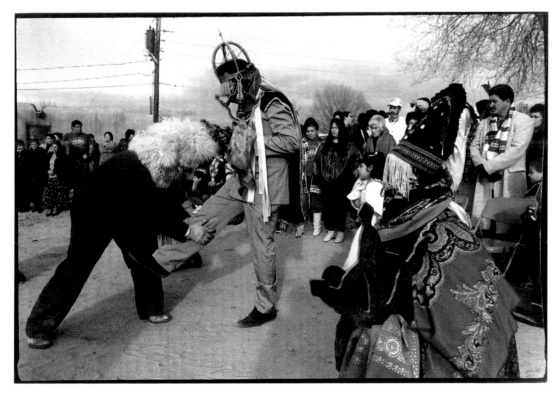

Vuelta de la Malinche, Alcalde, 1996

Abuelo Sumiso, Alcalde, 1996

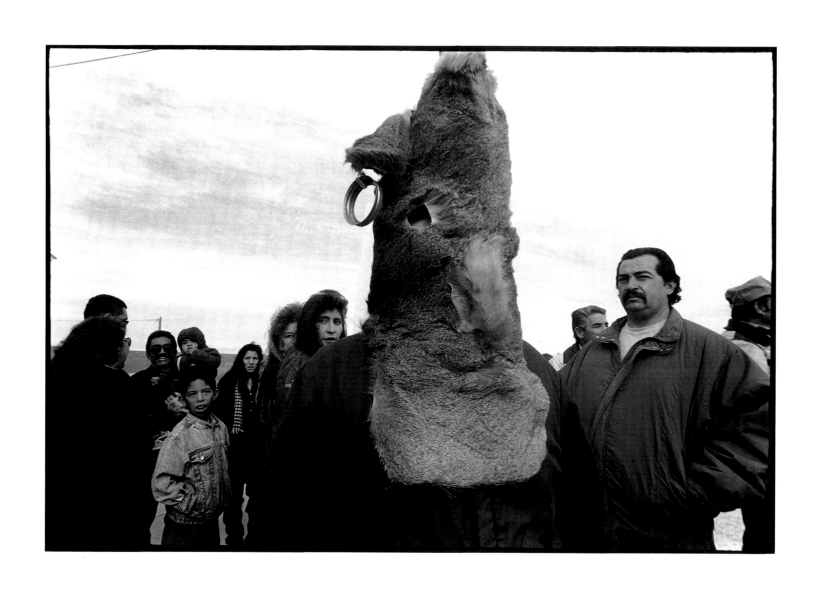

El Abuelo y su Gente, Alcalde, 1994

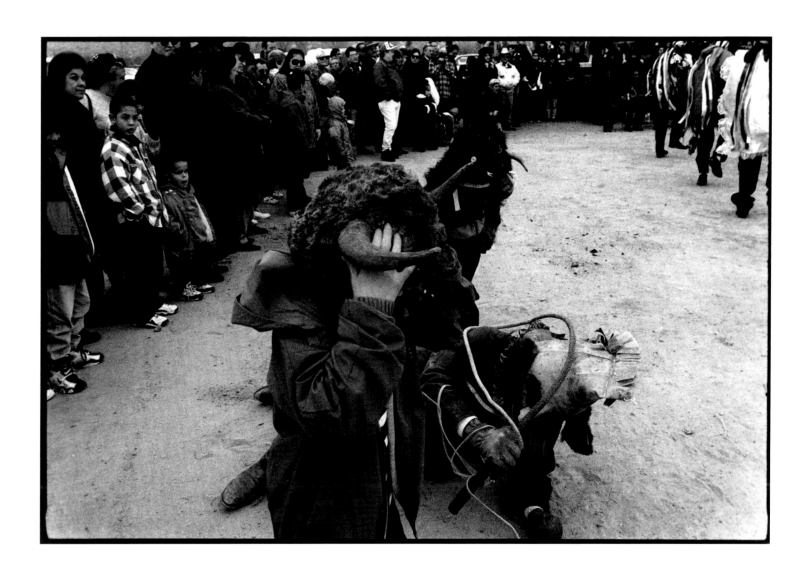

Abuelo Caído, Alcalde, 1999

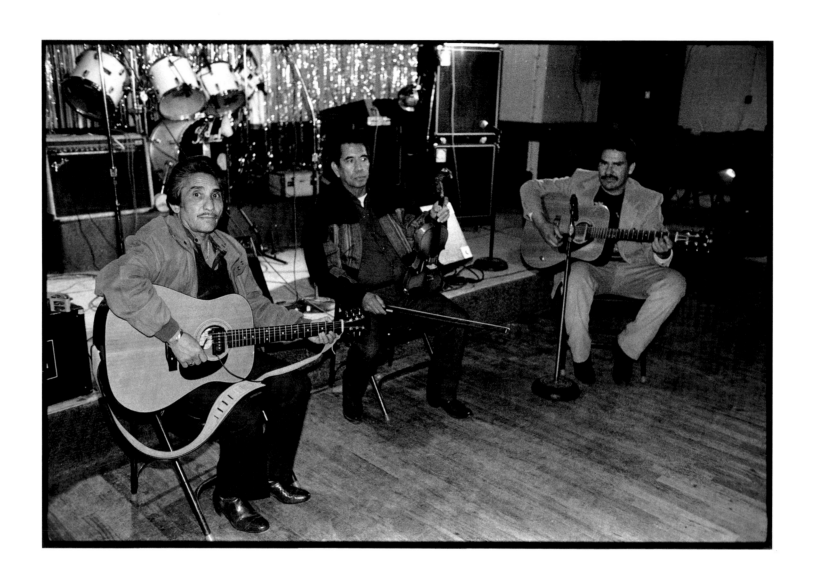

Tres Músicos, Alcalde, 1997

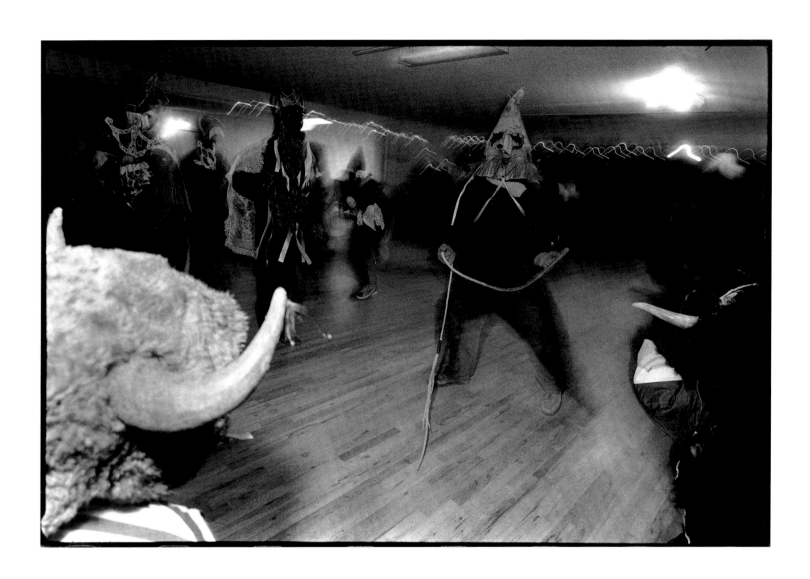

Tormento de los Toritos, Alcalde, 1997

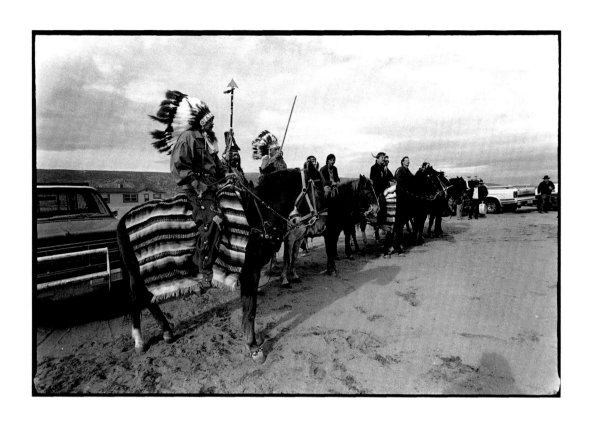

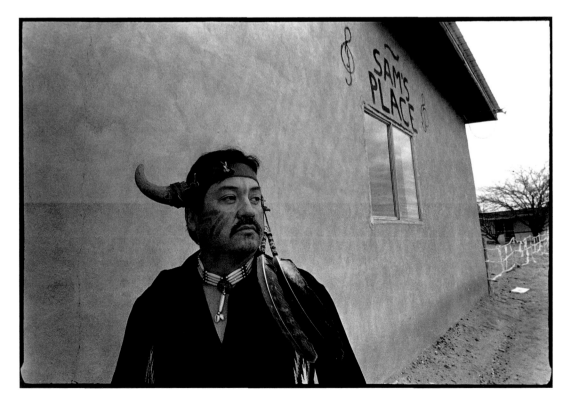

Antes de la Batalla,
Alcalde, 1994

Orgullo de Cuerno Verde,
Alcalde, 1994

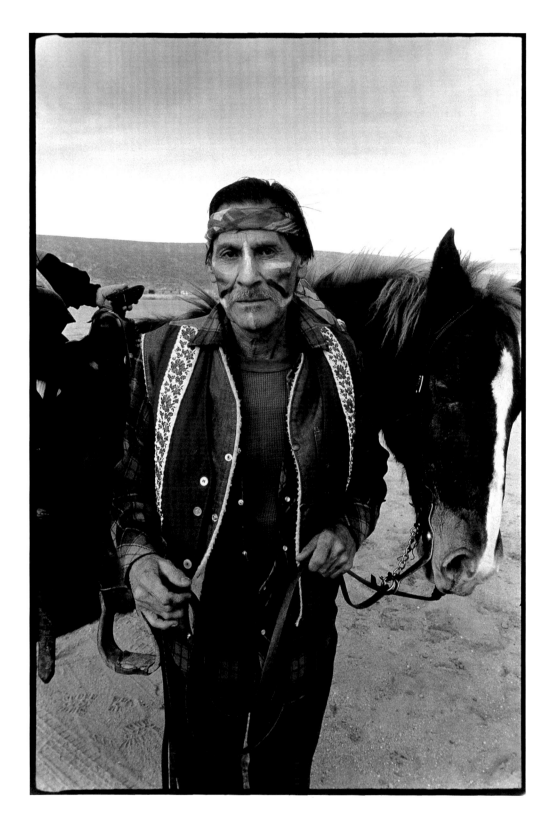

Galento el Embajador,
Alcalde, 1994

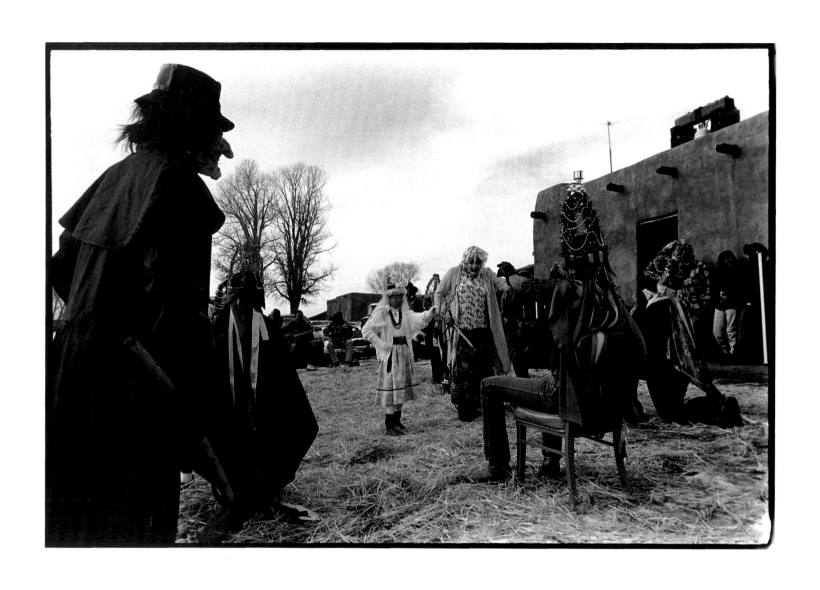

Sueño del Abuelo, Picurís, 1992

## PICURÍS   *Pueblo Matachines Renew a Sacred Space*

The northern Tiwa pueblo of Picurís lies in a high mountain valley between Alcalde and Taos. In colonial times it was one of the most populous Río Grande pueblos and a center of resistance to Spanish rule. Picurís was abandoned more than once in times of strife, but through sheer perseverance it has survived into the twenty-first century. Surrounded on all sides by Hispano villages, today it is the smallest pueblo in New Mexico.

The Picurís Matachines, one of the highlights of the ceremonial calendar, is performed for Christmas at the San Lorenzo church, which was razed and restored in the late 1980s. The reconstruction effort brought together support from neighboring communities and renewed enthusiasm for the Matachines.

Gandert's photographs commemorate the 1992 rededication of the church and the first Matachines to dance in it. In terms of costume, characters, music, and choreography, these dances share the same general features found throughout the region. What is remarkable is their similarity to the Matachines danced in Hispano villages both north and south of Picurís, an affirmation of the truly Indo-Hispano character of the ritual.

One movement, danced by only three of the northern Matachines, is *La Tejida,* known in English as the Maypole dance, in which dancers weave long ribbons hanging from a pole. In a Hispano village in Taos Valley to the north, dancers articulate the idea of the weaving

of people and cultures in conversation. In Picurís, as in other pueblos, people prefer not to speculate and choose the mode of contemplation and participation instead.

Despite the burlesque antics of the Abuelo and Abuela, and the little drama of the bull, the Matachines bring blessings to the people, although in some communities it is considered more sacred than in others.

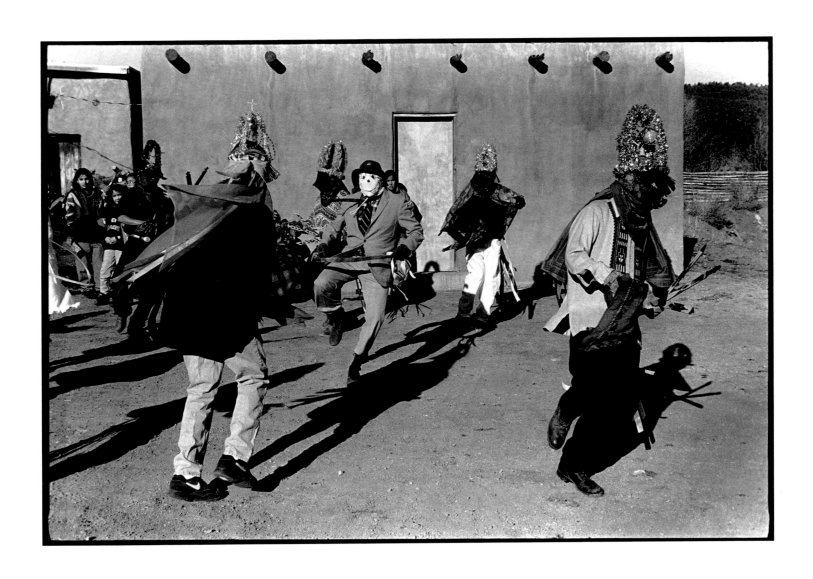

Alegría de los Matachines, Picurís, 1996

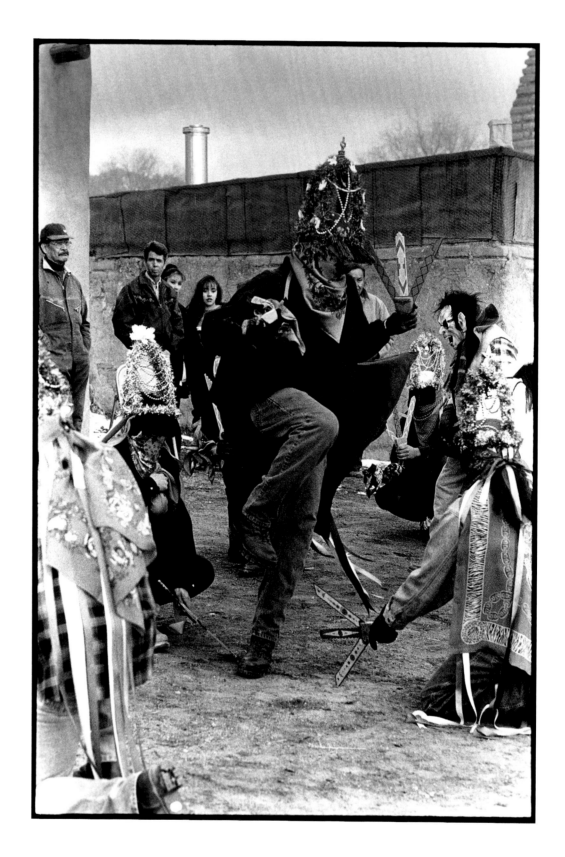

Danza del Monarca,
Picurís, 1999

32

Sombra del Monarca, Picurís, 1994

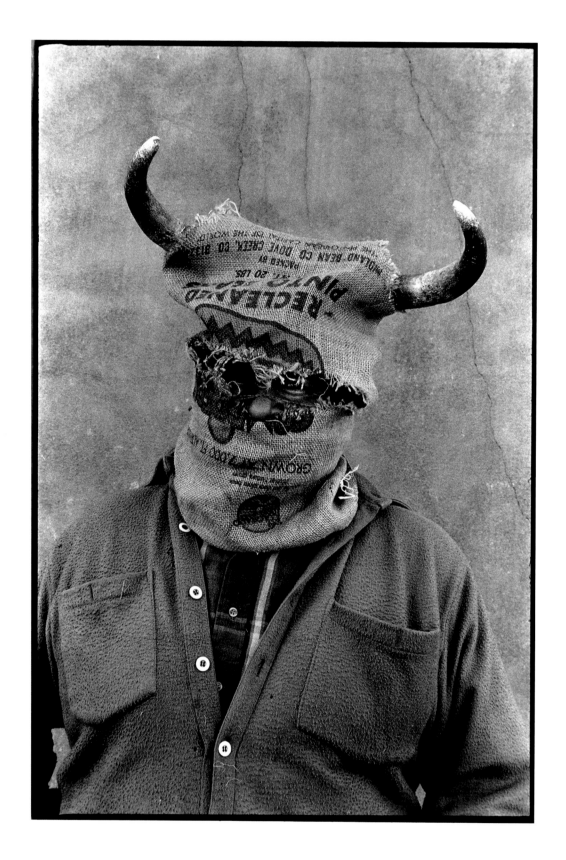

El Toro, Picurís, 1996

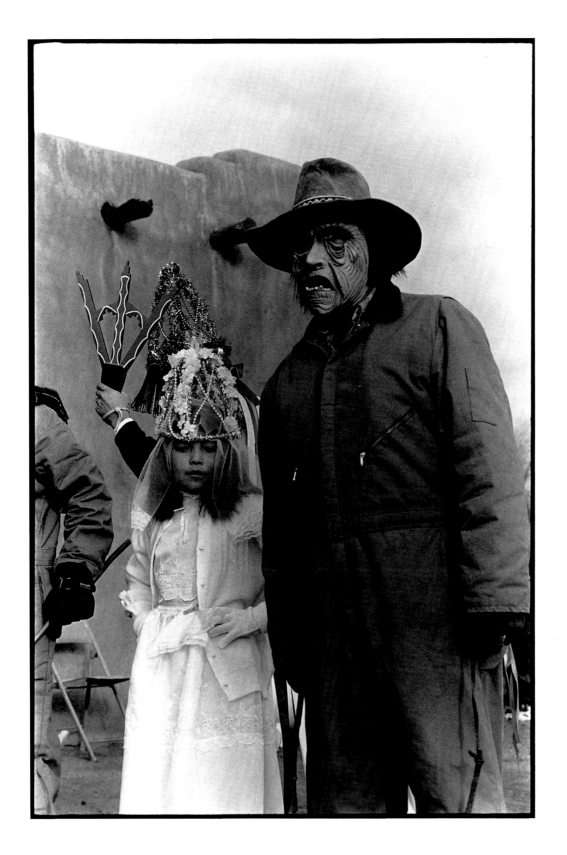

Malinche y Abuelo, Picurís, 1995

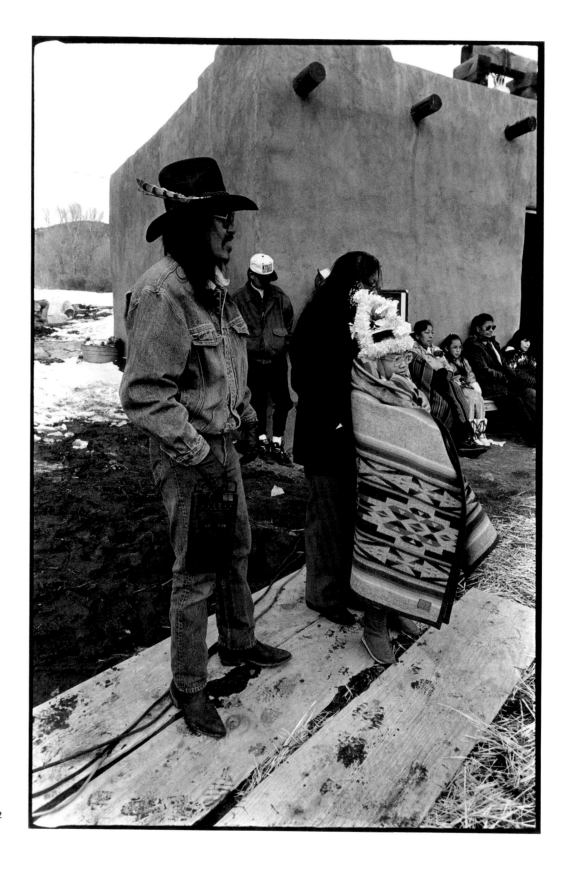

El Gobernador, Picurís, 1992

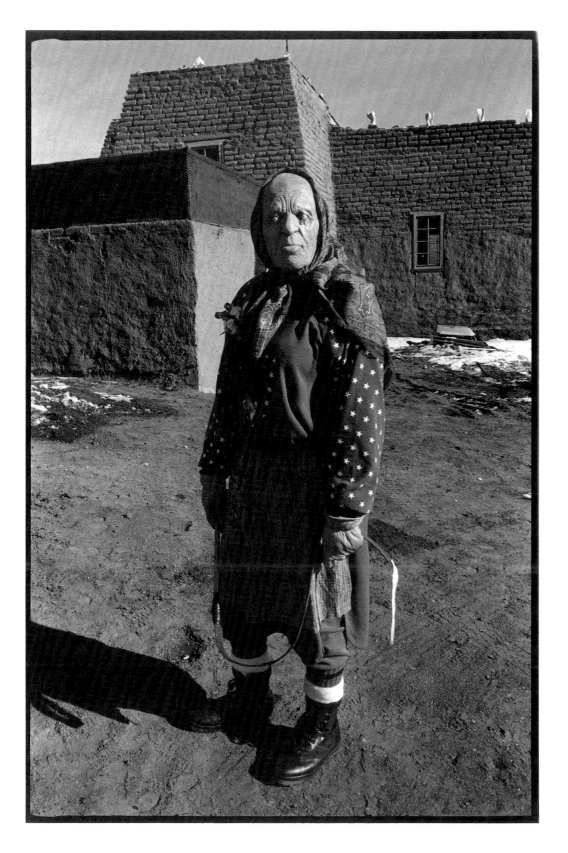

Abuela, Picurís, 1996

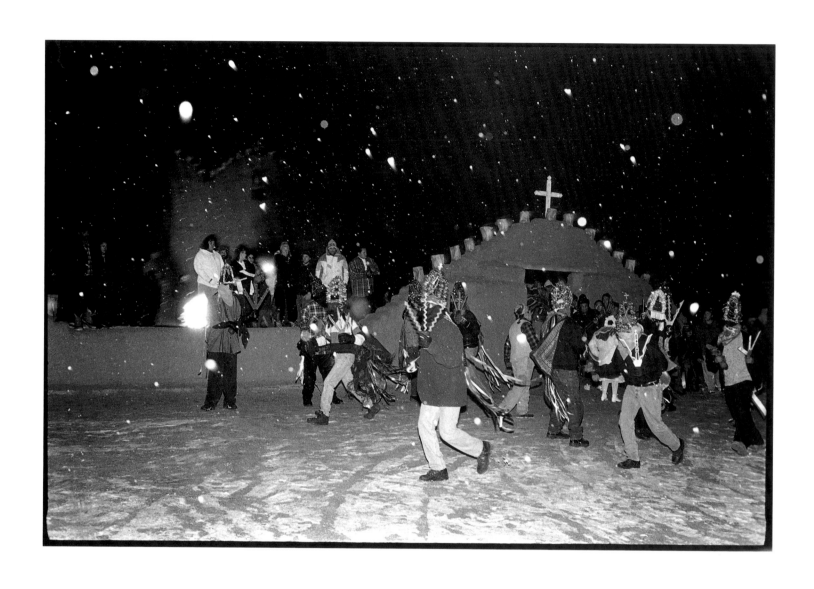

Matachines de Noche Buena, Picurís, 1993

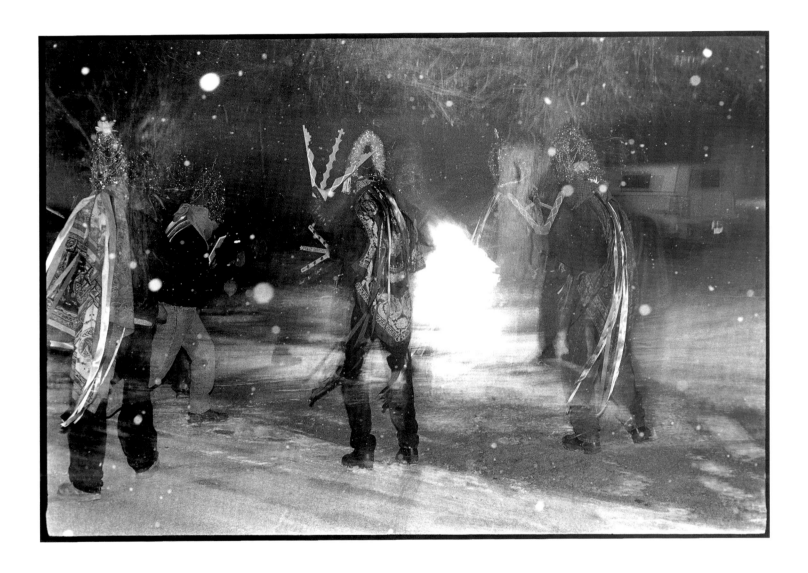

Luminaria, Picurís, 1993

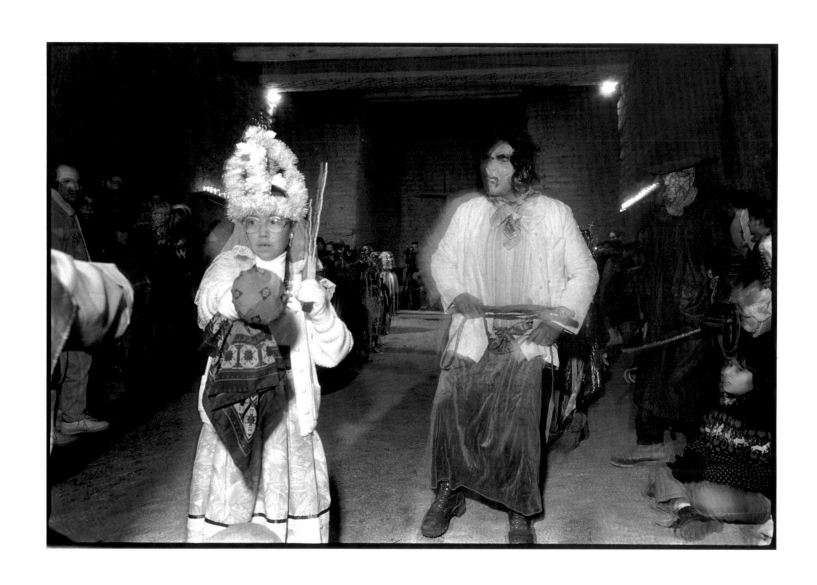

Malinche y su Abuela, Picurís, 1992

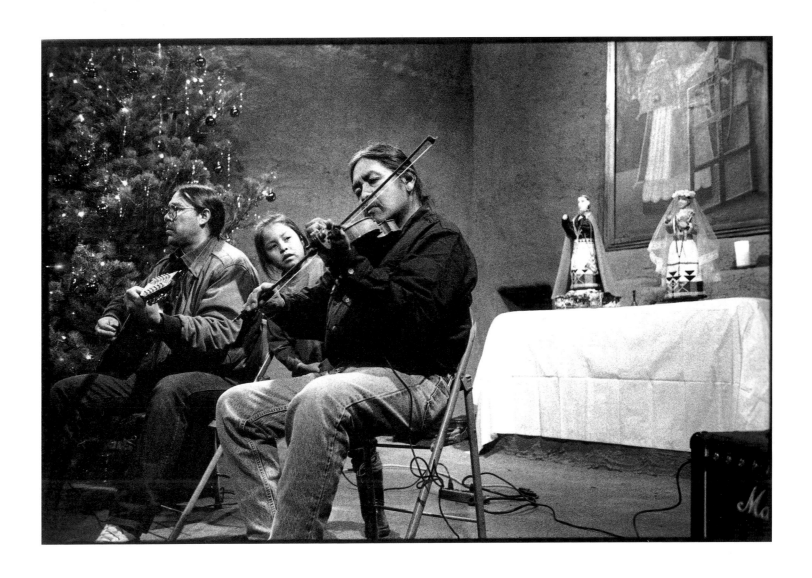

Músicos y Santos, Picurís, 1995

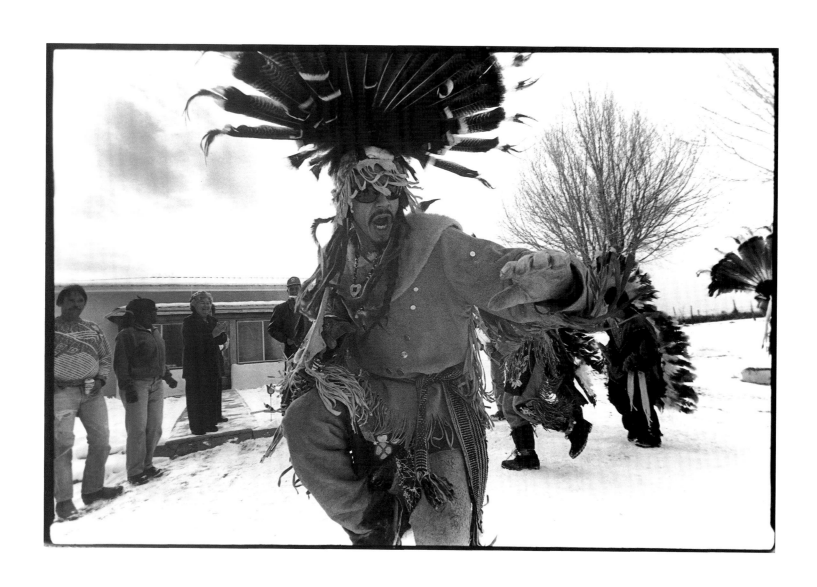

El Comanche David, Talpa, 1996

## RANCHOS DE TAOS     *Comanches and Captives Dance for Emmanuel*

To greet the first day of the New Year, several groups of Hispano Comanche dancers gather in the shadow of the San Francisco de Asís church and begin a rigorous day of celebration. From sunrise to sunset, from house to house in the villages of Ranchos de Taos, Talpa, Llano Quemado, Cordillera, and Los Córdovas, Los Comanches sing to the beating of single-headed drums. Their children dance to honor Manuels and Manuelas, the namesakes of Emmanuel, the Holy Child, on his blessed day. In fanciful costumes of buckskin, flannel, fringe, and feathers, they reenact the dramas of captivity and redemption to honor their genízaro heritage.

The itinerary of houses is based on a number of factors besides the presence of a Manuel or Manuela. Relatives are visited and brought into the circle of honor. Families of dancers returning from faraway cities for the fiesta make elaborate preparations to lure the group into lingering for extra dances and songs. Dancers come to pay homage to those Comanche elders no longer able to make the rounds with the group. Important singers are always remembered. Special requests are also accepted from non-Comanche neighbors eager for the colorful spectacle to grace and bless their homes. Singers also perform at the bedsides of the sick to raise their spirits. By the day's end, a single group may have performed at as many as twenty houses. The singers are hoarse, the dancers exhausted and cold in their sweat-soaked buckskins. If there is snow or mud, moccasins don't stay dry for long.

The Hispano Comanches of Ranchos de Taos perform a repertory of more than two dozen songs and more than a dozen dances. The songs are a synthesis of old and new Pueblo, Plains, and Navajo styles and sources. Recognizable Nuhmuhnuh/Comanche musical elements, turns of phrase, and syllable sequences surface in several songs. The existence of this repertory in the mestizo Comanche settlements of the Taos Valley is a tribute to the persistence and adaptability of genízaro culture.

The Comanches of Ranchos de Taos sing a number of Spanish songs. Some lyrics are raucous and burlesque, a characteristic aspect of the intercultural traditions of Nuevo México Profundo:

| | |
|---|---|
| Anteanoche fui a tu casa | Night before last I went to your house |
| y me dites de cenar, | and you gave me dinner, |
| tortillitas chamuscadas | singed tortillas |
| y frijoles sin guisar. | and badly cooked beans. |

Unrequited love takes on a new dimension when it occurs between cultures. Under- or over-cooking is a sign that the appropriate cultural process has been bypassed.

Other verses have enticing references to warfare, some of which may actually be attributed to certain historical periods. The following verse features a combat scene between Comanches and Apaches in which each has equal footing and prowess:

| | |
|---|---|
| El comanche y el apache | The Comanche and the Apache |
| se citaron una guerra, | made a date for war, |
| el apache no se raja | the Apache doesn't give up and |
| y el comanche se le aferra. | the Comanche bears down on him. |

Most Hispano Comanche songs use vocables, the characteristic syllable singing style of indigenous North America. The combination of specific melody and vocable sequences clearly identifies each song and imparts its individual mood, theme, and meaning. Dancers know to prepare themselves for *El Espantado,* the Enemy Combat dance, with its unmistakable call. Sung to a loud, slow tremolo on the *tombé,* or Indian drum, the taking of honorary captives is signaled by another distinctive prelude to *La Rueda,* the Ring or Captive dance. Even an ear attuned to Western music can hear the moans of the captives. Emotions run high for participants in the pantomimes of battle, captivity, and redemption.

The Hispano Comanche repertory also includes striking animal dances and their accompanying songs, including *El Aguila* (the eagle), *La Tortuga* (the turtle), *El Torito* (the little

buffalo bull), and *El Coyote,* a hunting dance. Every dance set begins with *El Redondo,* the Round dance, performed to a variety of songs. The selection of other dances in a set is negotiated and determined by the singers and dancers. Sets invariably end with *La Rueda,* the Ring or Captivity dance, which concludes with handshakes and hugs all around as the captives are released. *El Desempeño,* the captive's ransom, takes many forms, including the simple giving of thanks, a drink of water to the dancers and whiskey to the singers, a bit of lunch, or even a few dollars for gasoline or material for costumes.

During the eighteenth century, the valley of Taos was attacked many times by Comanches in times of conflict; in times of peace, Taos Pueblo was the site of the most important Comanche trade fair in New Mexico. Every aspect of Hispano Comanche celebrations could be found there, including the equestrian play, a Nativity play with Comanche visitors, and the cycle of genízaro dances. Taos will never forget its Indo-Hispano roots.

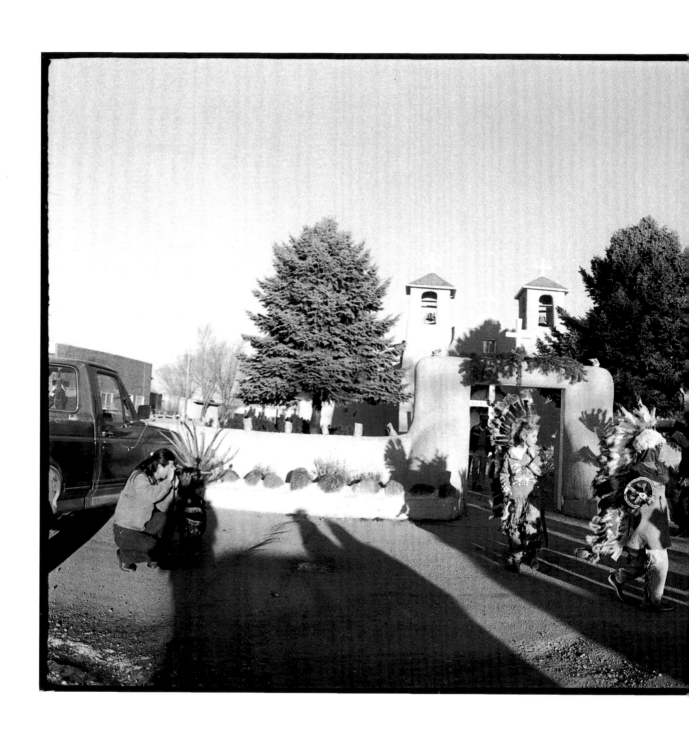

Mañanitas del Niño Manuel, Ranchos de Taos, 1995

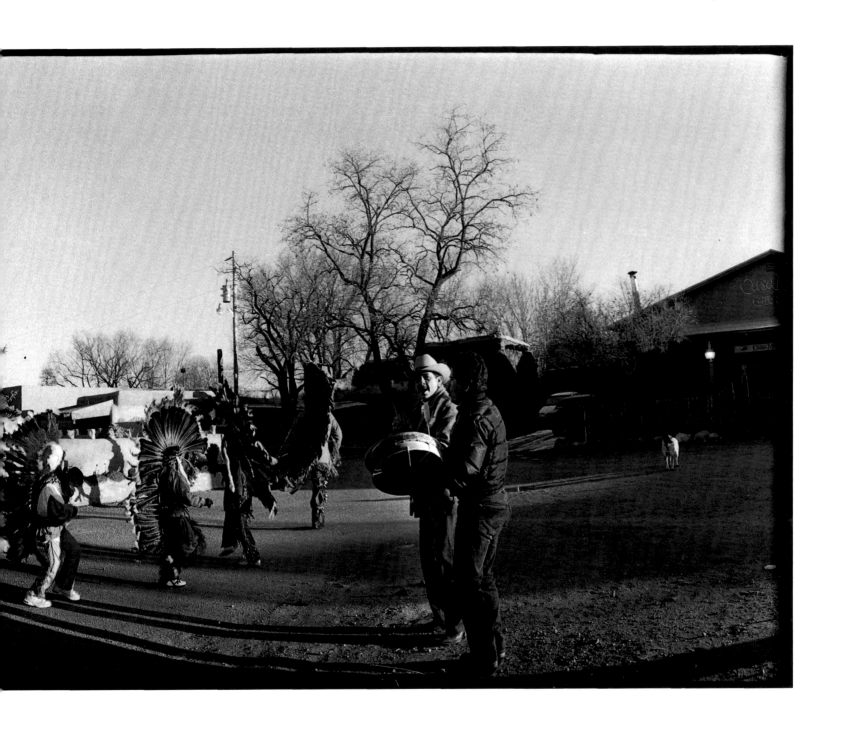

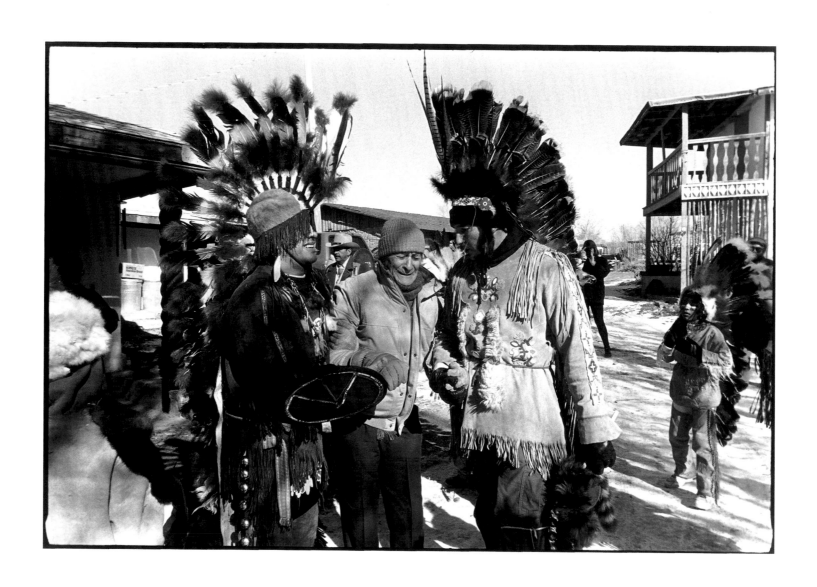

Memorias del Cautivo, Talpa, 1996

Nevada del Año Nuevo, Talpa, 1996

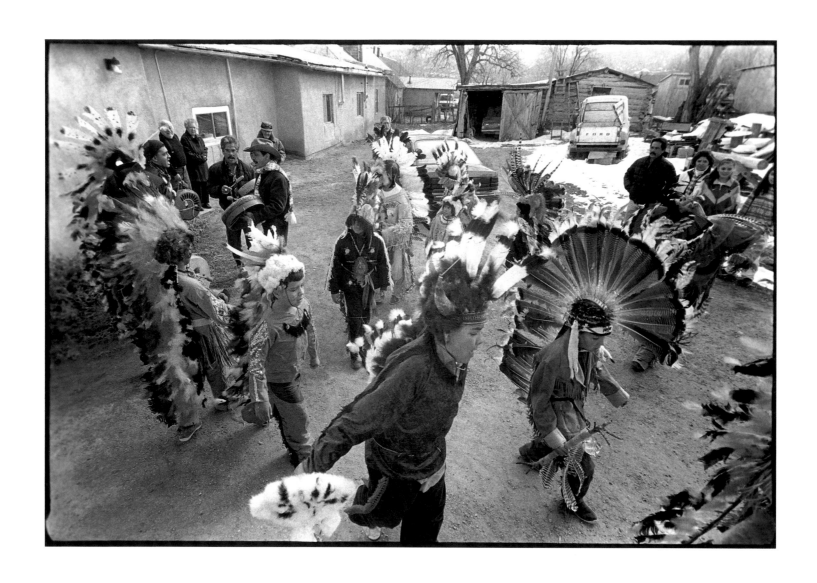

Baile del Paseado, Talpa, 1997

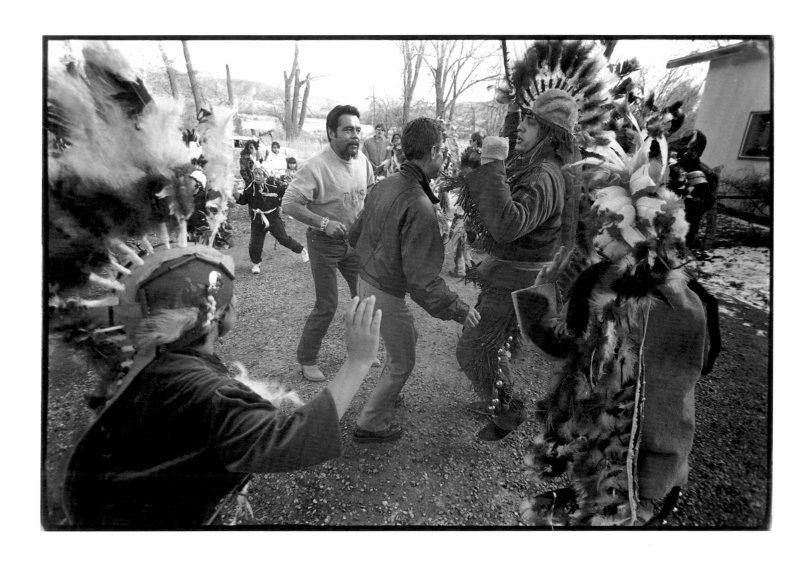

Los Cautivos, Talpa, 1995

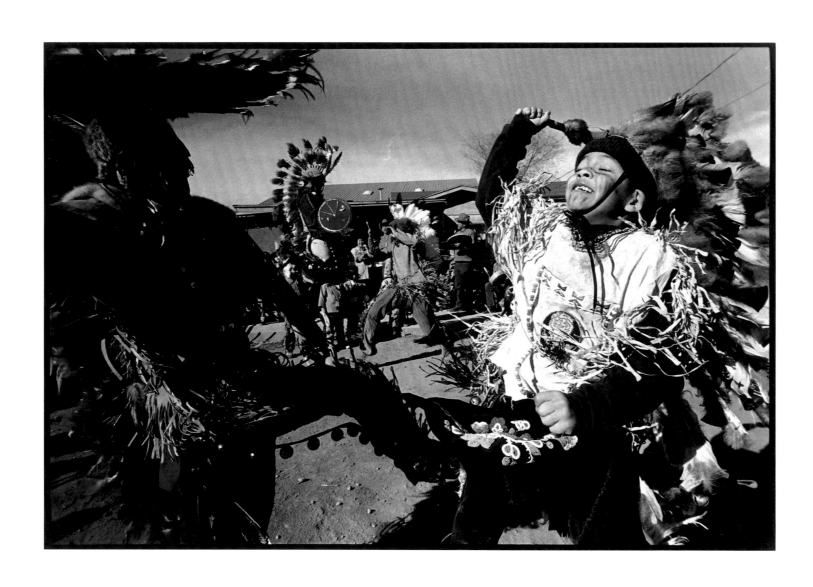

Baile del Espantado, Llano Quemado, 1998

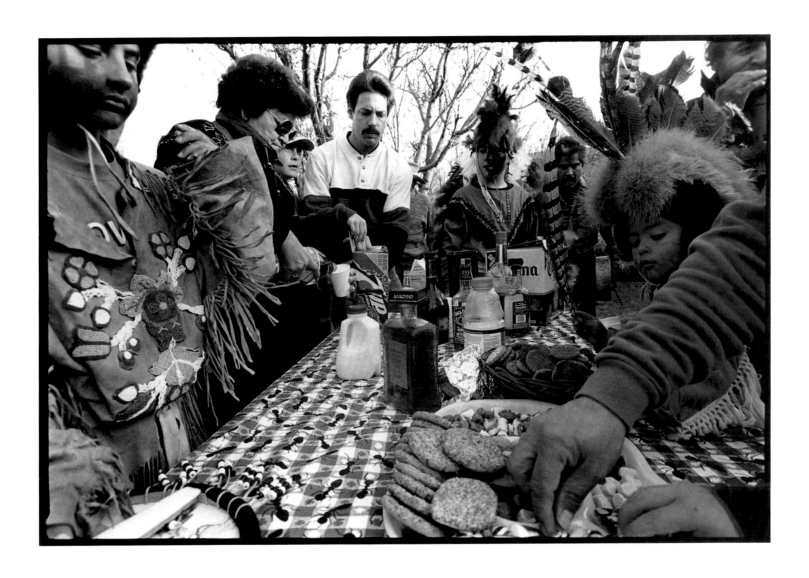

Dulces y Tragos, Talpa, 1997

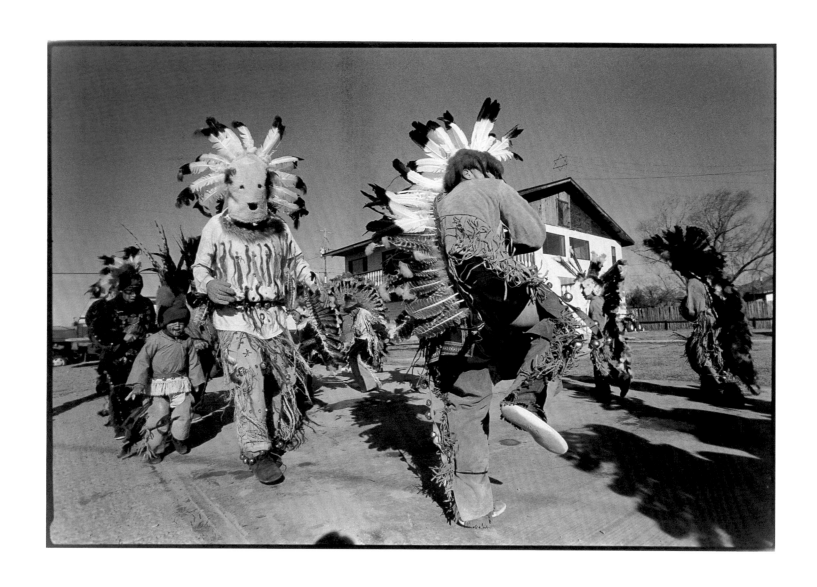

Baile Redondo, Llano Quemado, 1997

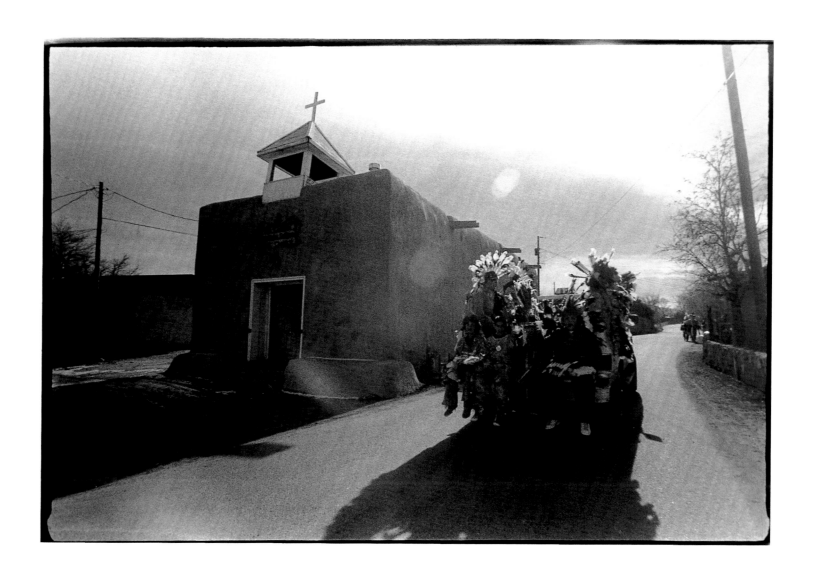

Capilla de Talpa, Talpa, 1997

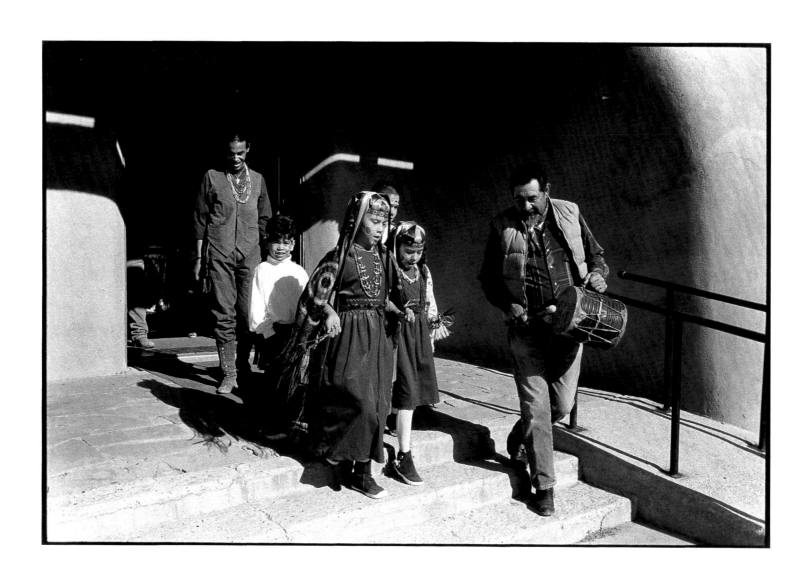

Floyd y su Tombé, Abiquiú, 1999

**A B I Q U I Ú**   *Genízaros and the Price of Freedom*

The last outpost on the Old Spanish Trail to California, Abiquiú was founded in the mid-eighteenth century as a defensive genízaro settlement. The Chama River valley was a natural corridor for commerce as well as warfare, and the village was the first line of protection against hostile invaders. The people of Abiquiú came from diverse tribal backgrounds and included Hispanicized Navajos, Utes, Comanches, Apaches, and even Hopis and other displaced Pueblo people.

The feast of Santo Tomás the Apostle in November specifically honors the genízaro heritage of the village. Many genízaros were orphans or captive children, victims of the protracted wars of the eighteenth century, who were raised in Hispano households. Almost every family in Abiquiú has stories about how one ancestor or another was taken captive or redeemed from captivity. This tribal memory is enacted at the fiesta by dancing children dressed in bright red cloth, buckskin, scarves, ribbons, feathers, and Tewa-style face paint. After mass at the church door, the little *cautivos* dance back and forth in rows, waving a single eagle feather in each hand. The *Nanillé* dance is sung with vocable choruses to the cadence of the tombé. Like other genízaro songs, it includes mysterious words like "nanillé" that no one recognizes anymore. The Nanillé song sounds Navajo to some listeners; others have noted its similarity to a Towa eagle-hunting song from Jemez Pueblo.

As if soaring, the cautivo children dance with outstretched arms and eagle feathers. The origins of this and other Abiquiú songs and dances are still a mystery.

Later in the day, there are moments when the dancing suddenly stops and a pantomime of captivity and redemption is acted out. A cautivo is taken prisoner from the crowd and presented to the people with a shout of *"¿Quién lo conoce?"*—"Who knows this person?" Someone comes forward with the desempeño, which is paid to the singers. If nobody claims the captive, the person remains the "property" of the singers. In the pantomime, the cautivos are either strangers being sold off or former residents whose relatives are paying back their ransom.

After the price is paid, *El Borracho* (the Drunkard) is danced. In this burlesque, dancers circle around each other as though falling down drunk; one waves a nearly empty whiskey bottle. There is something strangely triumphant in these ironic antics and gestures. The people achieve communion and victory through sharing alcohol. Both women and men make ululations or "war cries" during the dance. This disturbing scene is a reminder of the colonial policies regulating the *presidios,* or military installations, and their relations with nomadic Indians. The "civilizing effect" of alcohol is stressed because it helps make the Natives more dependent on the government. Drinking helped them "enjoy and reflect" on their new life in the colony and the "opportunities" it afforded them. The Indo-Hispano heritage has a dark side that stems from the historical struggle that molded it, but here, as with the Matachines dance, satire and burlesque minimize the pain of such memories.

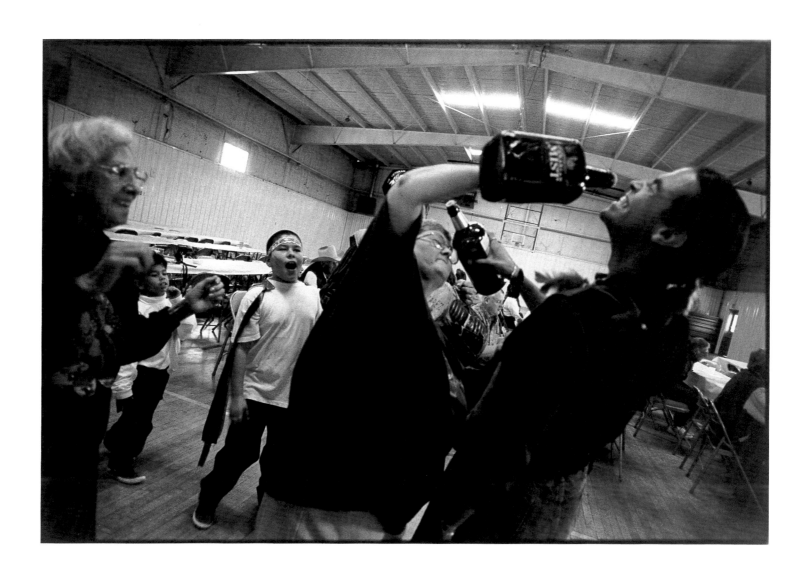

Baile del Borracho, Abiquiú, 1999

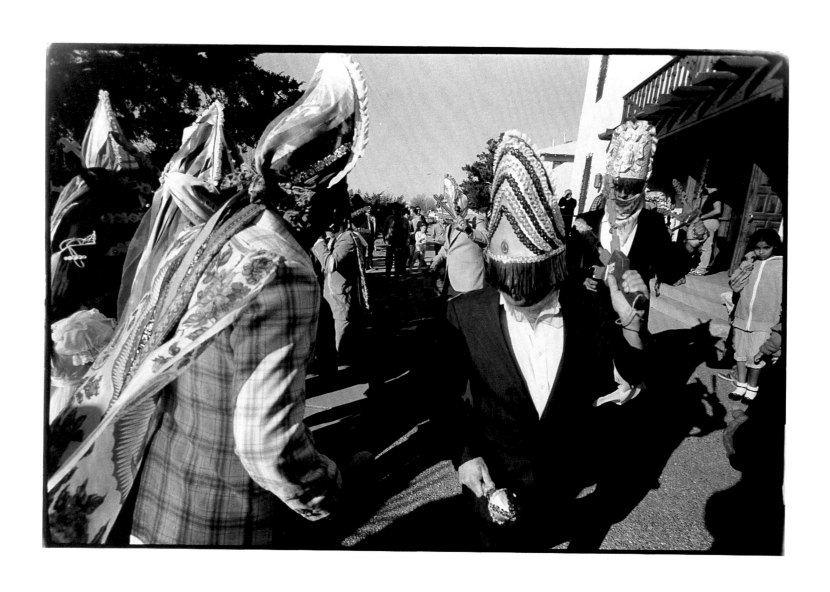

Despedida, Barrio San José, Albuquerque, 1986

**T I G U E X**     *Comanchitos and Matachines Come to Town*

Founded in 1706, Alburquerque (its original spelling) was the third villa of Nuevo México and the capital of the Río Abajo. The Tiguex province of which it is a part was passed over by early colonists, because the local Tiwa Indians still resented the abuses of Coronado and his army in 1540. When the Comanche wars concluded in 1786, farmers ventured out from the fortified settlements and founded a string of villages that are now a part of metropolitan Albuquerque.

The Matachines that dance the streets of the city come down from the Sandía and Manzano Mountains to the east to honor Guadalupe on December 12, for San Isidro and the blessing of the waters of the *acequias* of Atrisco on May 15, and for prayer vigils and feast days all across town. The theme of water is paramount in the east mountains. At San Antonio, the *mayordomos,* or fiesta stewards, carry their saint dressed as a miniature Matachín halfway up Sandía Mountain to bless the only source of surface water in the area. When the community was attacked by Apaches on its feast day in the mid-nineteenth century, the Indians were frightened away by the masked dancers and their strange three-pronged swords.

One of the largest Matachines celebrations can be found in the village of Bernalillo, north of Albuquerque, on the feast of San Lorenzo on August 10 — the very day of the great Pueblo Revolt of 1680. On the eve of the rebellion, local settlers in the area were warned by their

Indian neighbors and were able to escape in time. According to legend, because of the shared Matachines traditions, the local Tiwas and Spanish Mexicans were close friends. When Governor Don Diego de Vargas led the reconquest of Nuevo México in 1692, he promised to honor the martyrs of 1680 and the spirit of reconciliation with Matachines celebrations. Perhaps because de Vargas died in Bernalillo, contemporary dancers recall his promise and add *promesas* of their own to their devotions. The Bernalillo Matachines are so numerous and popular with the people that mayordomos are scheduled well into the twenty-first century, and newly married couples have promised their unborn daughters for the role of Malinche, the little virgin responsible for the conversion of Moctezuma.

Bernalillo also observes Los Comanches, the nativity play that originated west of the Río Grande Valley in the villages surrounding Mount Taylor. According to local legend, Hispano villagers were celebrating one Christmas Eve long ago when they were disturbed by a knock on the door. A group of Comanches, clad in buckskin and feathers, had heard there was a miraculous child in the house and wished to pay him homage. The villagers somewhat reluctantly let them in, knowing it can be dangerous to refuse hospitality to a Comanche. In the play, the visitors promise that all they want is to offer their dance to the *Santo Niño*. They sing "Indian-style" verses such as the following:

| | |
|---|---|
| A las doce de la noche | At twelve at night |
| Le hemos venido a buscar | We have come looking for him |
| Nosotros los Comanchitos | We the little Comanches |
| Le hemos venido a bailar. | Have come to dance for him. |

Once inside the house, the Comanches dance and eat with their hosts. They then proceed to the altar and steal the Santo Niño and, sometimes, one of the children of the household. They flee, pursued by their hosts. In the mock struggle that follows, the daughter of the chieftain and other Comanches are captured and later ransomed. To the accompaniment of more songs, the Santo Niño is recovered and mayordomos are chosen for the next year. The elements of the plot in this religious drama are loose and vary from community to community. In Alameda, between Bernalillo and Albuquerque, Los Comanches has been revived to honor the Virgin of Guadalupe.

In recent years, the Comanches nativity play has been restaged by Bernalillo families with roots in the Mount Taylor area. Several songs from the play have been linked with the well-known Christmas pageant of *Las Posadas,* in which Mary and Joseph search for lodging in Bethlehem. On Christmas Eve, on their last homeless night, the Comanchitos dance for the Holy Child in the community church. The music is fanciful, the lyrics evocative of a people that implicitly recognizes and honors its Indo-Hispano origins.

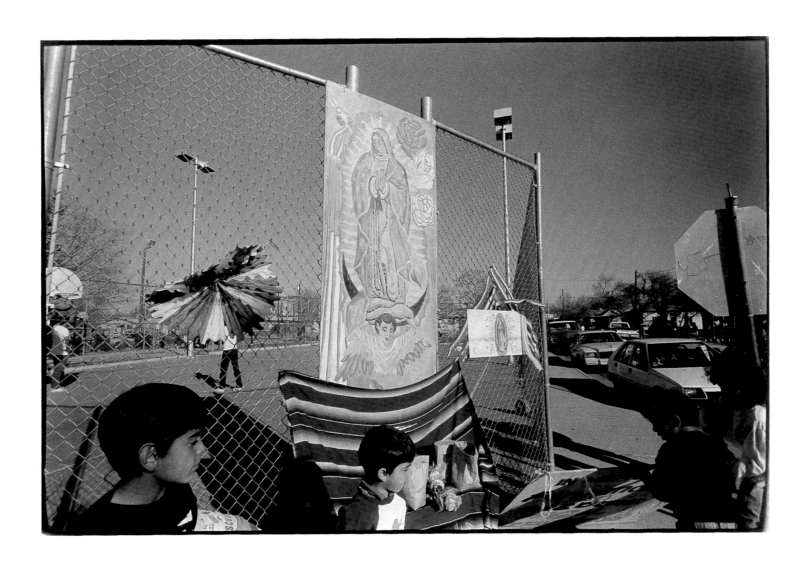

Altar de la Esquina, Barrio San José, Albuquerque, 1989

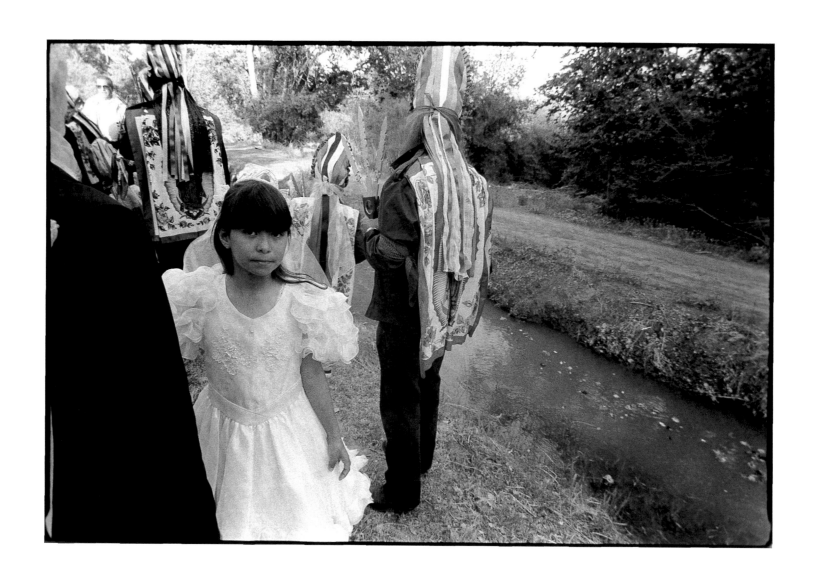

Bendición de las Aguas, Atrisco, 1997

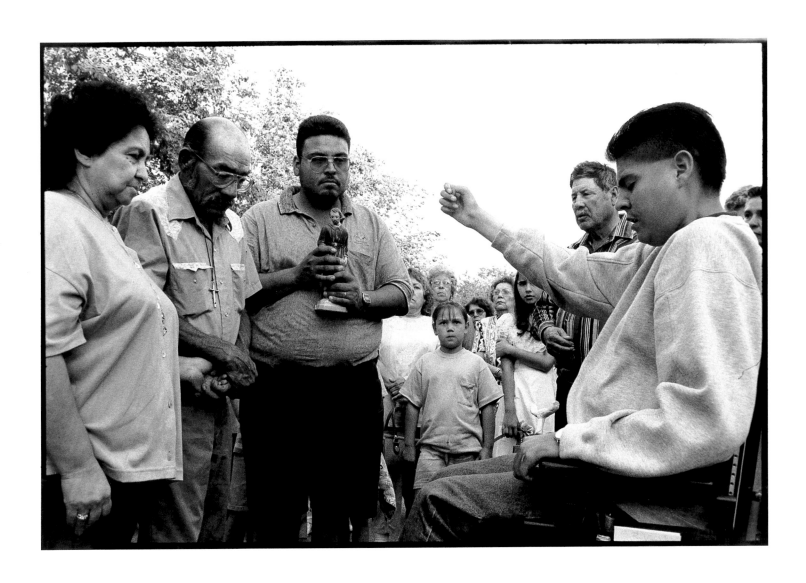

Entrega de San Isidro, Atrisco, 1997

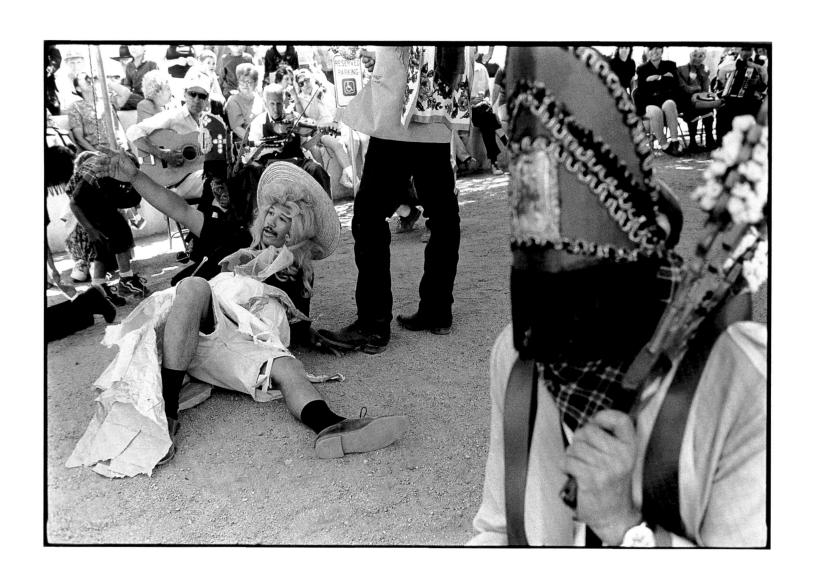

Atrocidades de la Perijundia, San Antonio, 1998

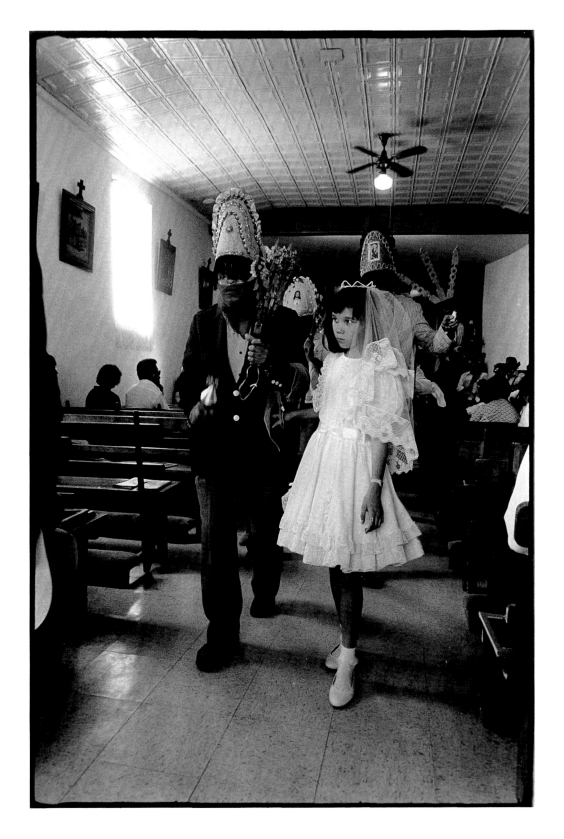

La Malinche y su Luz,
San Antonito, 1988

Ojos al Cielo, San Antonio, 1998

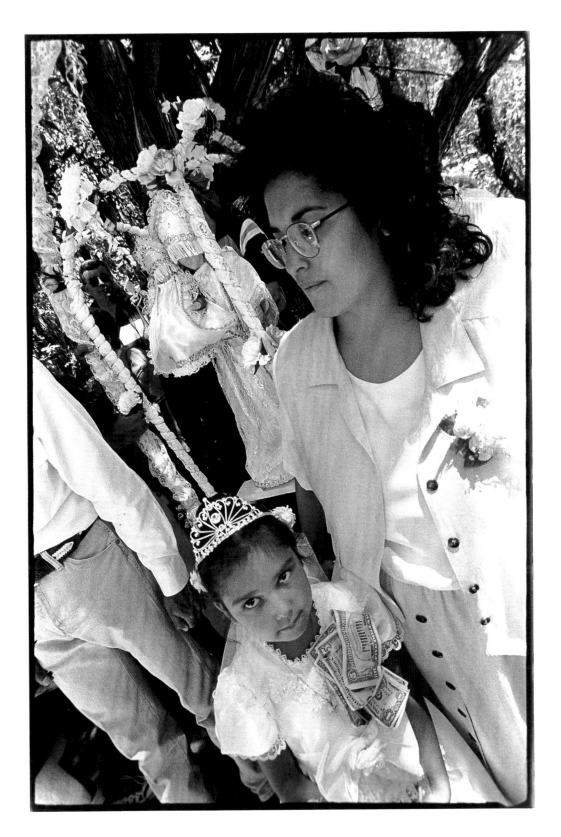

San Antonio Matachín,
San Antonio, 1998

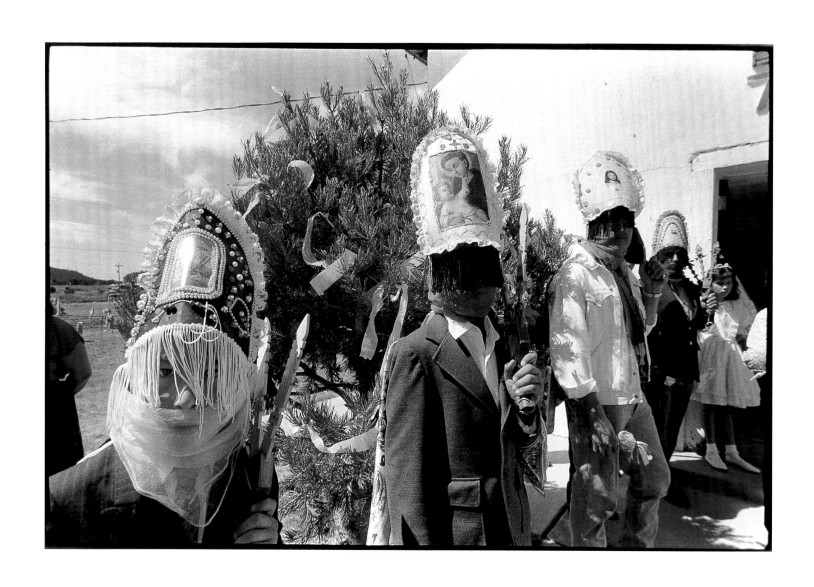

Soldados de San Antonio, San Antonito, 1988

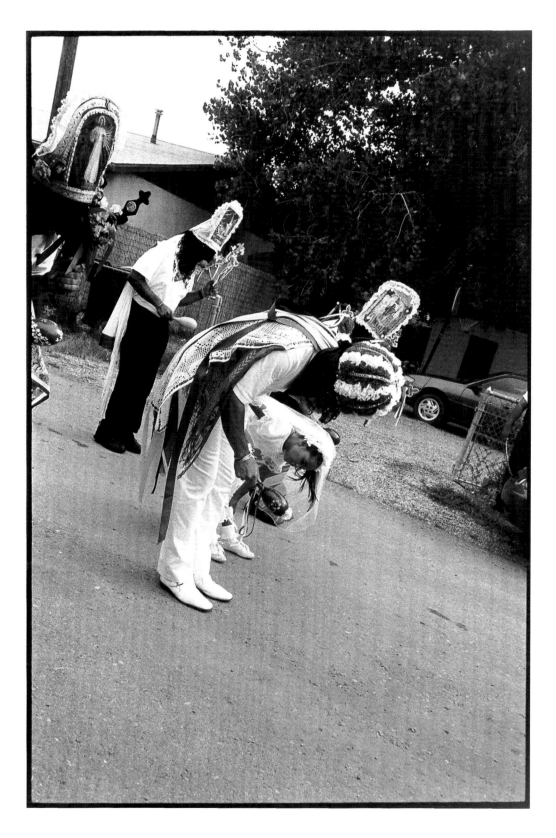

Adorando a San Lorenzo,
Bernalillo, 1999

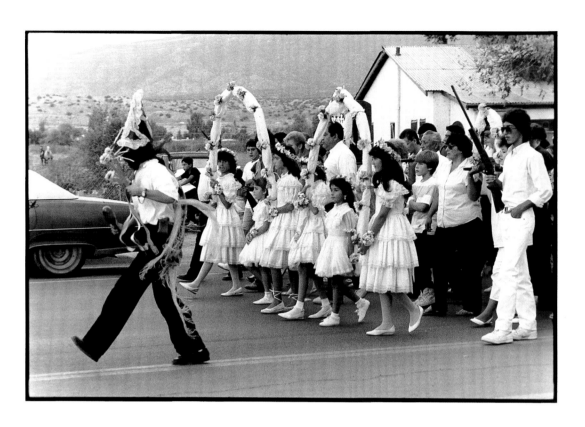

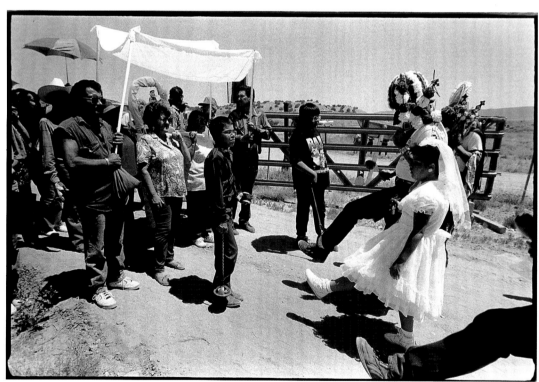

Procesión de San Lorenzo,
Bernalillo, 1987

Adorando a San Luis Gonzaga,
San Luis, 1993

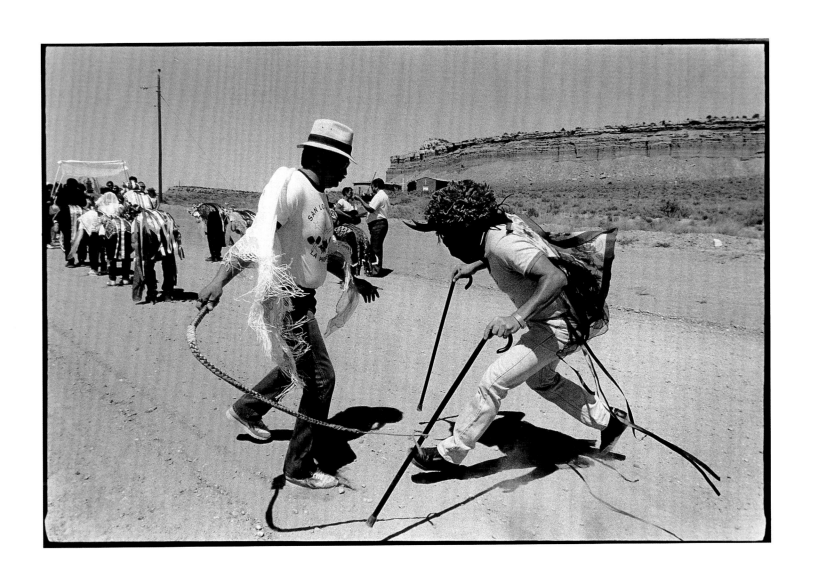

El Toro Peleando, San Luis, 1993

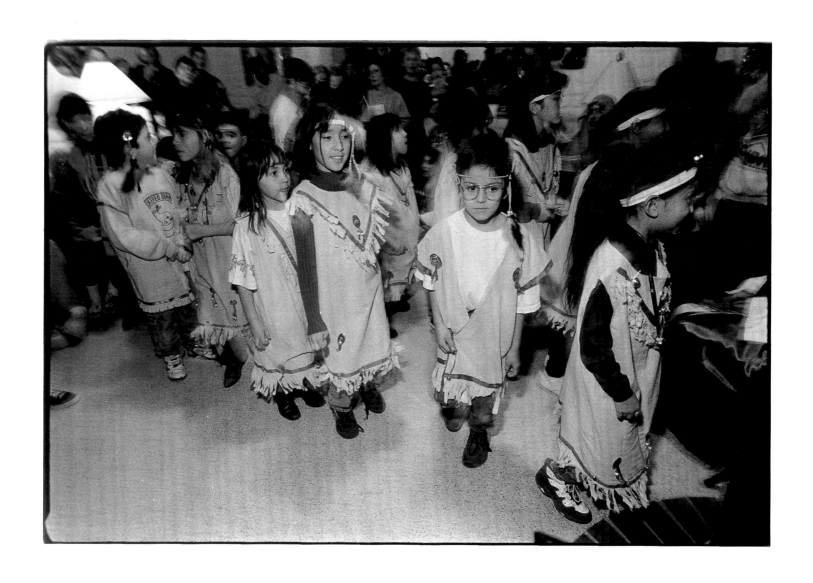

Comanchitos de Noche Buena, Bernalillo, 1996

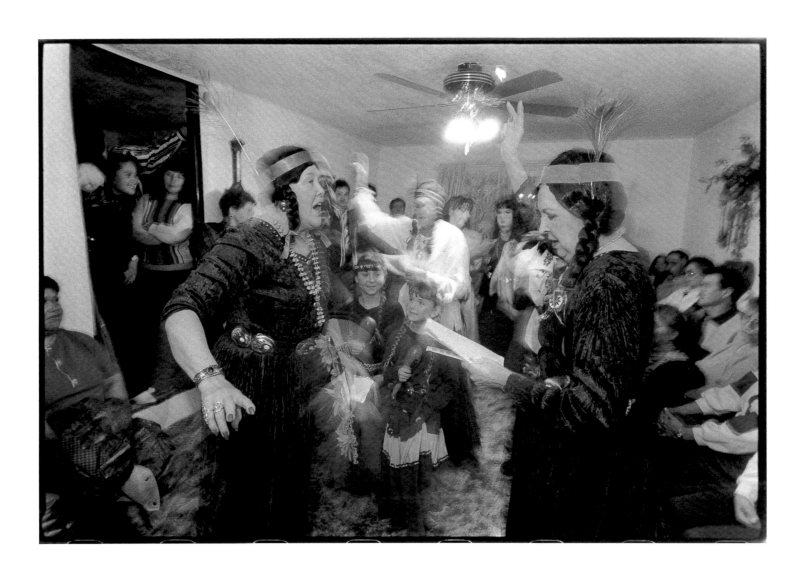

Las Comanchas y sus Cautivas, Los Griegos, 1997

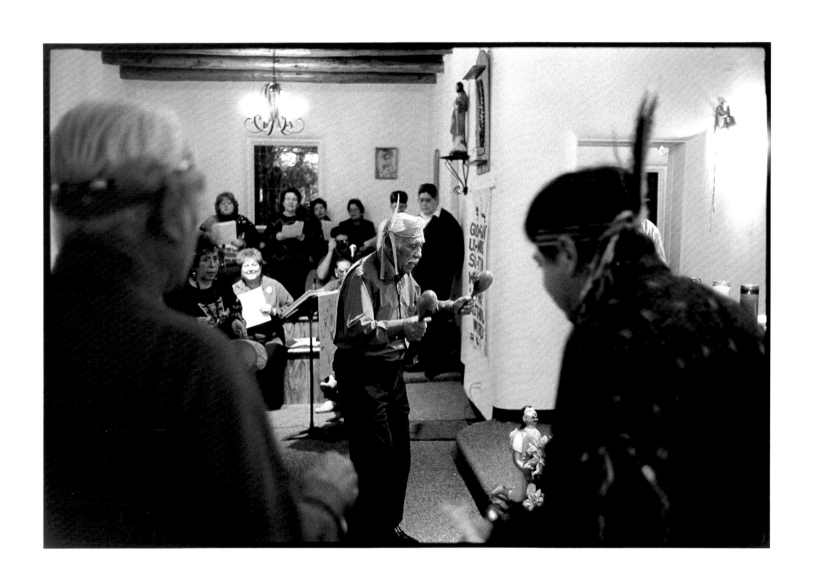

Eduardo y la Virgen, Alameda, 1997

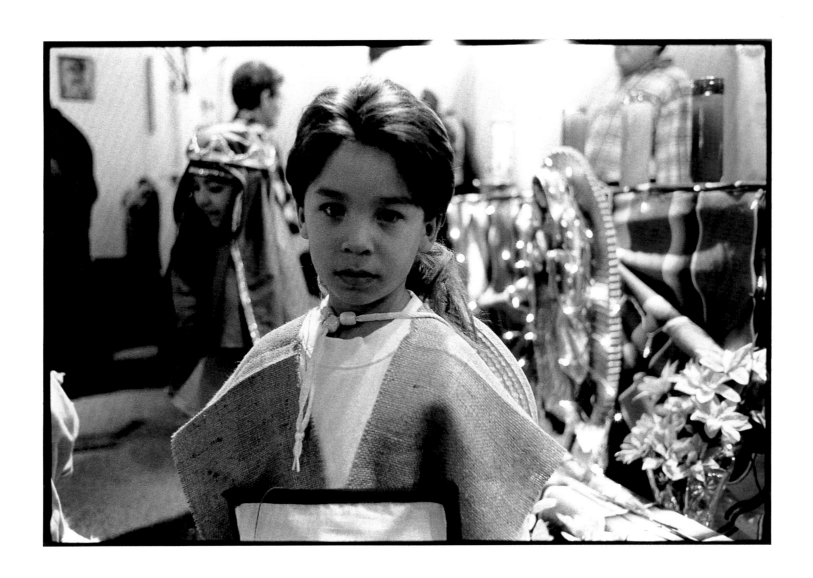

Juan Dieguito, Alameda, 1997

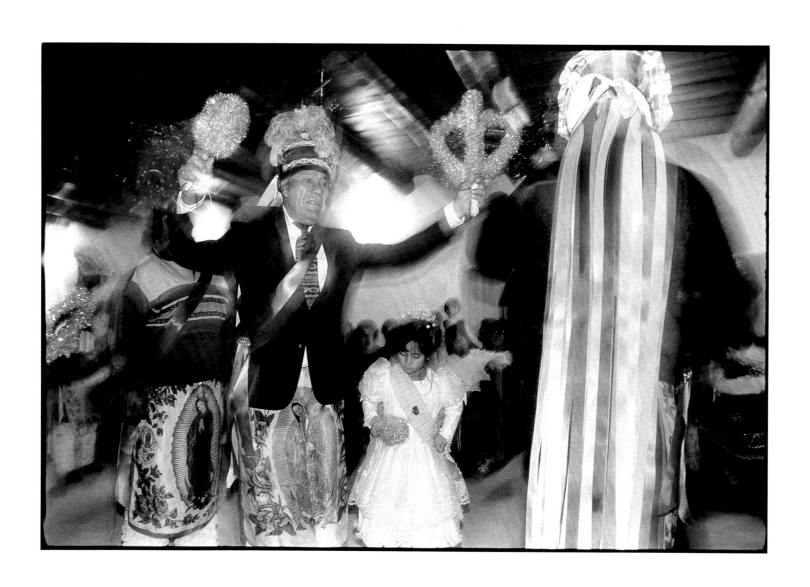

Moctezuma y su Hija, Tortugas, 1996

## TORTUGAS    *North and South Are One*

Settled in the Mesilla Valley after the war with Mexico by Mexicanized Tiwas and Piros from Isleta del Sur and Senecú del Sur, Tortugas is a community deeply invested in its Indo-Hispano identity. Earlier, during the Pueblo Revolt of 1680, both communities fled their parent villages in the north, choosing to cast their fate with their Spanish Mexican neighbors. To the east of the settlement lies Tortugas Mountain and its sacred shrine to the Virgin of Guadalupe. Every year in the second week of December, the devoted walk up the mountain, carrying their *quiotes* (pilgrim's staffs) fashioned from the stalk of the *sotol* plant. *Luminaria* bonfires made from old tires and kindled by sagebrush illuminate the mountain on the night before the Virgin's feast on December 12.

Back in the plaza, hundreds of Matachines, Chichimecas, Danzantes, and Tiwas dance to the music of violin and tombé in rapt devotion to Guadalupe. The oldest group, or Danzantes, as they call themselves, most resemble the northern Matachines, complete with Monarca, Malinche, Torito, and Abuelos. As at Picurís Pueblo, they too weave a symbolic Maypole out of a rainbow array of ribbons.

Although the Tiwas no longer speak the language of their forebears, they honor their traditions with song and line dances. Women wear *manta* dresses similar to those worn in the north, and the men wear flannel "buckskin" and carry bows. The Chichimecas and

Matachines groups wear bright *carrizo* (reed) aprons with fanciful Aztec and Plains feather headdresses. Although the Plains war bonnets are symbolic of Comanche culture in other settings, and the Nuhmuhnuh were no strangers to southern New Mexico, there are no specific Comanche celebrations in Tortugas.

To mark time to the music, Chichimecas and Matachines dancers shake rattles and unusual clackers shaped like a bow and arrow. These groups have as many as five or six Malinches dressed in brilliant reds and greens. The grotesquely masked Abuelos engage in elaborate pantomimed fights, to the delight of the crowd. Their license to scandalize and satirize is in sharp contrast to the serious expressions of the dancers.

The profusion of color and sumptuous displays of the Tortugas dancers are truly overwhelming to the senses. The earth is blessed with each of their footsteps. Matachines is the regional dance of reconciliation and unification, and native cultures come together to celebrate it. In southern New Mexico, the prophecy of Moctezuma has come to pass. With each generation the dancers resemble each other more.

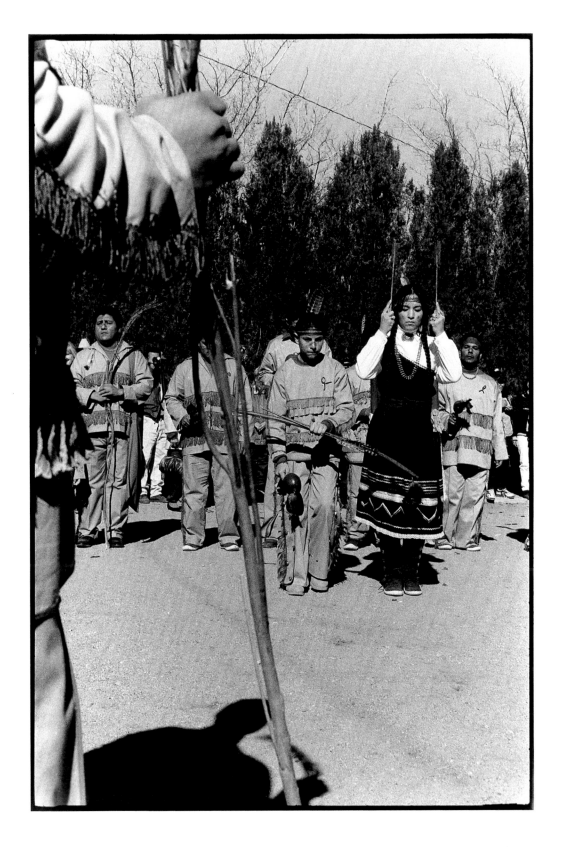

Armas de los Tiguas, Tortugas, 1996

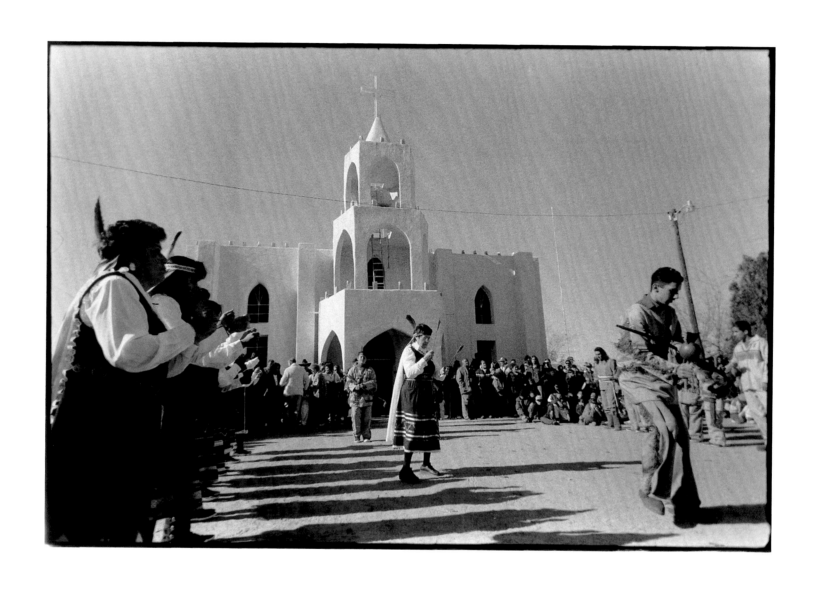

Capilla de Guadalupe, Tortugas, 1996

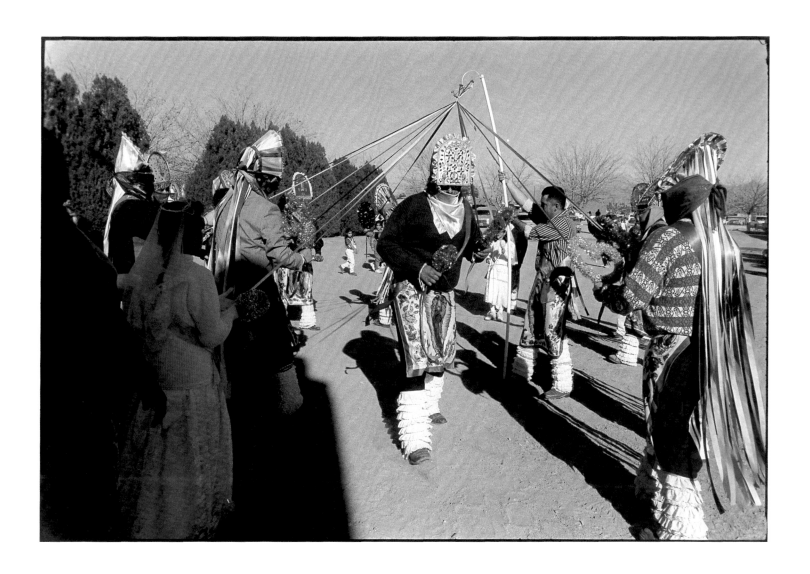

Danza de la Tejida, Tortugas, 1996

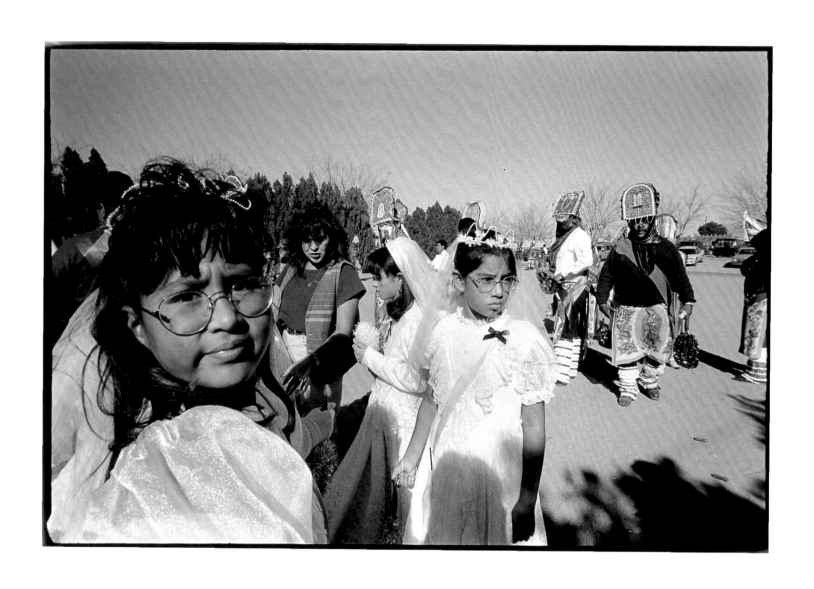

Las Malinches, Tortugas, 1996

84

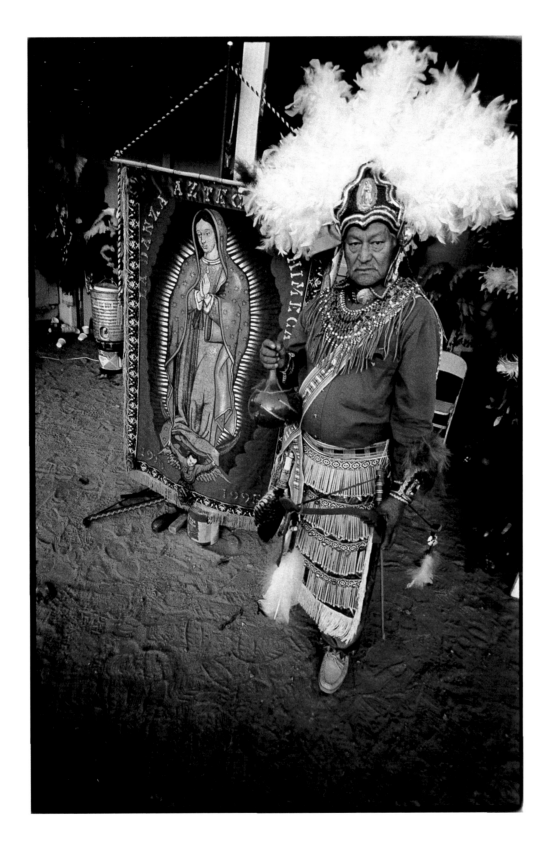

General Azteca Chichimeca,
Tortugas, 1993

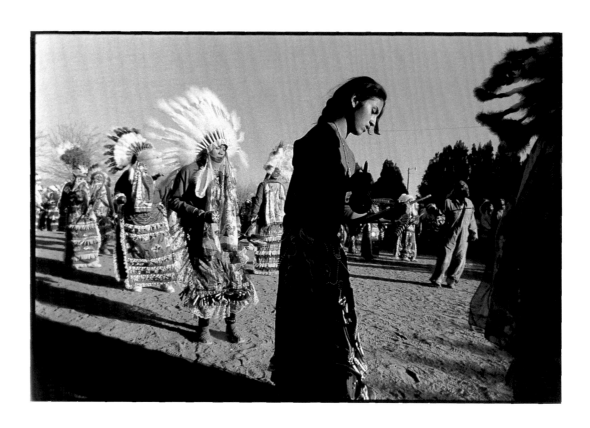

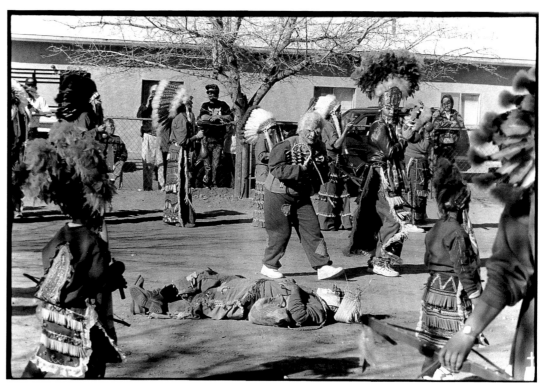

Devociones Guadalupanas,
Tortugas, 1999

Pelea de los Abuelos,
Tortugas, 1996

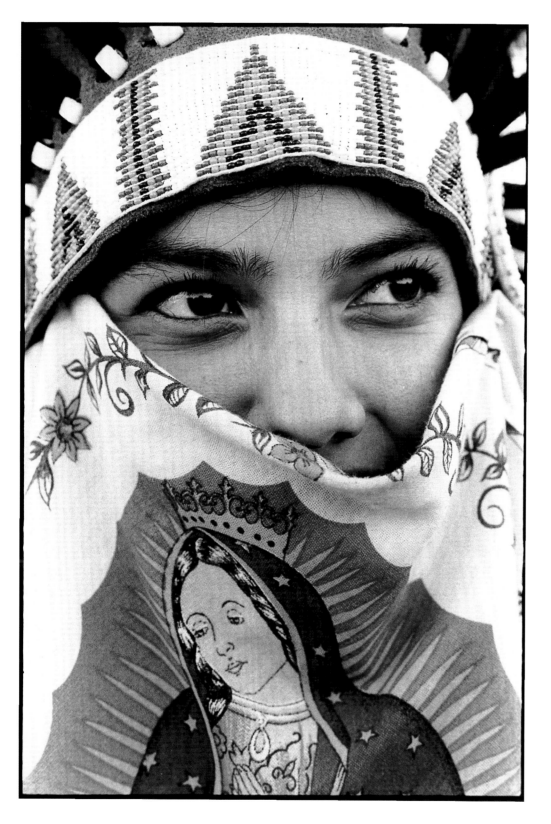

Guadalupana del Alma,
Tortugas, 1996

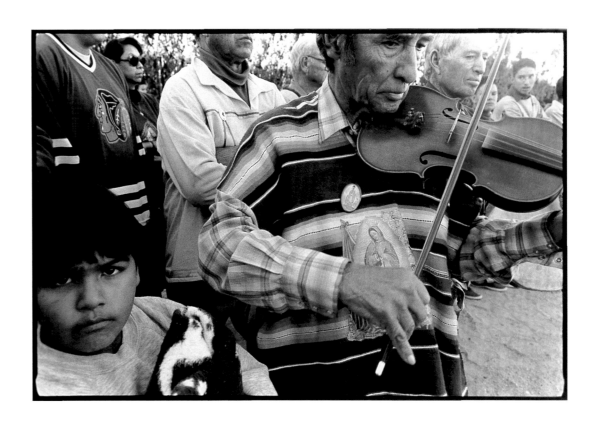

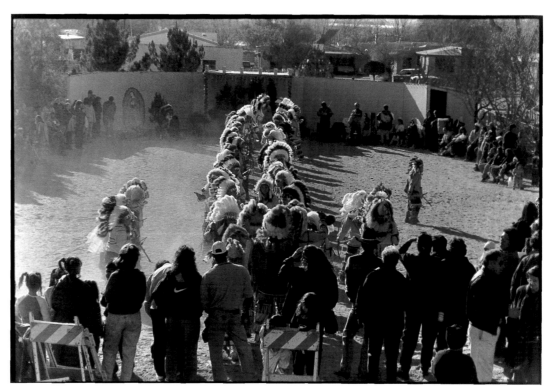

Música para Guadalupe,
Tortugas, 1996

Plumas en el Viento,
Tortugas, 1999

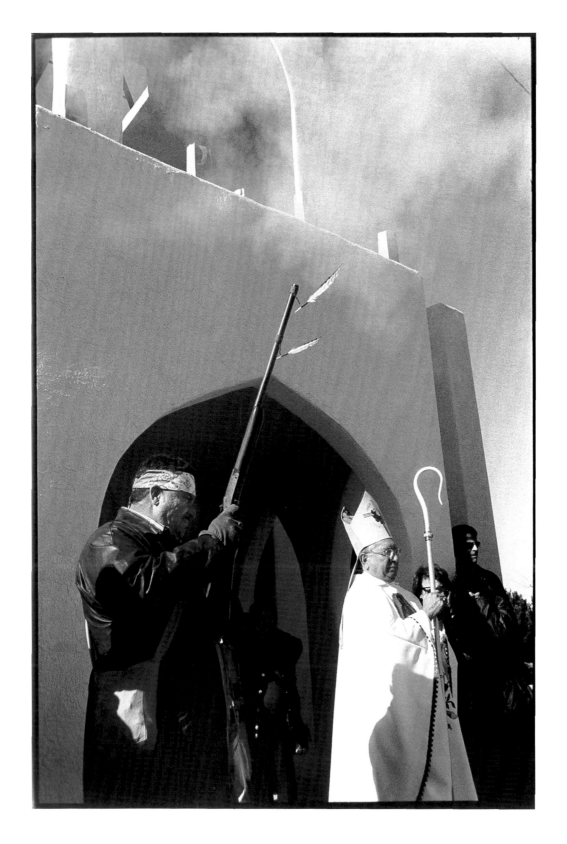

Balazo del Arzobispo,
Tortugas, 1999

Quiotes en la Puerta,
Tortugas, 1999

Devotos del Cerro, "A" Mountain, 1993

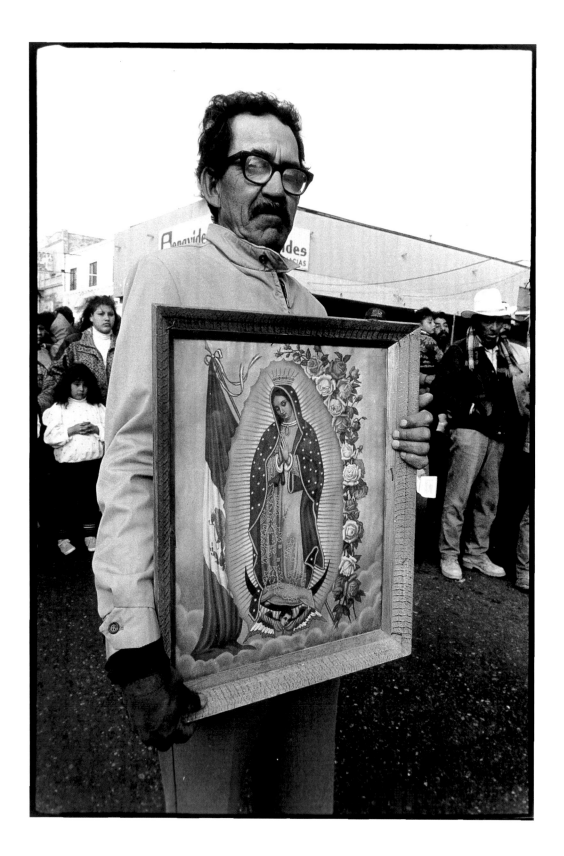

Guadalupano,
Juárez, México, 1993

## EL PASO DEL NORTE  *Guadalupe and the Promised Land*

El Paso del Norte, in its new guise as *Ciudad Juárez,* has always been the geographic, historical, and spiritual gateway to Nuevo México. It was the capital of Mexico when Napoleon's army occupied Chihuahua and Benito Juárez presided over the embattled republic from the banks of the Río Grande. The spiritual guardian of the gateway to the north is the Virgin of Guadalupe. Her image adorns every conceivable sacred and secular surface, including market shrines, calendars, taxis, gearshift knobs, and before all else the human skin, whether in the intimate contact of a garment or the indelibility of a tattoo. In their hearts, and as children, every man is and has been Juan Diego, and every woman Guadalupe.

For several days around the Virgin's feast day of December 12, the cathedral plaza of Juárez is filled with dancers of every description on pilgrimage from the entire state of Chihuahua and neighboring regions. Some are Matachines, others call themselves Apache dancers, and others focus closely on the Abuelos and Viejos, the grotesque grandfathers who pass on cultural values by imposing and impressing themselves on everyone through their outrageous humor. By necessity, the dancers' costumes are made from whatever materials are available, in the *rasquachi* style that incorporates all manner of recycled materials in folk-baroque combinations. Flour sacks, crepe paper, and cheap Christmas tinsel are transformed into the uniforms of mystic soldiers. Tin cans and old toilet floats are painted and made into rattles, and

discarded football helmets become Aztec headdresses. Meanwhile, a few blocks north of the plaza, armed guards and U.S. Immigration Service helicopters continually patrol the line.

In the *colonia* slums on the ragged outskirts of the city, thousands of newcomers from the interior stake out their claims with bits of fencing and scrap lumber. Soon, cinder-block walls are laid out to enclose the precarious sacred space of sanctuary; before the niches are even finished, they are adorned with images of Guadalupe. The irrepressible Indo-Hispano spirit of Nuevo México Profundo is inherent in all the peoples of the Río Grande.

Fe y Orgullo, Juárez, México, 1993

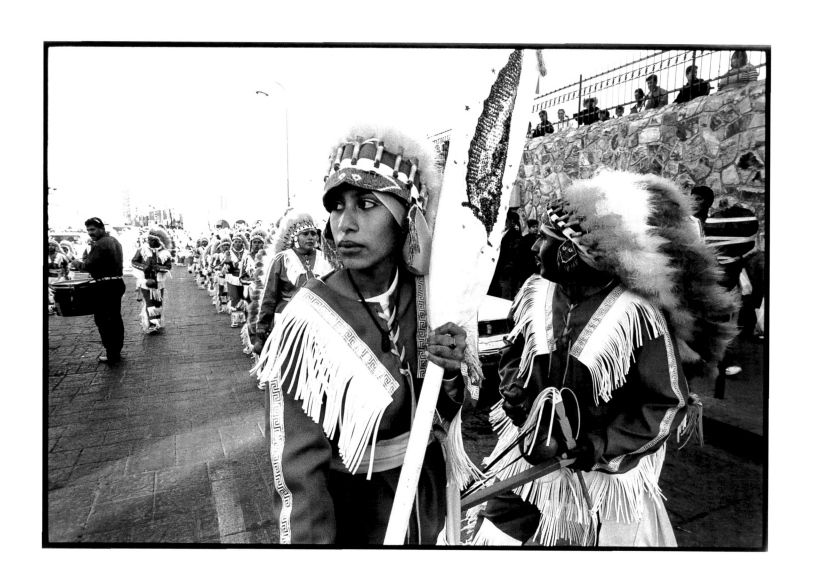

Devoción de los Apaches, Juárez, México, 1998

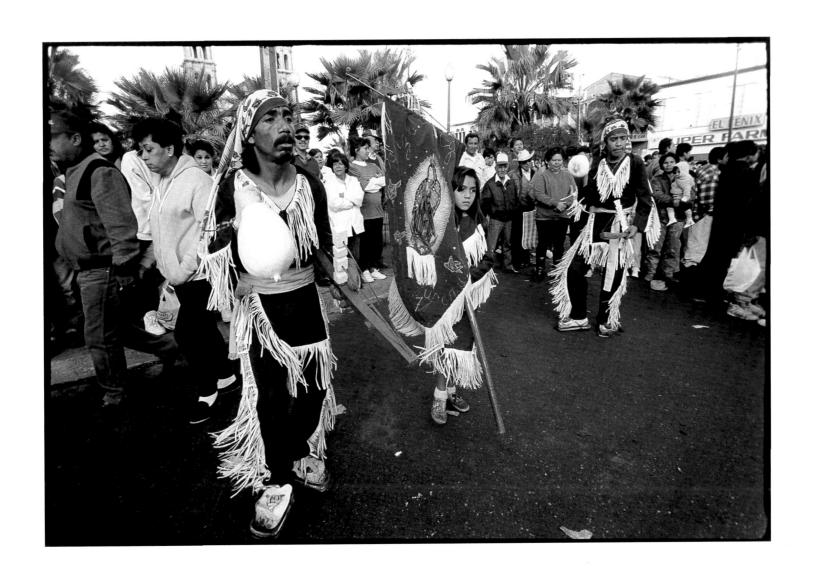

Danzantes de la Plaza, Juárez, México, 1993

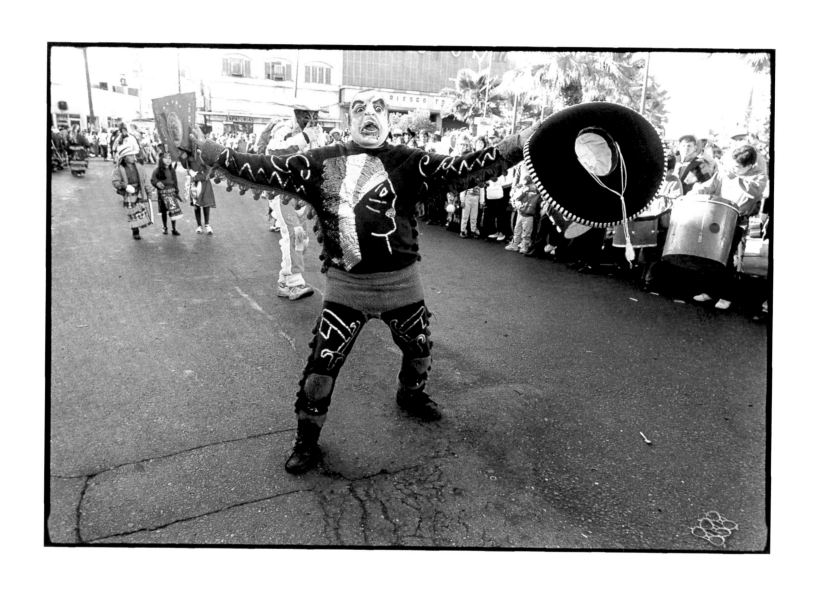

Abuelo Charro, Juárez, México, 1993

98

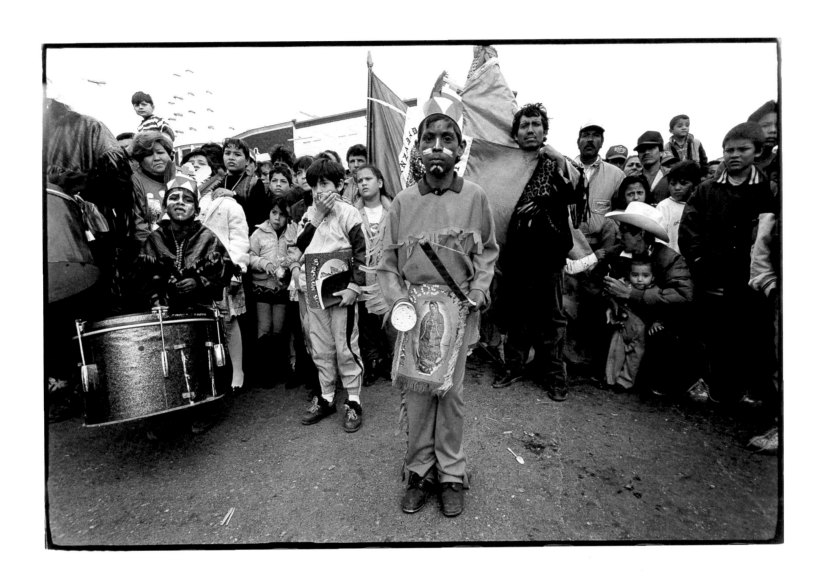

Indito de la Sierra, Juárez, México, 1993

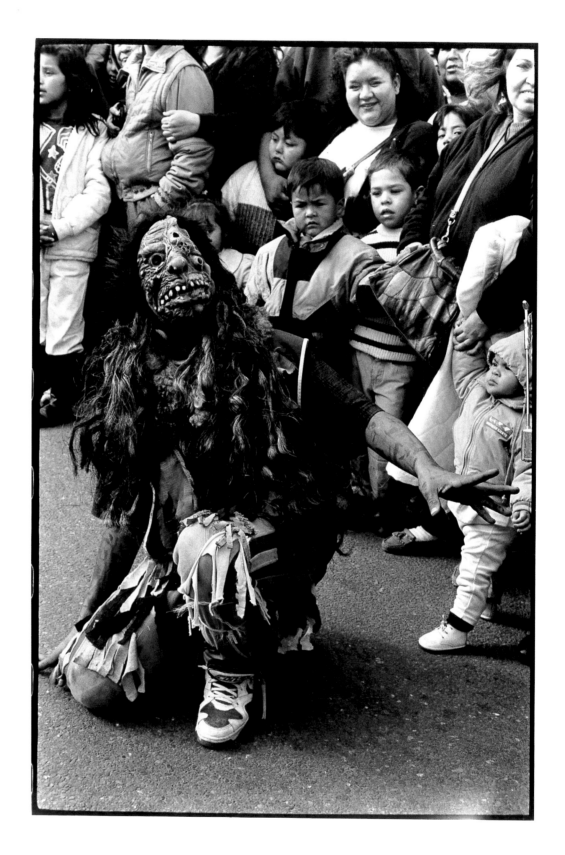

Dolor del Abuelo,
Juárez, México, 1993

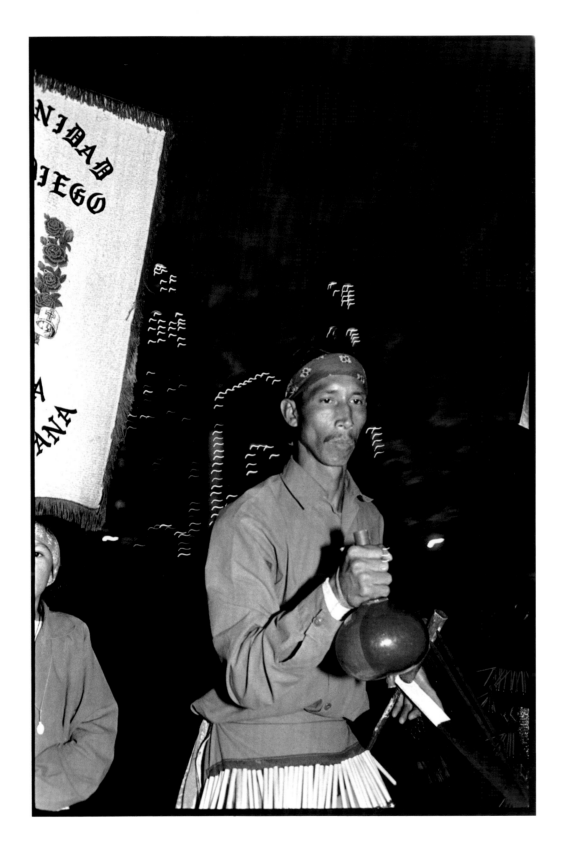

Vísperas de la Virgen,
Juárez, México, 1993

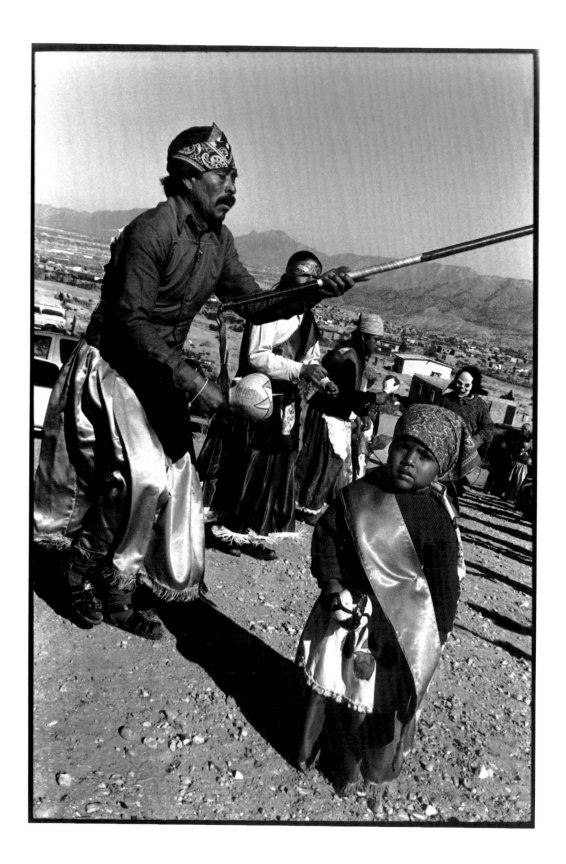

Javier y su Hijita, Ranchos de
Anapra, México, 1998

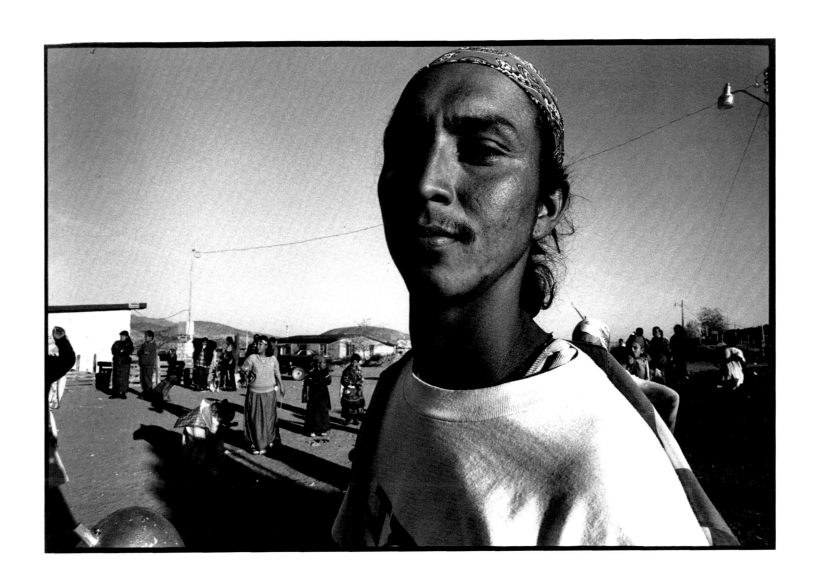

Orgullo del Guadalupano, Ranchos de Anapra, México, 1998

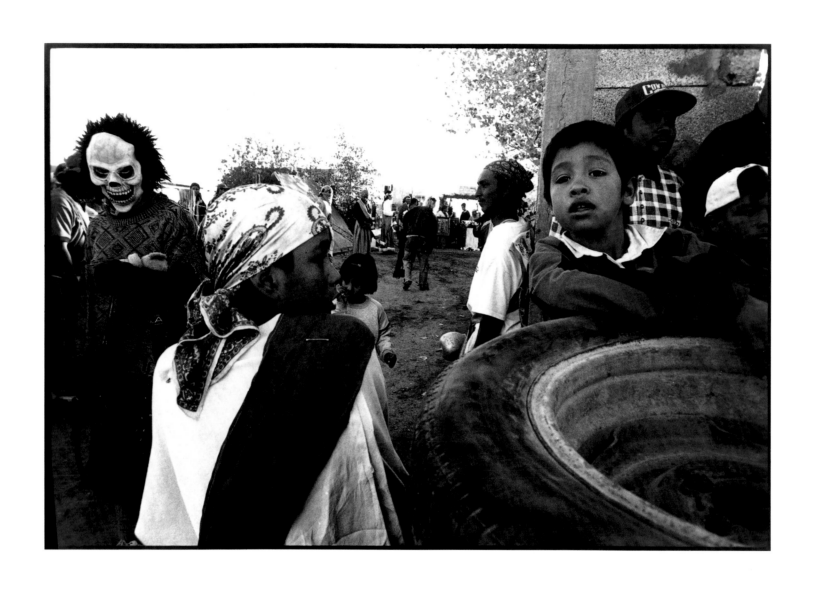

Niños y la Muerte, Ranchos de Anapra, México, 1998

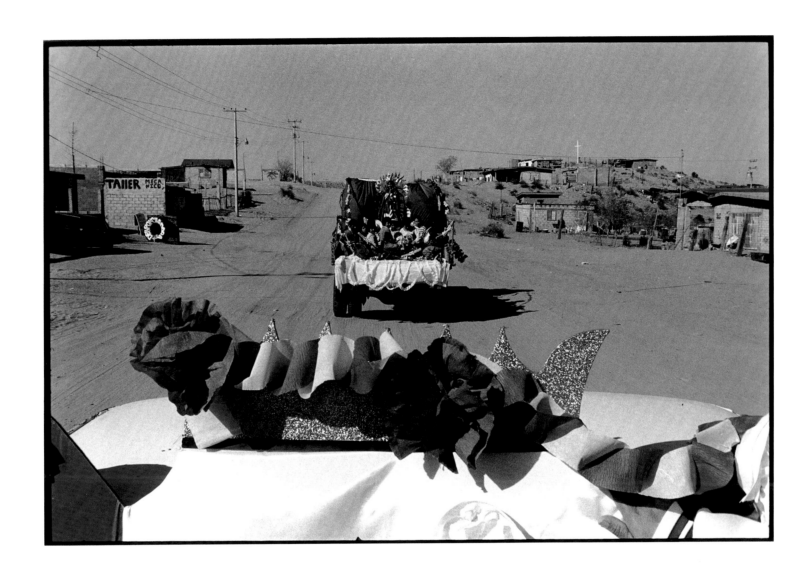

Procesión, Ranchos de Anapra, México, 1998

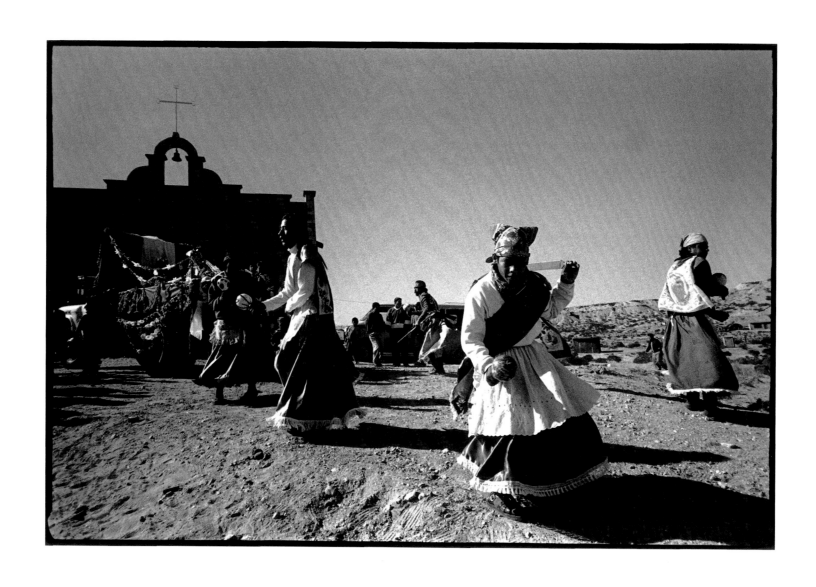

Bendiciones del Desierto, Ranchos de Anapra, México, 1998

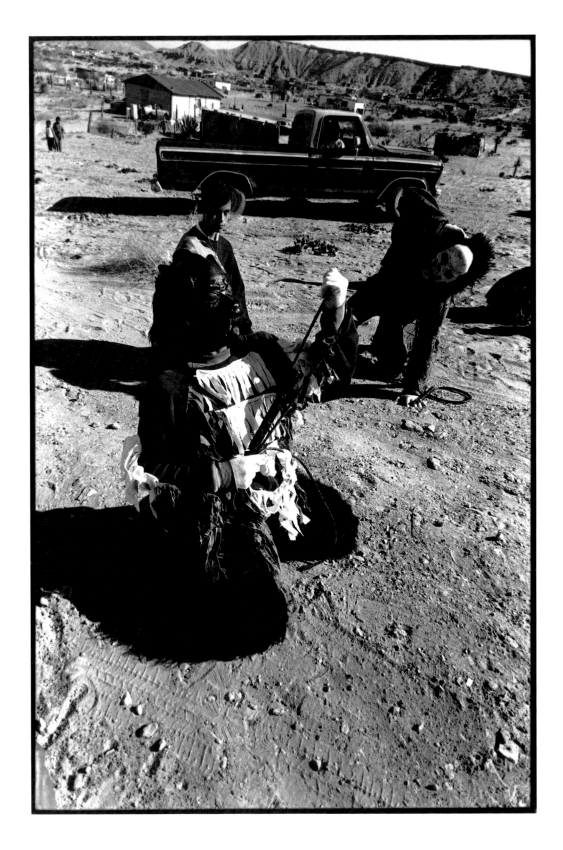

Abuelo y la Muerte,
Ranchos de Anapra, México, 1998

Soldado de la Virgen,
Ranchos de Anapra, México, 1998

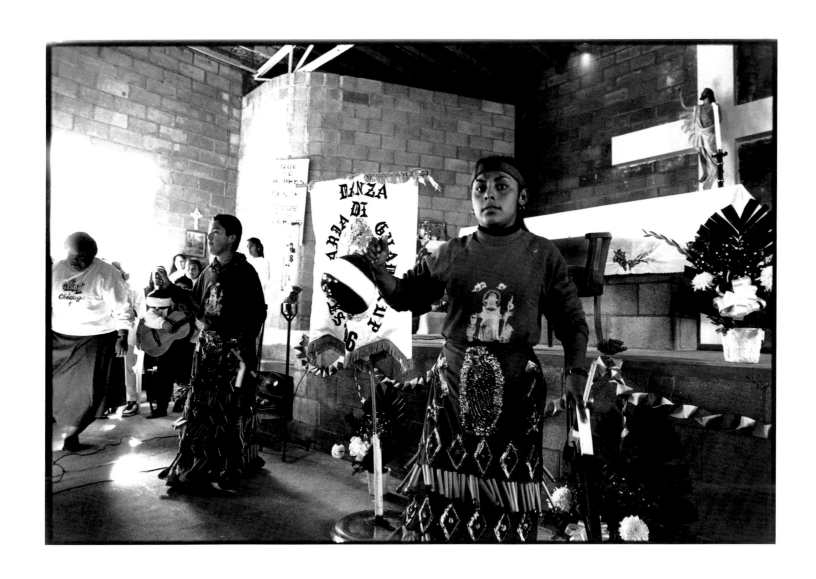

Danza en el Nuevo Templo, Ranchos de Anapra, México, 1998

*As geographic historians know, the tops of the oldest maps pointed east, the cynosure of medieval travelers, the cardinal orientation of commerce, and the direction of the holy cities of Rome and Jerusalem, the goal of every Christian pilgrim. In time, with the invention of the magnetic compass, the North Star became the focal point of cartography and the means of locating oneself anywhere on the planet. The prayer exhortation became "Viva María, mi Norte y Guía" (Hail Mary, my North Star and Guide), and the maps plot the coordinates of a northern homeland.*

*The indigenous coordinates of querencia, however, are laid out not from south to north or east to west, but rather from a sacred center toward all directions. All space is sacred, from the four walls of the house and underground kiva ceremonial chambers, to the plazas, to the shrines for the cardinal directions, to the mesas and mountain peaks beyond, always in fours. In a sacred landscape, only time is profane. People have always been challenged by the times they live in, and the purpose of religion is to seek and carefully maintain harmony through prayer and dance and dedication to others.*

*In the Pueblo world and throughout Mesoamerica, humans have always been part of creation; there are no origin stories akin to Adam and Eve, but rather emergence stories, in which the people come forth into new and successive worlds. Like pilgrims, they travel in search of that sacred Center place called home. The place of emergence is remembered and symbolized by the* sipapú, *the little opening in the floor of the kiva.*

Al Pie de la Cruz, Chimayó, 1996

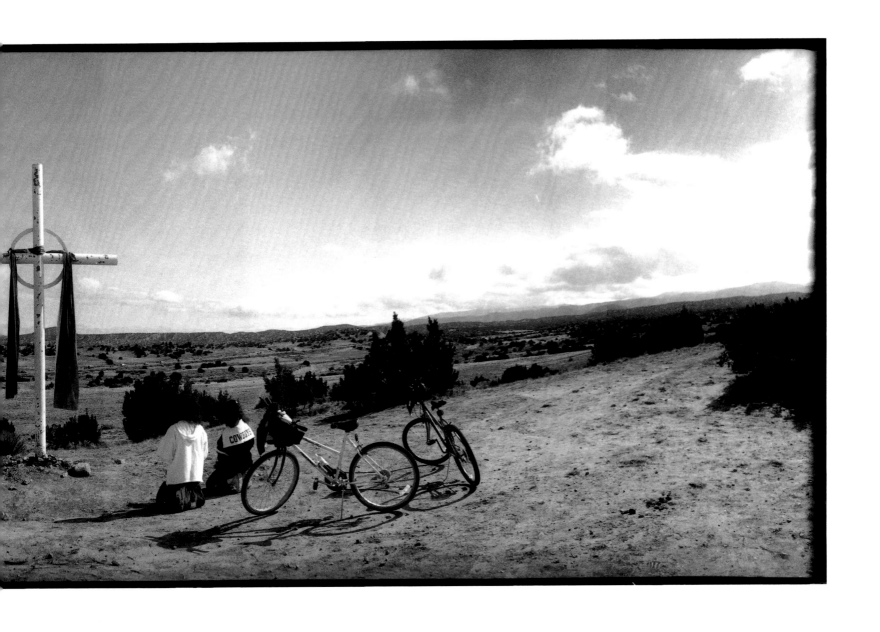

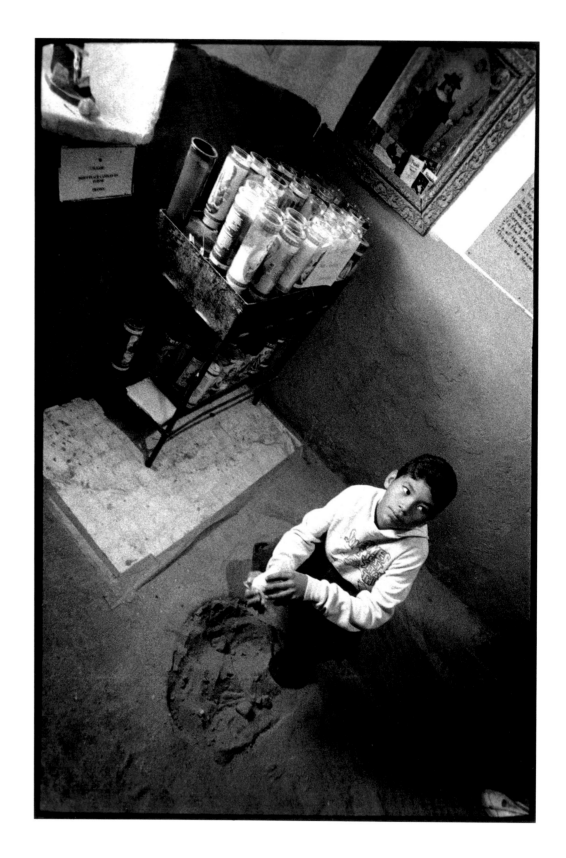

Tierra Sagrada, Chimayó, 1996

## CHIMAYÓ    *Emergence Place of Indo-Hispano Culture*

During the holiest season of the year, *Cuaresma* and *Semana Santa* (Lent and Holy Week), tens of thousands of pilgrims converge on a narrow valley in the foothills of the Sangre de Cristo Mountains. The plain adobe sanctuary and the earthen shrine it shelters contain a mystery revealed in a refrain from the oldest prayers of the Penitente brotherhood, *Santa Madre Tierra,* Holy Mother Earth.

The saints in the Santuario de Chimayó are all found in the other churches of the land: the crucified Christ, the blessed Guadalupe, and the little traveling Holy Child, the Santo Niño de Atocha. Some people say their presence gives healing power to the earth of Chimayó. Others believe the sacred site itself lends its power to these holy saints.

The throngs of pilgrims, for all their myriad reasons for coming here, are united in a single purpose: to pray, to make their holy vows, and to visit *el pozito,* the dry, sandy spring whose waters and earth have been healing the sick for over six centuries, well before the arrival of the Españoles Mexicanos. Chimayó is neither the North of the Spanish Mexicans nor the Southwest of Anglo-America, but that sacred Center, that holy emergence place of Indo-Hispano culture.

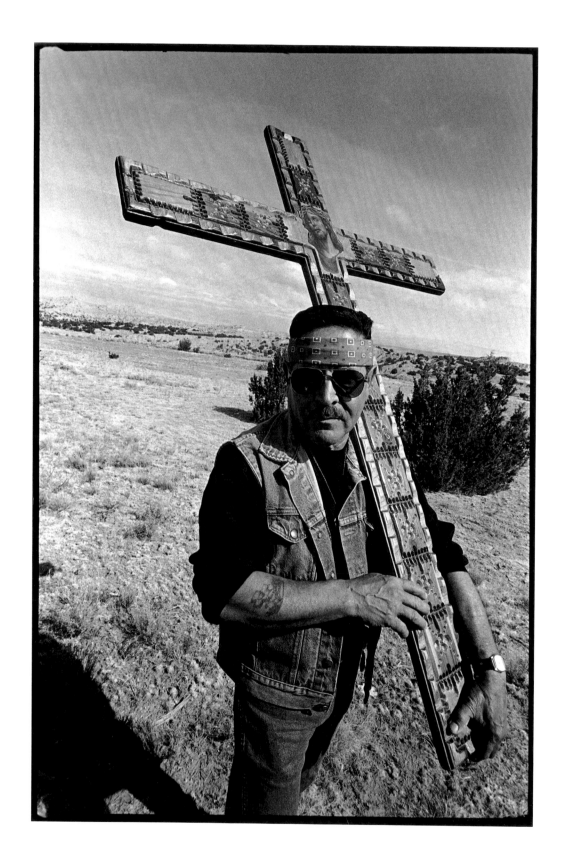

Siempre Devoto, Chimayó, 1996

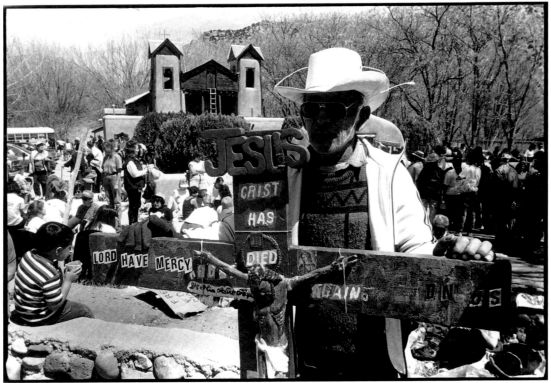

Siempre la Cruz, Chimayó, 1993

Misericordia de Chimayó,
Chimayó, 1996

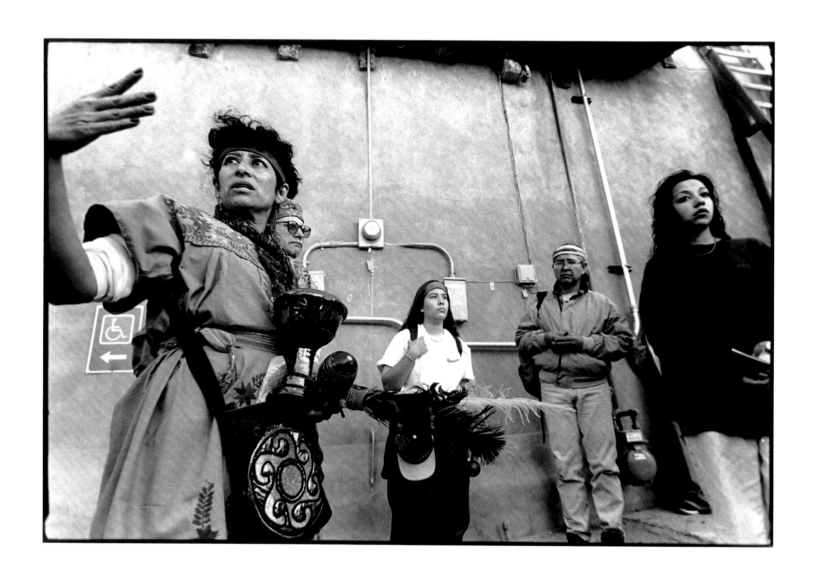

Malinche Tonantzina, Chimayó, 1996

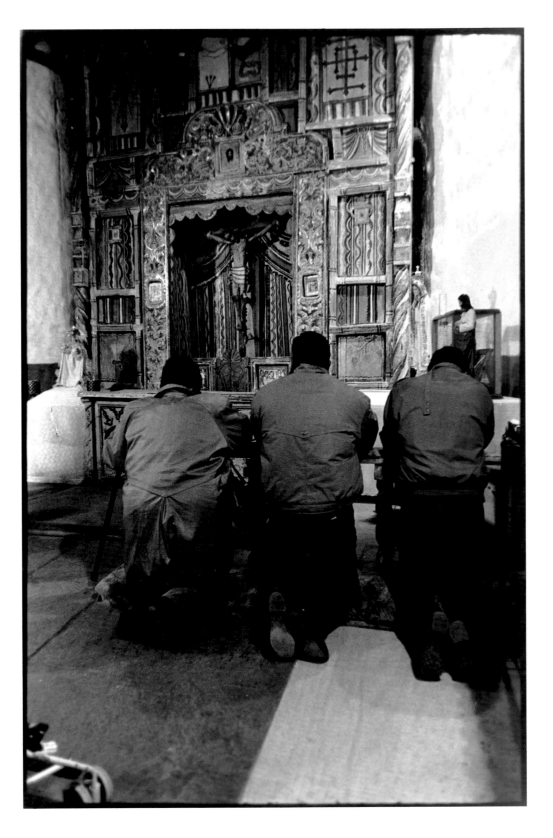

Nuestro Señor de Esquipulas,
Chimayó, 1995

Peregrinos de la Salud,
Chimayó, 1996

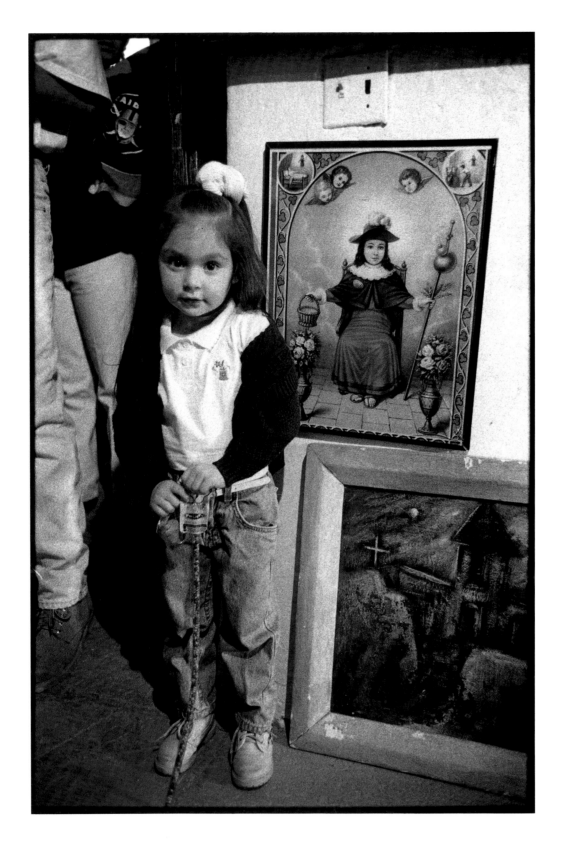

Santos y Niños, Chimayó, 1996

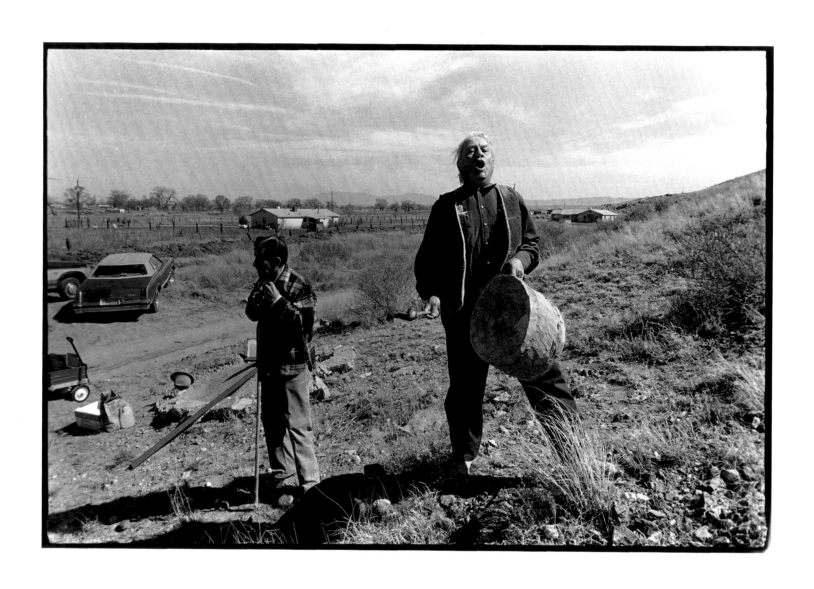

Edwin y su Tombé, Tomé, 1992

## CERRO DE TOMÉ    *Resistance and Recovery of Indo-Hispano Culture*

The other most sanctified place in Nuevo México Profundo is a hill in the center of the Río Abajo, unusual for its location in the very middle of the Río Grande Valley. Most of the volcanoes along the vast stretch of river are on the margins, outside the valley itself. The Cerro de Tomé has always been a sacred site, as the ancient petroglyphs etched in its black volcanic stone attest. Named for the first local patriarch to settle there, Tomé Domínguez de Mendoza, the community at the foot of the hill dates back before the Pueblo Revolt of 1680. As long as anyone can remember, the Cerro has served as the local *calvario,* or Calvary Hill, where people gather during Cuaresma and Semana Santa to recite the Stations of the Cross, to pray, and to contemplate the heavens and the earth.

The Cerro is old, but the pilgrimage to its slopes has grown exponentially in recent decades. When the common lands of the Tomé Grant were lost in litigation to a land development company in the 1960s, communal ownership of the hill itself was lost as well. Like vast stretches of the mesa to the east, it was slated for development and closed to the people. But fences and signs simply weathered away as the people reclaimed in their pilgrimage the sacred site that has always been theirs.

For the Indo-Hispano culture that enfolds and sanctifies the Cerro de Tomé, it is a place of renewal and resistance. From the altar at its summit at the Center of Nuevo México

Profundo, four centuries of cultural struggle can be clearly imagined and seen, from the first flights of Moctezuma's eagle to the awesome skirmishes of Moros y Cristianos. Led by Malinche and her Monarca, the spirit warriors of the Matachines dance by, unfazed by bulls and monsters. The sacred topography of El Cerro de Tomé recapitulates the other hills of Tepeyac and Calvary. Juan Diego and Guadalupe easily find their home on these heights where candles burn for them night and day.

The winds of history visit the Cerro, along with virtually every traveler on the Camino Real. Running between the pueblos of Isleta and Senecú, Popay rested on these slopes, as did Cuerno Verde in his eternal search for horses and Ecueracapa in his quest for the Pax Comanche. On his way to the siege of Chihuahua, Colonel Doniphan and the American Army camped here in December 1846 and moved on, leaving this English language in their wake. Like the other sites and rituals of cultural contestation and synthesis, El Cerro de Tomé has endured for the people of Nuevo México Profundo, another emblem of their querencia, the home space of their heart's desire.

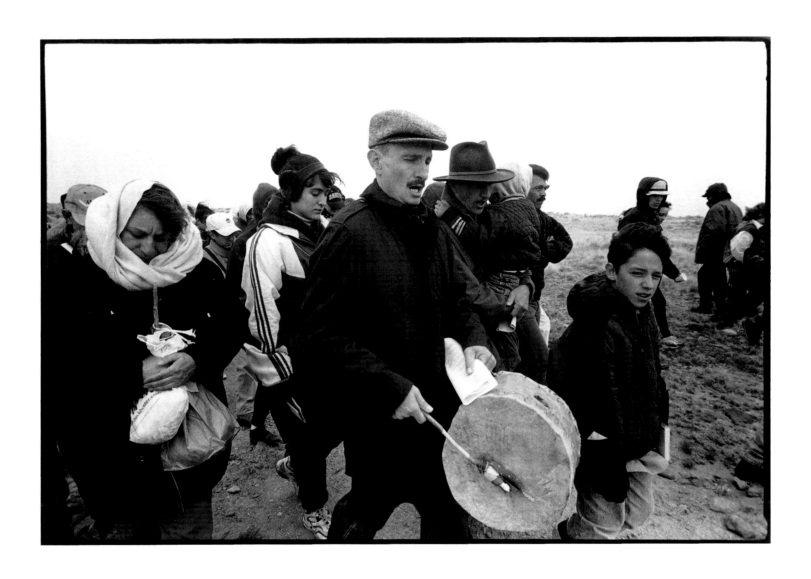

La Fe de los Hijos, Tomé, 1999

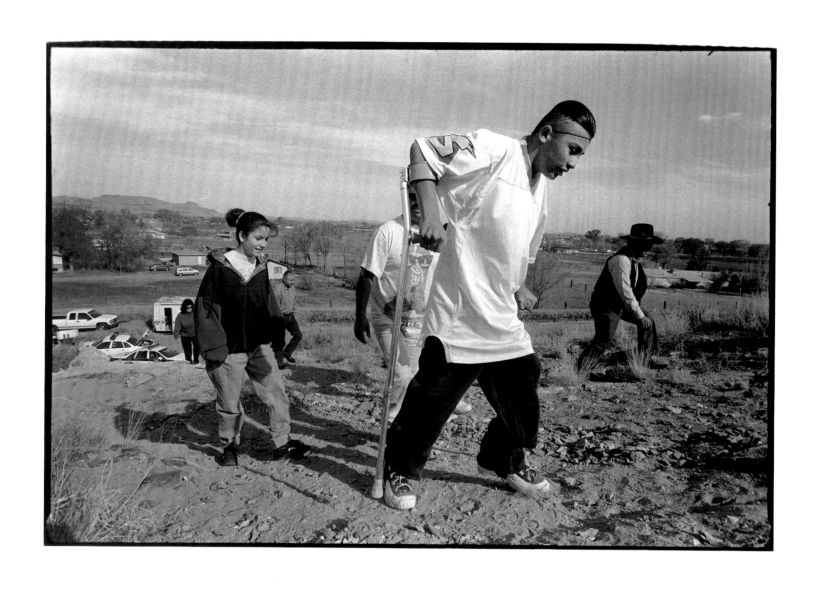

Peregrino de la Salud, Tomé, 1999

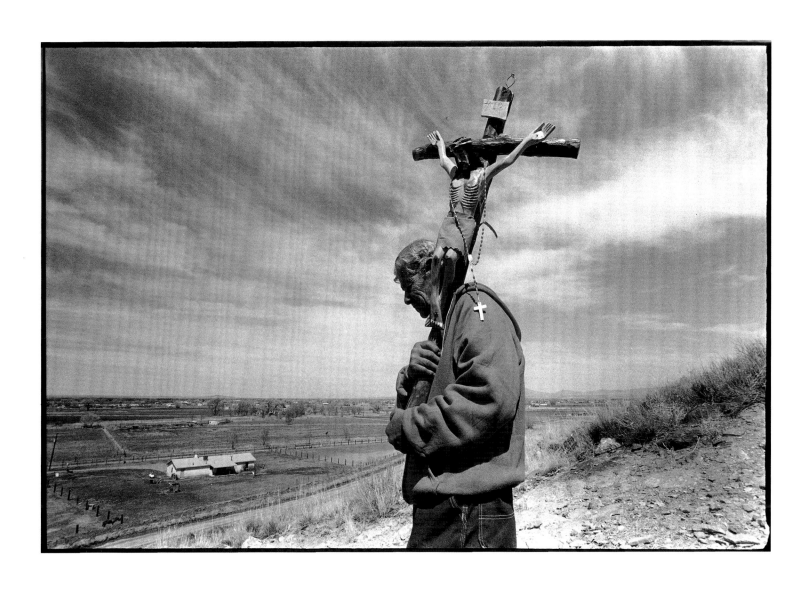

Devoción de Mano Lupe, Tomé, 1989

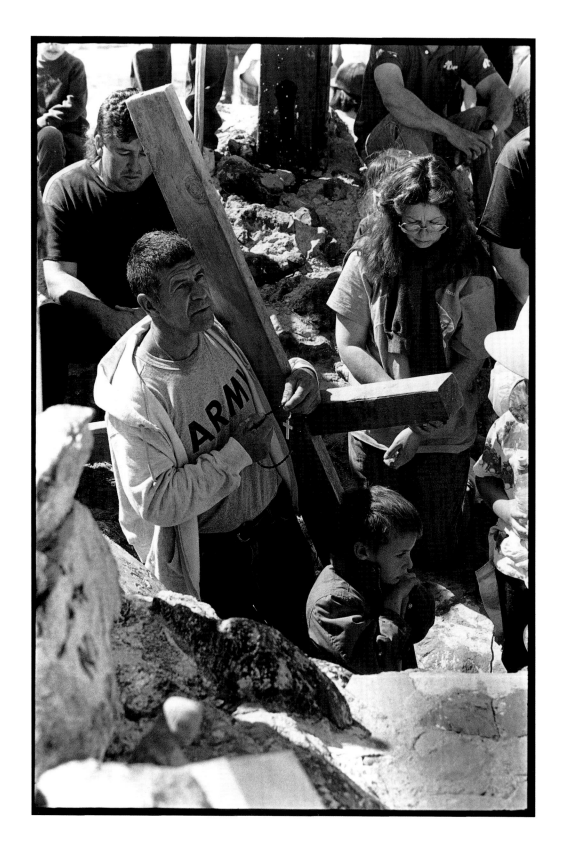

Ojos al Cielo, Tomé, 1993

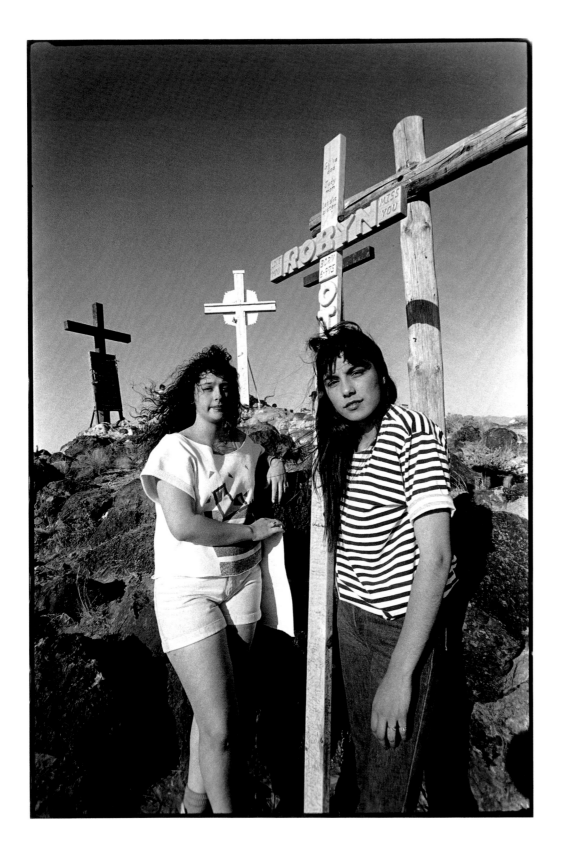

Recuerdos de Robyn, Tomé, 1993

127

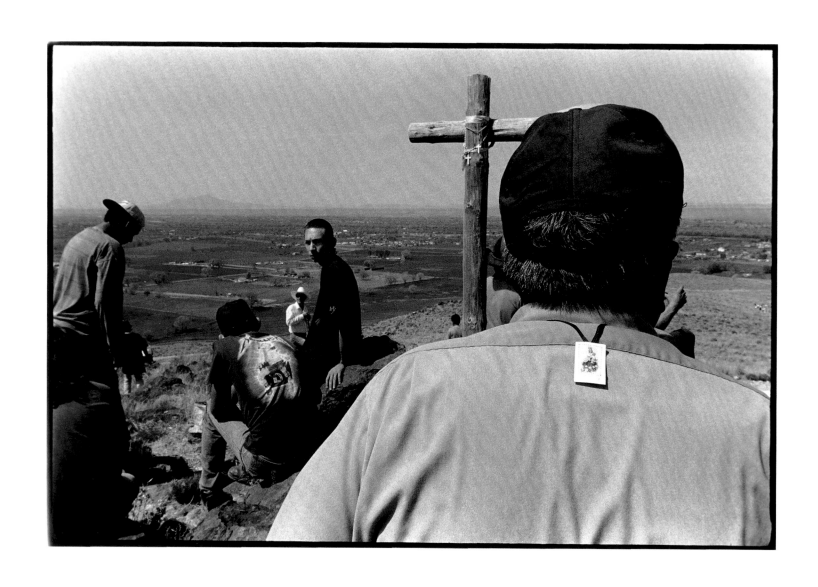

Escapulario, Tomé, 1992

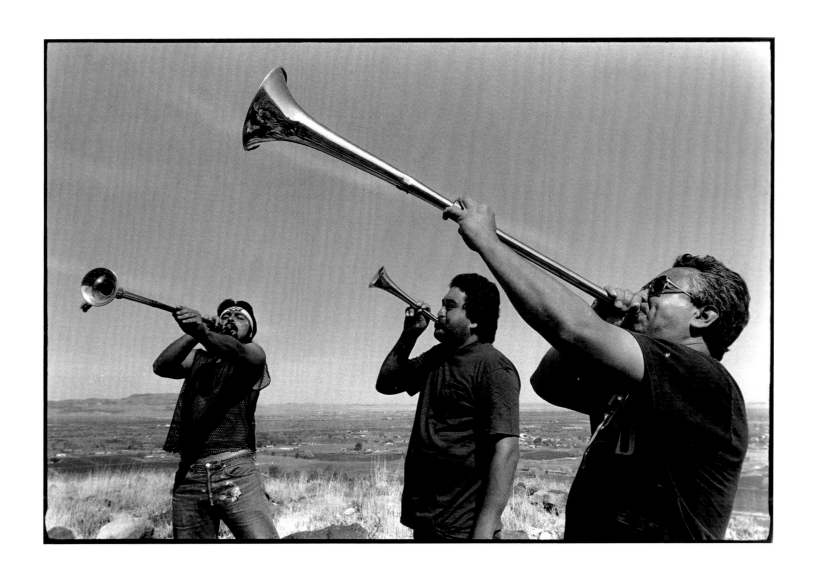

Trompetas y Clarines, Tomé, 1992

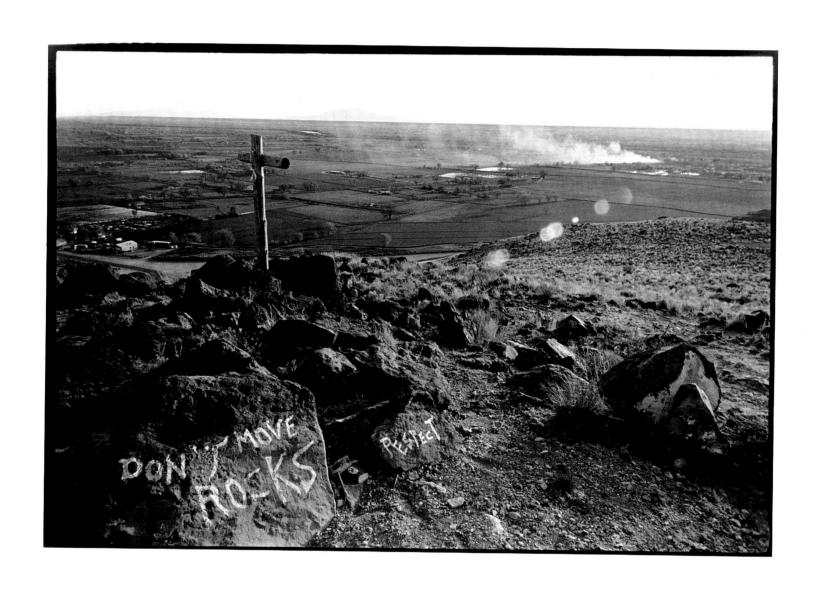

Cumbre de la Cruz, Tomé, 1996

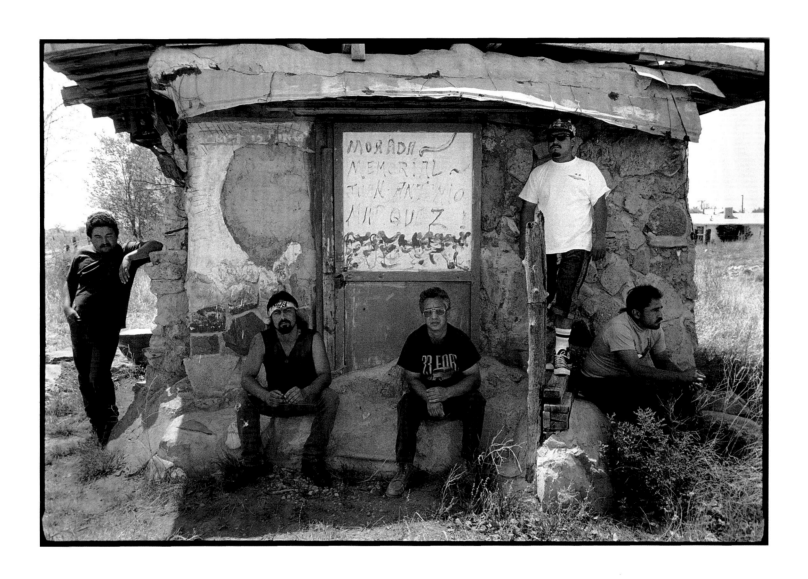

Hermanos de la Morada, Tomé, 1992

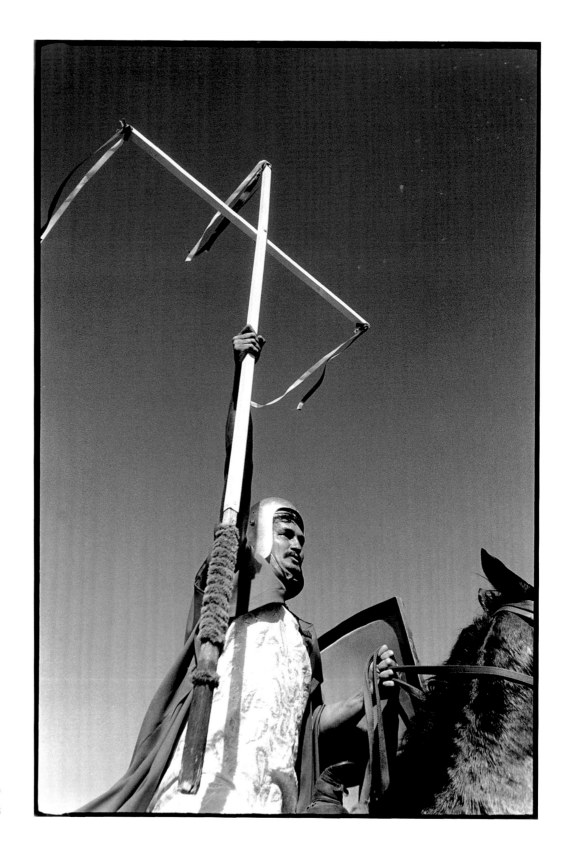

Soldado de la Santa Cruz,
Santa Cruz, 1993

# Culture Knows No Borders

*Ramón A. Gutiérrez*

The upper half of the Río Grande Valley, from northern New Mexico's Taos Valley south to modern-day El Paso, Texas, has for millennia been a land of turbulence and war. In pre-Columbian times, constant skirmishes over water, land, grain, and hunt products such as meat, hides, and tallow marked relations between sedentary farmers and their nomadic neighbors. In 1598, after a war of blood and fire, Spain conquered what it called the Kingdom of New Mexico and named the native inhabitants Pueblo Indians because they lived in towns. Mexico won control of this land with its own independence in 1821. And again through war, this time between Mexico and the United States from 1846 to 1848, the upper Río Grande Valley changed hands.

One can best understand the history of New Mexico as "cycles of conquests," according to anthropologist Edward Spicer. One sovereign power after another violently imposed its culture and its institutions on the area's residents. Each new set of conquerors tried to erase, disfigure, and distort what was previously there. But the process was never fully successful, and popular memories and ancient ways of life persisted, albeit in altered form. Such cycles of conquest produced a complex layering of historical symbols and memories, born of force and, just as importantly, resistance to it.

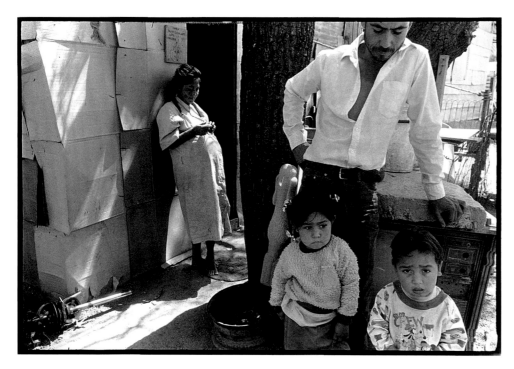

Casa, Familia, Hogar,
Ranchos de Anapra, 1998

The photographs of Miguel Gandert document some of the oldest memories of New Mexico's Spanish past as recorded in rituals and dances. The time periods that these pictures recall, the battle victories of which they tell, had their origins in Spain and New Spain.

Each powerful state that conquered and ruled the upper Río Grande drainage understood the region within a distinct matrix and set of orienting markers. New Mexico, for Spain and Mexico, was the far north in a complex trade and communications network that ran south and north of the capital in Mexico City. By contrast, what had long been thought of as a vertical space, unified both ecologically and culturally, was divided horizontally in 1848 after the Mexican-American War, with a distinct boundary line running east and west. A fence, a river, an obelisk-shaped boundary marker, and sometimes merely a line drawn in the sand now mark the place where these two nations meet and where their putatively distinct ways of life are set apart. Photographs of these border markers emphasize separation and are primarily militaristic in content and tone. The symbolic line that runs across the border from west to east, from California to Texas, separates Anglos from Mexicans, rich from poor, law-abiding citizens from lawless aliens, indeed, Western civilization from Latin barbarism.

Every day, television news programs describe hordes of Mexican women and men wading across the Río Grande under cover of darkness. We are shown green, heat-generated images of human forms in flight, allegedly entering the U.S. Other, similarly sophisticated scopes, which see what the human eye cannot, capture illegal aliens scaling barbed-wire fences with the same intent. Since 1993 the U.S. Immigration and Naturalization Service has staged a host of much-publicized border interdiction campaigns with lofty names like "Operation Hold the Line," "Operation Safeguard," and "Operation Gatekeeper," to reinforce the line. The visual images of these different military campaigns blur in our minds, but the message they convey remains the same — the Border Patrol defending the American way of life, giving chase, hot in pursuit of those Mexican renegades, those smugglers of drugs and human wares.

The photographs of Miguel Gandert remind us of a different time, of older times. They

help us recall that only in recent historical times has a border separated the place where Mexico and the United States meet, that for thousands of years there was little difference, geographically or ecologically, between what are now the northern states of Mexico and the southwestern states of the United States. Since the dawn of civilization in the Americas, peoples, ideas, and products have moved freely back and forth. When the first Americans left Asia and traveled across Alaska and down into Central and South America, their advance was not impeded. Maize, beans, cotton, and squash were domesticated in central Mexico, and from there both seeds and the know-how to make them grow traveled northward. The Anasazi Indians of the Southwest frequently sent their priests southward to central Mexico with turquoise and pottery to trade. They returned with technology, religious rituals, and the magical feathers that were deemed essential for these to work.

In colonial times, Spain's kings dispatched similar convoys between Mexico City and Santa Fe, carrying provisions and personnel northward, returning with skins, blankets, woolen textiles, and other locally produced goods, including the occasional flask of local brandy or wine. Under Mexican rule a similar trade flourished. Indeed, not until 1921 did such movement came to a halt. Though a border between Mexico and the United States had first been established in 1848, at the end of the Mexican-American War, it was not enforced or even patrolled until 1921. It was not the movement northward of Mexicans that was most feared then: the Border Patrol was established to keep Eastern Europeans from illegally entering the United States through Mexico.

Like the great river, the Río Grande—also known as Río Bravo, the wild river—that flows through this desert landscape, turning dust into verdant fields of beans, chile peppers, alfalfa, and corn, so too do Miguel Gandert's photographs turn our eyes, our thoughts, and our emotions to the depth and intensity of religious dance. The land his photographic eye documents, the stories his photographs tell, flow seamlessly from one space to another, from one generation to the next. It is nearly impossible to imagine the land Gandert documents as one riven by lacerating fences and guarded by state-sanctioned patrols.

The stunning photographs in this volume, most of which Miguel Gandert produced over the last decade, depict the unity of Hispano culture as it is lived, celebrated, and daily renewed along the upper Río Grande Valley, from Ciudad Júarez/El Paso, Texas, all the way north to Taos, New Mexico. These pictures are about the rituals of history. They are about memory. And most of all, they are about the ways religious beliefs and practices structure the course of life in a region not easily cut in half by a border.

For centuries, the residents of this land have thought of it and known it by names other than those that appear on contemporary maps. Chicanos have called it Aztlán, harking back to what were once the ancient northern homelands from which the Aztecs, the lords of

Mexico, first emerged, before they migrated south to found what became Tenochtitlán. The cultural, linguistic, and historical continuities that bind and integrate this space have prompted many historians, geographers, and anthropologists to call it the Greater Southwest. Whichever names one thinks most apt, they all evoke an ancient, indigenous sense of a place that national borders cannot erase.

The upper Río Grande drainage was a Native American place centuries before the Spaniards dreamt of a New World. It was transformed by the Spanish conquest, and it was from the violence of war that the *mestizos* were born. Mestizos are the descendants of illicit biological mixing between Spaniards and Indians. The process began in sixteenth-century Mexico, but the heritage of race mixing, or *mestizaje,* lives on today. Indeed, the mixing and blending of Hispanic and Native American cultures, customs, and genetic stocks could not be stopped. What evolved over centuries was thus a new culture, a culture marked by complexity, hybridity, and heterogeneity.

Miguel Gandert thinks of the culture of the upper Río Grande as Indo-Hispano, a profound mixing of the Indian and the Hispanic. The spatial orientation of this culture is vertical in space, running north and south. Gandert's photographs are thus of a culture set in motion not only by the gusto and tempo of the dances he records, but also by the constant movement of people, ideas, and cultural forms that daily traverse the upper Río Grande. These movements have for centuries integrated, united, mixed, and made one the people that reside here. Renewed by their songs, steadied by the precision of their dance steps, the certitude of their prayers, and the antiquity of the mythologies that give them form, the Indo-Hispano peoples of the upper Río Grande seasonally ritualize their pasts.

The upper Río Grande Valley has been the setting for repeated conflict, instigated first by nomadic raiders, then by sedentary farmers, and finally by soldiers and settlers from Spain, Mexico, and the U.S. For good reason, then, the ritualization of conquest and war, of subordination and submission, and of treaties that brought peace looms large in the dances, songs, and rituals of the land.

Miguel Gandert thus draws our attention

Batalla de Moros y Cristianos, Santa Cruz, 1993

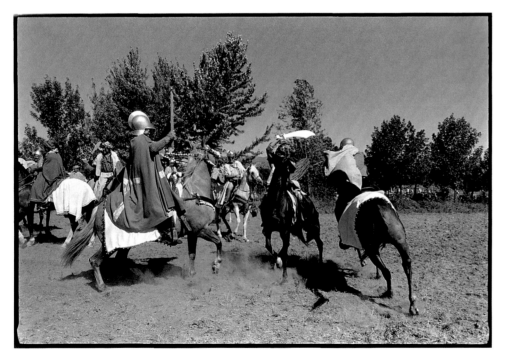

to the drama of Moros y Cristianos—the dance of the Moors and Christians. Moros y Cristianos was a Spanish colonial import into this region. It depicts the cosmic struggle between Christians and Moors, waged between 711 and 1492, for the reconquest of the Iberian Peninsula. The Christians won, of course; after all, they had the true cross of Christ and God on their side. To drive this point home to the Indians of the Americas, the Spanish conquistadors immediately staged Moros y Cristianos everywhere they went. Don Juan de Oñate and his soldiers performed the play for the Indians who greeted him near El Paso in 1598. And from then on, whenever the Spanish founding of a town was remembered, whenever a Christian saint's day was honored or victory over enemies was celebrated, Moros y Cristianos was danced to remind the Indians of their defeat.

Miguel Gandert takes us from dances of defeat to dances of humiliation, intricately documenting historical memory as performed in the Matachines dance. The Matachines came to the upper Río Grande Valley's towns as an import from Spain, or so legend holds. First taught to the Indians by Franciscan friars in the sixteenth century, it was but one of many dances the Indians were forced to enact as part of a conquest theater of humiliation. In these dances the Natives mocked themselves, bearing the blame for their own defeats while heralding the might of the conquering Spanish lords and the power of their God, Jesus Christ.

The story the Matachines narrates is pure fabrication—the kind of story conquerors devise to explain to the conquered how they should remember their own defeat. The dance depicts the Aztec Emperor Montezuma's submission to Spanish authority and his willing conversion to Christianity. Historical documents record no such conversion. Nevertheless, the drama has Montezuma led in elaborate dance steps by Malinche, the legendary interpreter and mistress of Hernán Cortés. Malinche curtsies and leads facing teams of dancers in lines, in circles, in crosses that weave back and forth. And at the end, she leads Montezuma into church where he accepts baptism.

This formal narrative is the official script that gives the Matachines dance its shape. But history teaches us that the version of the victors does not always reign supreme and uncontested. Conquered peoples constantly subvert colonial scripts of subordination and humiliation. As performed in the upper Río Grande Valley, the Matachines has two very distinct sets of dancers. Montezuma, Malinche, and their retinue are one. The other consists of two *Abuelos* (grandfathers), a carnivalesque figure known as Perejundia, usually played by a man in drag, and a person dressed as a *toro*, or bull. Throughout the formal dance these characters in the second group watch and comment from the periphery, constantly mocking and poking fun at the official narrative history recounted in the dance. They ridicule Malinche. They perform the true history of the sexual conquest of Mexico, which was one of brutality, particularly toward its women. They ritualize what to them have been the facts

of history—Spaniards and Indians so profoundly mixed in the upper Río Grande that from this mestizaje a thoroughly Indo-Hispano culture was made.

Some of Gandert's most stunning images are precisely of the counter-narratives of once-dominated peoples. His photographs of the Abuelos at Amalia, dressed in sheep skins, is

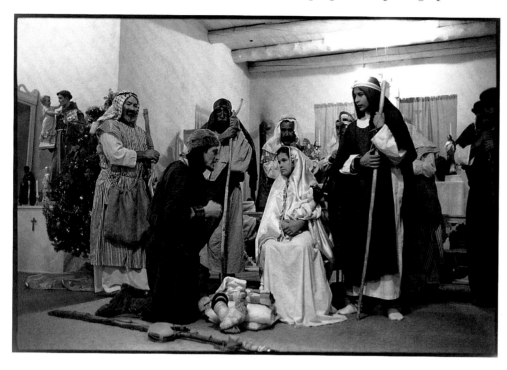

Pastores a Belén, Belén, 1997

singular. So too is the ugly figure of toro, the bull from Picurís, which was originally intended by the Indians to scare the Christian god away. One sees the staging of such a fight between the toro and the Matachines at Alcalde.

Equally fascinating in Gandert's Matachines photographs, particularly from an ethnographic point of view, is the great array of inventive costume elements. At Tortugas, for example, the Matachines are decked out in Plains Indian headdresses, while sporting elaborately decorated pants and skirts most typically found in southern Mexico.

Gandert's photographs of Los Comanches at Alcalde and Bernalillo capture one of the truly local dramas of New Mexico's past. Throughout most of the eighteenth century, Comanche Indians preyed on the Hispano mountain villages of northern New Mexico and southern Colorado, raiding for livestock and slaves. New Mexicans to this day recall the terror of these raids in their *cuentos* (stories), in songs about their bravery in adversity and their fear of captivity, and in the Los Comanches play, which tells of the capture of the Comanche chief Cuerno Verde and the conclusion of a peace in 1787.

Some of Gandert's most moving pictures depict war not against Indian enemies, but against sin. As the photographs in this volume amply testify, the Indo-Hispano peoples of the upper Río Grande are deeply religious. Indigenous beliefs and practices were, through Spanish conquest and Christian conversion, melded into new forms that had a Christian veneer but supported a more complex set of beliefs. Where the Indians of the upper Río Grande once celebrated the winter solstice and rites of sowing at spring, for instance, Franciscan friars superimposed the story of Christ's birth on the former and his death and resurrection on the latter.

Beginning the week before Christmas, in places like Barelas, Alameda, and many, many

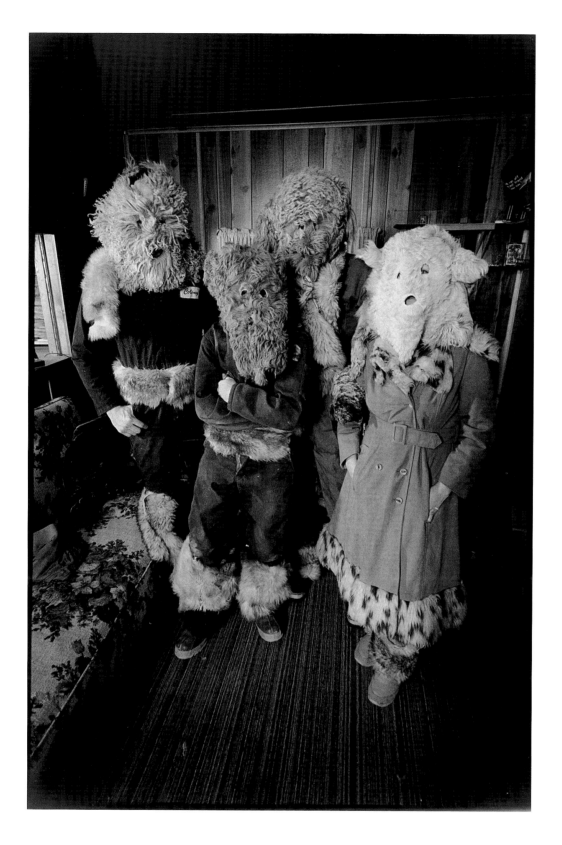

Abuelos, Amalia, 1986

more towns, it is customary to see the staging of Las Posadas. This pageant tells the story of Mary and Joseph, traveling from place to place in search of shelter for the night and being turned away. The drama culminates on Christmas Eve with the birth of Christ. Las Posadas is festive and gay. It is a time for communal celebration, a time when food is shared and potential enemies are neutralized with sugar cookies.

With the coming of Lent, the mood is quite different, somber and stern, full of death and the sinfulness of the flesh. Many New Mexican villages still have large and even growing numbers of lay brotherhoods devoted to the passion and death of Jesus Christ. Again, as with so many other religious rituals of the upper Río Grande, Franciscan friars first introduced this devotion in colonial times. Over the centuries it has taken on unique features and practices deemed quite heretical and repugnant by the Catholic Church.

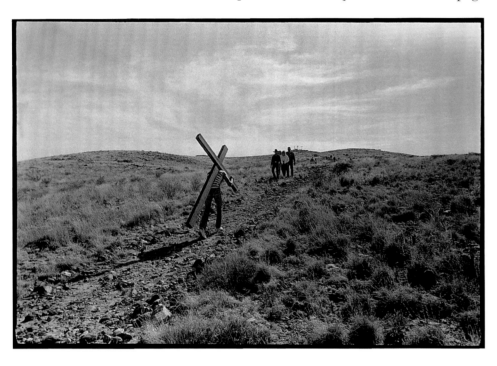

Pasos al Calvario, Tomé, 1989

Those who carry the crucified Christ in their hearts and on their bodies are commonly called Hermanos Penitentes, or penitent brothers. Throughout Lent, and particularly during Holy Week, they engage in acts of fasting, mortification, and penitence to cleanse their minds and bodies of sin and to prepare for the resurrection of the flesh that Easter will bring. Gandert's photographs of this penitential ritual come from two sites. The first, the Santuario de Chimayó, is the largest pilgrimage site in the U.S. On Good Friday the population of this northern New Mexican village swells to the tens of thousands, as pilgrims come from far and wide bearing crosses of every size. Many walk to the Santuario, some-times spending a week or more on foot to reach the shrine. They come with prayers, with promises, with petitions to the crucified Lord, hoping that two days later, on the feast of the Resurrection, the physical and psychological crucifixions they bore on Good Friday will bring renewal and transformation. Gandert's photographs of the Tomé Good Friday penitential procession likewise are full of fervor and passion. As men and women ascend the hill they call Calvary, they too hope that their battles against sin will be won and that they will be born anew.

Life and death, renewal and transformation, the flows of Indo-Hispano culture up and down the Río Grande Valley—these are the themes Miguel Gandert brings to our attention in his mesmerizing photographs. The photographs are full of motion, a motion also evident in Gandert's body as he darts from here to there, camera in hand, to capture the essence of a dance, the emotions of a moment, and the substance of memory. Gandert's photographs are not images of separation but of the unity of Indo-Hispano culture, which fences, border patrols, and lines on maps cannot and will not easily erase or divide.

## Source

Edward Spicer, *Cycles of Conquest: The Impact of Spain, Mexico, and the United States on the Indians of the Southwest, 1533–1960.* Tucson: University of Arizona Press, 1962.

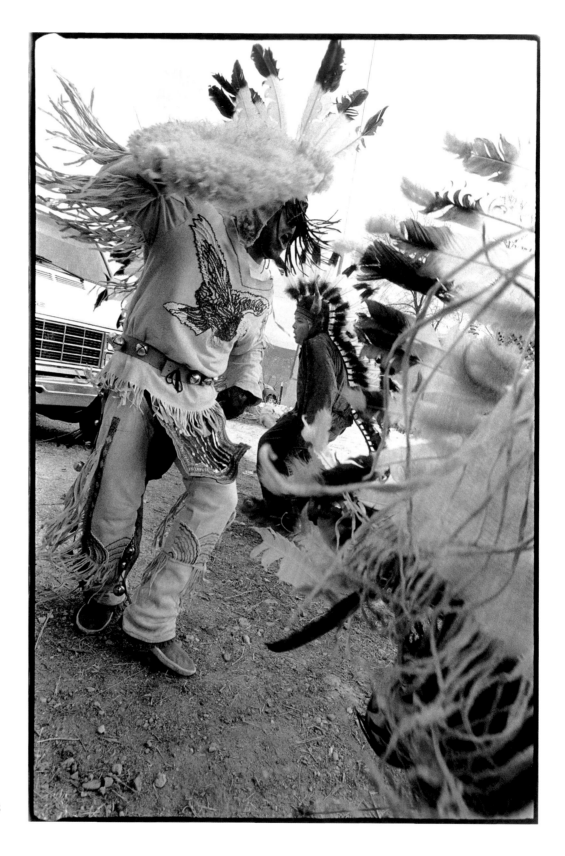

Danza del Aguila, Talpa, 1998

# Walking the Tightrope

*Lucy R. Lippard*

Llano. Talpa. Ranchos de Taos. The first sun of the New Year rises to the beating of drums. Hispano Comanche dancers enter the famed Santuario de San Francisco de Assís to pray. So begins the feast of Emmanuel in the *Nuevo Mexicano* villages, the celebration of a holy promise fulfilled. Divinity and humanity become one, so the people dance. Like their neighbors at Taos Pueblo, the *gente* in these villages dress in buckskin and feathers and sing their oldest songs in tribute to their indigenous, mestizo heritage.

Two days after Christmas, dust, thundering hooves, and battle cries are raised in Alcalde, a village south of Taos. Los Comanches, a folk play dating to the 1780s, celebrates the heroic struggle between Españoles and Comanches. The death of the great chief Cuerno Verde marks the end of generations of violence and the beginning of a lasting alliance.

— MIGUEL GANDERT

Miguel Gandert is a cultural *maromero*, walking a tightrope between his various identities as photojournalist and artist, local and outsider, participant and invader, audience and interpreter. Locating himself as an Indo-Hispano New Mexican, he is a documentary or ethnographic photographer working within one of the most interesting cultural encounters taking place at the turn of this century: the triangular relationship between photographers, their subjects, and their viewers. When the photographer is concentrating on a performance

context, as Gandert is in *Nuevo México Profundo*, a fourth leg is added—the audience in situ, who may also double as participants and viewers. And of course subjects, viewers, and audiences are never monolithic, so the categorically obsessed could go on breaking down this figure exponentially.

In any case, it's a lot of people to be involved in an art/photographic activity. Like music, performance often provides a clear interface between cultures. Here photographer, performers, and audience are all *disoriented* in one way or another. Spatial dislocation has its cultural parallels. What Barbara Kirshenblatt-Gimblett has called "the pleasures of confusion" kick in. The audience/participant mix is also tripartite. Some (presumably the performers) are living it; some (former performers who are watching, and perhaps Gandert and a few scholars) know what they're doing and why; some are familiar with the performance experientially rather than in terms of information; other are "looking at it." Yet often the audiences consist primarily of relatives and the dancers themselves, so at times Gandert and his subjects and the onsite audience almost merge, leaving the role of outsider to the eventual viewers of his images.

To an unsympathetic outsider accustomed to the lush, shiny, selective images by exploitative contemporary photographers of other cultures ubiquitous in magazines and coffee-table books, these dances might seem tawdry and vestigial instead of the evolving, imaginative hybrids they are shown to be in Gandert's photographs. At the other extreme, to scrutinize these dances with an avant-garde sensibility is to compare apples and oranges. The postmodern notion of "appropriation" is not a good fit. In New Mexico the "indigenous" is a syncretic *fusion* of Native American and Hispano American. Just as Pueblo people who are Catholics also embrace their traditional religions, Nuevo Mexicanos who wear Metallica T-shirts also attend mass and clean the ditches. The fact that both good and bad aspects of the larger pop culture are welcomed with open arms in New Mexican villages and pueblos does not belie the passion with which local ethnic culture is embraced. The performances photographed here incorporate both survival and everyday life. For all their devotional intensity, they can be read as political affirmations of identity as well as religious affirmations of faith.

The conventional, or conventionally avant-garde, view of art defines the artist as rugged individual in an almost adversarial position to an admiring or baffled viewer. Gandert's practice is, unconventionally, a collaboration on several levels, expansive in space and in time. He is well served by his partial disguise as photojournalist rather than "art photographer," with all its pitfalls and pretensions. Many documentary photographers walk that tightrope, focusing on the lure and impossibility of "realism" and "authenticity" while painfully aware of the unequal power relations inherent in the imaging enterprise. While journalism's quick

take seems to suit Gandert well, he usually underplays the pictorial spectacle in favor of the lower-keyed community profile, making pictures that return the gaze. He sees the directness of his photographic approach as the beginning of a dialogue.

When he first arrives in a community, Gandert says, he is "just a photographer like any other" (although he does have the advantage of not being an "other" in most of the communities treated here). But he returns again and again, and over time his gregarious nature and emotional commitment to the people and the place he is shooting endear him to his subjects. Handing out prints to the community—now a common method of ingratiating oneself to one's documentary subjects—makes him "feel like a widely exhibited photographer, since the pictures are on everyone's refrigerator … [It's] the least I can do, because these people give me so much."

For fifteen years Gandert has moved up and down the Río Grande Valley and environs, from Taos Pueblo in the north to Tortugas and Juárez in the south, tracking variations on Matachines, Comanche, and Moros y Cristianos dances and "folkplays." Acknowledging the extent to which the Spanish learned from Native spirituality, he works at the interface between the descendants of Hispanicized or detribalized Indian people and those who count themselves as Native or Hispano. The performances, processions, and occasional church services that he has chosen to further this goal are fascinating even within the cultural panoply of New Mexico, with its maverick religions, land-based rituals, and hybrid alliances.

Cultural pride is a factor in all of Gandert's work, which he intends to counteract the historically negative and culturally dismissed image of "the forgotten indigenous people of a very rich cultural region." He is also sophisticated enough to frame his celebration of *mestizaje* and his desire to preserve it within a larger intellectual context, while allying himself with the villagers he photographs. Rigorous analysis of the contradictions inherent in this process provides fertile ground for looking at work like Gandert's.

Ever since Edward Curtis became the scapegoat for photographic manipulation of ethnic representations, progressive artists, critics, and scholars have had to suppress and examine our own initial (and inevitable, given Western education) excitement at images of the "exotic" or the other. Virtually all photography must now be subjected to an examination of motive, cooperation, and aesthetic intent. Gandert, who has been gratuitously compared to Curtis, has turned this left-handed compliment back on itself by intentionally appropriating Curtis's portrait style and identifying to some extent with his role as preserver of a "vanishing culture." "Bad Curtis is better than none," Gandert says. "We can deconstruct him, but the images remain valuable." At the same time, however, Gandert has employed Curtis's ambivalent heritage to make his own critical statements on the documentary tradition. As Chon Noriega has written of the Comanches series, "The viewer is led along a

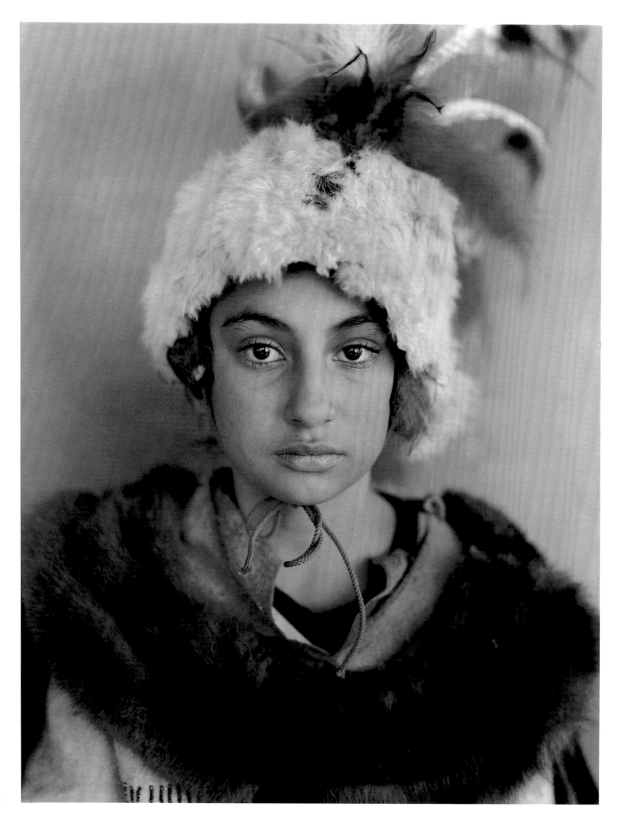

Linda Elena, Talpa, 1995

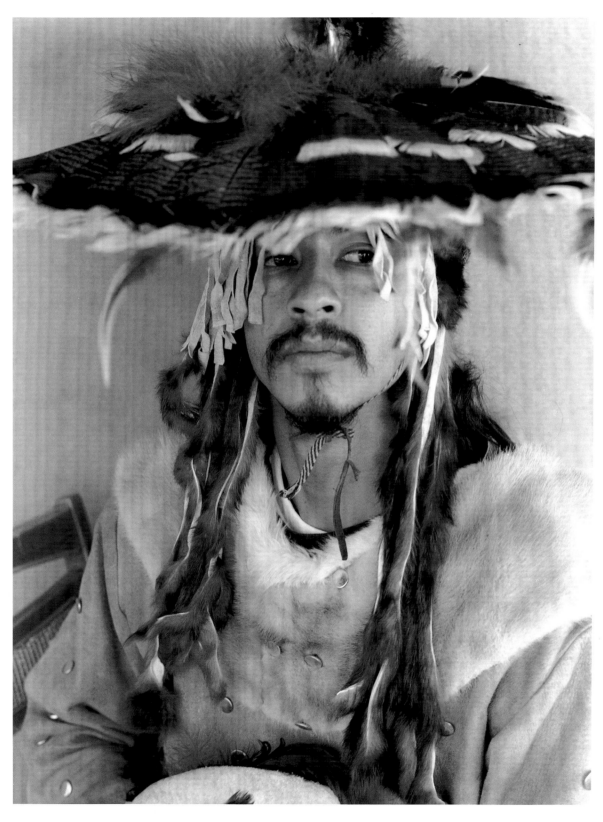

David Gonzales, Talpa, 1995

sequence of images that becomes both decreasingly romantic and increasingly prosaic," recirculating stereotypes until the contradictions are exposed and can be used to the photographer's own ends.

Native people at the turn of the last century, even in the depths of their very real cultural and economic despair, seldom seem to have believed that they were vanishing. Nuevo Mexicanos today, however, are well aware that their traditions are under assault by the entire dominant culture. Television too often replaces the oral histories and moral dramas that nourished northern New Mexico when the villages were self-sufficient. Those days came to an end when the *manitos* (from *hermanitos*, or little brothers) had to leave home in order to find work in the railroads, mines, and farms of other states, a situation exacerbated by the Depression, which for New Mexico began in the 1920s.

The camera is not mistrusted in Hispano villages to the extent that it is in Native American communities, for good historic reasons (although during the WPA period, as Suzanne Forrest has shown, northern New Mexican villages were sometimes studied within an inch of their cultural lives). "The people I photograph don't always understand what I'm doing," says Gandert, "but rarely do I get someone who doesn't like a picture. Sometimes they have questions as to why I photographed them the way I did. Usually they like the idea that someone cares." He acknowledges that "the camera changes everything. My photos show how I feel about these people and these events. I can't help but change them. I just hope the changes I make don't affect the integrity of what people are seeing in the images....I feel guilty, as though I'm taking their images away." At the same time, Gandert says, "People are very conscious of the camera, and they're very sophisticated about it. I hope people become so consumed by the dance and the beat of the music that they ignore me or forget me." The process is helped along by the myriad local onlookers with their own cameras and camcorders, although Gandert is usually far more visible and hyperactive than they are.

Documentary photographers have frequently ignored or blown off this level of political anxiety—sometimes for the better, sometimes for the worse. Ignorance is bliss? Ignorance is no excuse? The best of them, Gandert included, continue to agonize over the exploitative nature of their craft and then go on working as best they can, making some mistakes, making some marvelous and some offensive images (sometimes the two overlap), occasionally wounding their art with an overdose of self-censorship, finally balancing it out, and going on.

What, for instance, distinguishes the work of Miguel Gandert from the ethnic tourism most of us (audiences and viewers) enjoy when we look at the performances or his photographs of them? To begin with, Gandert's Indo-Hispano-Euro background gives him an edge, or a wedge (as does his exuberantly extroverted personality). He is a native New

Mexican, born in Española, at home in multiple territories: in his grandfather's village in Mora County; in urban Santa Fe and Albuquerque, where respectively he was raised (with a sojourn in Ecuador) and has lived and worked as a TV cameraman and news producer; at the University of New Mexico, where he studied and now teaches photojournalism; in Bernalillo, where he now lives with his family; and in various barrios and Hispano villages all over the state, where he has photographed for years, making friends as he goes. With his gift for becoming a part of other communities by dint of sheer energy, warmth, and persistence, Gandert is in fact fundamentally a community photographer, even when the community is not his own in lived experience. The intensity of his photographic commitment to mestizo New Mexicans is reflected in his imagery, which is paradoxically casual and intimate, fusing the immediacy of a snapshot and the aesthetic considerations of art.

It is difficult to pinpoint the ways in which social relations inform Gandert's images. As anthropologist James C. Faris has remarked, "Photography never developed *to simultaneously show the photographer and the conditions of photography*." Gandert is both an insider and an outsider—the first by virtue of being a mestizo like most of his subjects, the second by virtue of being a photographer and being a mestizo from elsewhere. He is close to being a "local,"

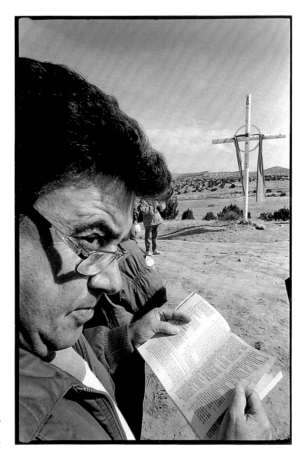

Palabra de Dios, Chimayó, 1996

in the sense that Faris uses the term: Westerners "do not see on local terms, but transforming terms, comparative terms," which are deeply affected by the fact that "power is rarely ever given, it must be taken or subverted." Similarly, all photographers (and writers) are once removed from their subjects. On another level, the distance inherent in difference, and in the photographic enterprise per se, is blurred in this case by Gandert's amicable relationships to the people he photographs. The intimacy that marks his style is consensual, but if it were forced, could we the viewers tell the difference? He often shoots action very close up, because "I want to be a part of it and I want to feel that intimacy, and I think that intimacy translates into the pictures."

This is a dangerous statement to make in today's photo climate, given all the fakes and con artists looking to represent, appropriate, and profit from communities not their own, and Gandert knows it. To use phrases from Roland Barthes, the "power of authentication" can exceed "the power of representation." At the same time, Gandert's commitment (like Curtis's) is genuine, and he hopes to allay fears of exploitation by his own "authenticity." Here too he is on shaky ground made firm only by his own cultural commitment and technical confidence.

Yet it behooves all of us who are about to throw the first stone at documentary photographers for their aggressive or naive approaches to check out our own genuine responses before we gather up the weapons of the deconstructivist

arsenal. How often have we been struck by an image, even moved by it, only to pull back, apply progressive analyses, and, in the process, find that we have lost not only respect for the insouciant photographer and enjoyment of the image but our own experiential connection with it? I am not recommending that we toss analysis and self-criticism to the winds to justify our excesses, nor that we enjoy spectacles of denigration, but that we use them to test our own approaches as well as those of the photographers. Critical investigation of our personal motives and those of the photographer in question need not exclude consideration of the three- or four-way cultural encounter from each different vantage point, as we try to figure out what *else* is going on. Here the tightrope is strung between skepticism and cynicism.

All documentary photography takes place in local spaces; they in turn provide the engaged photographer with a layered narrative. Gandert takes full advantage of this and his own multicentered experience. Unlike many documentary photographers, he has specialized in potentially familiar places, to which he has a certain access. In the process of photographing, he moves toward a familiarity that is closed to those outside the community. We his viewers are included at one remove in the intimacy he accomplishes, but we are excluded from the heat, the dust, the risky social process of the photographic act itself. It is all too easy for us to make the "victimization" critique so often aimed at even the most engaged progressive photographers: that is, that the very act of photographing anyone in sad or dire straits, or almost anyone at all outside one's own family (also vulnerable, as testified by Sally Mann and Tina Barney, among many others), is an unwarranted invasion of privacy. All the more so if the power relations between photographer and subject are unequal.

Drawing attention to the erotic underpinnings of cross-cultural appropriation (going so far as to call it an analog for pornography), Faris envisions a new photographic enterprise that is "liberated from desire, from the symbolic, from the ego—from metaphor and from meaning. It has got to be open, without method, free of will and truth, and the will to truth." A tall order, if not virtually impossible. Yet when he recommends "seeing in a way that listens," Faris locates a central element in Gandert's *Nuevo México Profundo* series, fraught as it is with conflicting cultural expectations.

Gandert is both a listener/seer and a storyteller, exploring the social power of the black-and-white still photograph, iconic in its own history. "Documentary photography allows me to explore things over a period of years," he says. "I'm interested in allowing the people to tell their story. I want them to be my friends and I want to understand why they do what they do. That only comes with time." The very stillness of a black-and-white print provides an appealing sense of permanence that is lacking in moving images. Monochrome evokes the past in a way not available to color, which, because of its extended realism, seems

more of the present. For all the accessibility of Gandert's process, viewers outside the communities being photographed will not have much interpretive information; they must enter the place by responding first to his imagery, eventually discovering the narrative in sequences and in time. Similarly, though Gandert can make striking images, the aesthetic autonomy of any single print is less than the whole. It is the range, the sequence, the unselfconscious style, and our expanded comprehension over time that give his work its power.

Stereotypes are constructed through conscious and involuntary mystification as well as by "naturalization," in which the mystified is assumed to be normal. In this series Gandert has another advantage: his performative images are foreign even to the stereotypes of rural Hispanos. Genízaro hybridity (a complex mixture of Hispano, Pueblo, and Plains "tribes") is little known both in and outside of New Mexico. Thus these confusing images of Indo-Hispano dance dramas, historically related both to European and Pueblo ceremonials and to the contemporary peripheral local circumstances accompanying them, come as a surprise to most of Gandert's viewers—and to uninformed audiences of the Comanche, Matachines, and Moros y Cristianos dances. Since heritage and tradition are themselves always changing and renewing, the search for an elusive authenticity is a false grail.

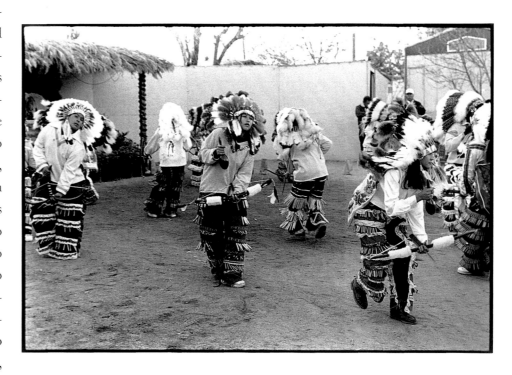

Matachines de Carrizo, Tortugas, 1993

The events shown in *Nuevo México Profundo* are open to outsiders; they are *public* performances. Viewers, in their familiarity or ignorance, inevitably assign new meanings to the primary experience of the dancers and the secondary experience of the photographer. Gandert glories in the potential conflicts provided by such a process. His subjects wear buckskins, war bonnets, *cupiles*, petticoat pants, camouflage pants, Army T-shirts, and Dallas Cowboys jackets. They bear with pride their "new scapulars" (tattoos, sports logos, T-shirt slogans). The "third space" where these raw ingredients meet but do not necessarily mix is Gandert's home turf, and he locates new ways in which the sacred and the profane define each other. "I love rituals," he says, "because rituals are something that people do not because they have to, but because they need to. When you get up in January, and it's cold in Taos, and you're there at sunrise at the Ranchos de Taos church, and there's nobody there

to watch you, and you go inside and dance, there's something profound going on, especially because a couple of miles away at Taos Pueblo, there's thousands of tourists watching the Deer Dance."

The dances and dramas featured by Gandert in this series were being performed when Edward Curtis was touring New Mexico in 1907 and 1913, but the self-appointed documenter of the Vanishing Indian never gave them the time of day. Their hybridity would presumably have appalled him, seeker after (and concocter of) authenticity that he was. Miscegenation was disapproved by turn-of-the-century Anglo society. Events like the Comanche dances, in both Pueblo and Hispano villages, were undoubtedly disparaged as impure and therefore worthless. (Many tourists have the same initial response to the garish colors and improvised costumes of the Comanche dances.)

Even today, Los Comanches and related dances as performed in Hispano villages are cultural stepchildren in relation to the immense literature on the Pueblo kachina dances. (The Matachines are an exception, perhaps because their origins are so mysterious, and presumably European.) Most of these local dramas are rarely mentioned in print, except in passing or in small-press folklorist literature. When I looked in the libraries and archives for references and old photos of Comanche dances to compare to Gandert's, I had little luck. Reference librarians wanted to steer me toward the dances at the pueblos rather than at the northern villages, which have seldom been written about in the last quarter-century.

In a tourist-dependant New Mexico, the mythical status of "Indians" is always in the foreground, while in the background lurks an unremarked competition between New Mexico's two cultural tourist attractions, one of the symptoms of the unresolved crossovers that take place so often in everyday life. Enrique Lamadrid has outlined how images of cultural superiority in the movies reflect Indianophilia and Hispanophobia, as well as the suppression of the genízaro as a unique style of *hispanidad*. By the early years of the twentieth century, he writes, the stereotypes of "Mexicans" were fully formed, "radiant with all the persuasive power of the hegemonic forces that had begotten them." Charles Lummis, in *The Land of Poco Tiempo* (1928), could describe "Mexicans" as "ignorant as slaves, and more courteous than kings, poor as Lazarus, and more hospitable than Croesus." By the twentieth century the northern New Mexican land grant heirs were déclassé, lacking the cachet of the romanticized (if previously vilified) "primitive" or the Spanish aristocracy. Hispanos were still "troublesome"—in part because there were so many of them. Indians, on the other hand, no longer a threat in internal exile, could now be idealized. The genízaros in turn represent the banished "mixed bloods" or "half breeds" (which Plains Cree artist Gerald McMaster says suggests "half a person"). As nomadic Natives were captured, they were detribalized, thrown out of the Pueblo kivas, landing inevitably in Spanish culture.

Indo–Hispano would still be considered by some as the "worst half of both" (even ignoring the usually forgotten Moorish component).

The cultural crossover that is at the heart of New Mexican culture is exemplified, even exaggerated, in the Fiesta of Guadalupe, celebrated annually on December 12 in the Las Cruces barrio of Tortugas, near the Mexican border. This extraordinary event has enjoyed a certain cachet in the past (it was written up in *New Mexico Magazine* in 1949, 1956, and 1976), but when I attended in 1999, there was a notable absence of outside audience, and no resemblance to the tourist events most such ceremonies have become around the state. We talked to people living as close as Las Cruces and White Sands who knew nothing about this vivid local ceremony, and we were acquainted with the few Anglo outsiders present, most of whom were shepherded by Gandert himself, when he wasn't virtually participating in the dances as a paparazzian extra.

The four dance troupes at Tortugas are Pueblo (although clad in buckskins reminiscent of Plains peoples), Matachines (called *Danzantes*), who began here at the turn of the last century, and two groups of Chichimecas or "Aztec dancers"—the red-garbed original Aztecas del Carrizo and the yellow-garbed split-off group. The Chichimeca dances, accompanied by a fiddler, bear strong resemblances to the Matachines, though the performers wear different regalia, sometimes including "jingle" pants and the tall, feathered headdresses more common to reconstituted Aztec or Toltec dancers today. Both feature multiple Malinches, little girls dressed in communion white or in yellow, pink, red, or green velvet, who dance solemnly, guided by the Monarca and Abuelos.

The dance performances are only part of a three-day religious event involving a Guadalupe shrine and masses at the church, a bonfire-lit procession up Tortugas (or "A") Mountain (where fifty fires were reported in 1976), much regulated ritual gunfire, a huge public feast featuring *albondigas* (little meatballs), and an array of interwoven ceremonials involving all of the various troupes. A Maypole like that used in archaic Britain on May Day climaxes one of the Matachines performances, the ribbons woven in dance by the Malinches and Abuelos. Another striking feature of the Tortugas Guadalupe fiesta is the *quiotes*—tall staffs made of yucca stalks and the white petal-like blades of the *sotol* stalk—that are created near the mountain shrine and carried down to the bonfire at the Casa del Pueblo.

In a 1949 *New Mexico Magazine,* writer Theron Marcos Trumbo, enthusing over "Montezuma's Children" at Tortugas, observed that "these sturdy people forget that they are mechanics, truck drivers or clerks, and revert to the primitive urge of Indian dances."

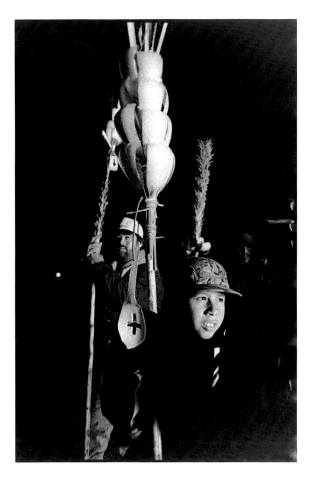

Peregrino y su Quiote, Tortugas, 1999

He reiterates a blatantly apocryphal story that Montezuma was of Tewa origin, a halfwit named Pose-ueve, born in Pose-uinge near Ojo Caliente in northern New Mexico, who won a lottery to become cacique, became disgruntled and stomped off to Pecos, married a Zuni maiden named Malinche, then left to follow an eagle south, where he founded many pueblos. This is typical of the absurd coverage that these ceremonials have received, as is a rather condescending 1956 version in which journalist Betty Woods remarks on Indians "dancing in bright red, long-skirted garb— gold fringed, ribboned, beaded and mirror-trimmed … dark faces made pagan with gaudy paint." More respectfully, Luke Lyon wrote in 1976 that the annual Guadalupe feast is "a viable religious event" with active local and out-of-state support and "has no taint of commercialism," which is true to this day, thanks in part to the fact that it is disregarded by the tourist literature, precisely, I suspect, because of its hybrid nature.

Tortugas, right next to the freeway southeast of Las Cruces, has a mestizo identity of its own. The inhabitants were originally Tiwas from Isleta Pueblo who founded Isleta del Sur near El Paso after the 1680 rebellion, some of whom later headed north. In the 1850s they became a "refuge" community made up, according to Adolf Bandelier, of "Spaniards, Mansos ["gentle" Indians—not a tribe but a description], Piros, Tiwas, Zumas, Tanos, Zunis, Apaches, Yutas, Jumanos, Conchos, Quiviras, Pananas, Keres, Tewas, Xanos, Tompiros, besides Mulattos and Mestizos." Tortugas is both pueblo and barrio, or neither. Formed in 1909–14 as El Corporation Indígena de Nuestra Señora de Guadalupe, it was organized (almost incredibly) by one "Colonel" Eugene van Patten of Rome, New York, a conductor on the Butterfield Mail stagecoaches, who married a Pueblo woman from Juarez and bought the land where the corporation now stands so that the motley crew of mestizos could have a place of their own to live and hold their ceremonies. Tortugas is still federally unrecognized as an Indian tribe.

In contrast to the religious basis and the separate-but-equal Guadalupe Fiesta in Tortugas, the Comanche dances originated in warfare, probably based on an earlier "conquest drama"— the Moros y Cristianos "games," which were brought from Spain. The latter were first performed in Nuevo México in 1598 and are presented today in Chimayó, where Gandert has photographed them. Los Comanches may have been written around 1780 by Pedro Pino, a wealthy Galisteo rancher who probably participated in the military campaign that defeated Cuerno Verde— the drama's hero, or anti-hero, aka Tabigo Naritgante (Handsome Brave). Gandert's photographs show a dashing figure on horseback engaged in mock battle. The actual Comanches continued to visit and interact with the people of the Río Grande Valley until they were confined to a reservation in 1875.

The Comanche dances are not just rituals commemorating victory. More subtly, they

function to capture the spirit of the former enemy in a cultural mimesis that includes cross-dressing. (There are examples of similar homage/mockery in contemporary Pueblo dances, such as Santo Domingo's Navajo dances, which sometimes include mustached men who appear to be Hispano.) Disguise can signal either assimilation or distinction from the dominant culture. It is tempting to see the act of taking on the garb of the "enemy" as a theft of his power. On a more mundane level, however, there are stories from across the country of Europeans disguising themselves as Indians so that Native people would be blamed for thefts and massacres they had not committed.

Pedro y su Tierra, Tierra Amarilla, 1988.

The confusion between inherited regalia, everyday garb, and "costume" is salient in another of Gandert's favorite events. The Good Friday procession in Tomé has taken place in various incarnations for over 250 years, beginning as a Penitente ritual of cross-bearing and self-flagellation in 1739. After the Hermanos's public flagellation was banned by the church in the late nineteenth century, participation fell off every year until the 1940s when, according to Elliott Kahn, Edwin Berry, "a lifelong preserver of middle Río Grande Valley folklore," was asked to revive the Passion Play "and to add costumes." He transformed the procession into a colorful pageant of the *calvario*. The hooded and robed costumes were derived from a German priest's memories of Passion plays and from Berry's wartime memories of North Africa—ironic, considering the largely suppressed Moorish influence on New Mexican culture. The Church once again opposed this event in 1956, but in 1957 Berry persisted, leading the procession up the hill identified as "once sacred Indian and Spanish ground."

"Today they're Indians, tomorrow they'll be Hispanics again," we were told of the dancers at Tortugas. A few weeks later a New Mexican from the northern village of El Rito told me, "We're all Indians up here, you know," noting the proximity to the genízaro or "refuge" village of Abiquiú. When Gandert asked Hispano land-rights activist Pedro Archuleta from Tierra Amarilla why the land should not be given back to the Indians rather than the Hispanos, he answered, "*¿Quién es mi mamá?*" Who, after all, is the "native," once mestizaje is the rule rather than the exception? Is this dressing up, or across, a need and a longing to be someone else, to be different? Or is it directly linked to ancient identities and ceremonial

practices? Gandert wants his pictures to "say that we need to re-examine how we define our-selves so that it's not inappropriate for Hispanic New Mexicans to dress in Native American garb and dance—something they have been doing for centuries."

The motives for Hispano communities assuming the Comanche persona are multiple. Los Comanches may have originated as homage (their bravery was much admired and feared) or derision. Sometimes Comanches were also denigrated in Spanish-speaking cultures, filling the role of the savage or that of the Polish and Irish in bigoted Anglo jokes. The Moors were the first cultural "other"; then came the Pueblos, and finally the raid-

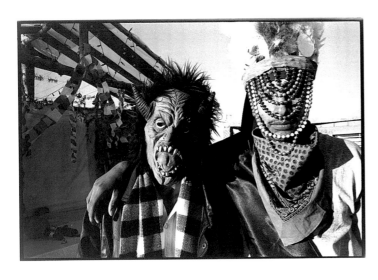

Diablos y Santos,
Ranchos de Anapra, México, 1998

ing/trading Plains tribes like the Comanches, once the Pueblos had become Spanish allies. Mela Sedillo described another popular dance/drama recorded in the twentieth century, called *La Raspa* or *La Indita,* as "a rather malicious poking fun at the Indian by imitating his dance or by singing more or less caustic words."

In the 1938 Los Comanches performed in El Rancho both by villagers and by Tewas from San Ildefonso Pueblo, actors playing Comanches pilfered things from cars, buggies, and wagons while the congregation was at mass; individuals were captured and made to pay ransom. Later the stolen people and items were redeemed—usually for a quart of wine in the cantina. In other villages, Indian impersonators sometimes kidnapped the Christ child on Christmas Eve during a house-to-house procession resembling the more common *Las Posadas* drama. Hispanos may have laughed at the "otherness" of Indians, but they shared and benefited from their spiritual traditions.

Much of this folk drama is based in captive narratives, a situation that, like cultural cross-dressing at dances, went both ways. Plains Indian and Pueblo women and children were captured and enslaved (or at least "enservanted" as *criadas/os*) by the Spanish; at the same time, Spanish and Pueblo women and children were abducted by raiding nomadic tribes. The captive theme runs through a number of nineteenth-century ballads and dramas, including variations on "Indita de San Luis" (from the Spanish-American War period) or "La Cautiva Marcelina," tales of love and warfare between Hispano and Indian people. All of this crossing of cultural boundaries is based in the historical fact of intermarriage and an erotic humor, which Lamadrid suggests might express "the wish for a more intimate cultural relationship."

In some versions of the Matachine dances, cross-dressing is gender rather than culturally based. The Perejundia character that appears in Los Matachines at Alcalde, Picurís, San Antonio, Tortugas, and elsewhere is a man dressed as a woman who sometimes gives birth during the performance. Masks are a salient feature of the Matachines and other dances.

(The name Matachines may come from the Arabic word for "those who put on a face" or who "face each other.") Gandert's photographs show a range from burlap renderings of Native masks to dime-store rubber Halloween masks. The Danzantes are more veiled than masked, with beaded loops that hang down from the mitered headdresses and cover their eyes. Brenda Romero has examined in depth the various theories on the origins of the Matachines performances, which range from Aztec courts to Roman sword dancers to Italian buffoons, and are said to be related to the ancient English Morris dances as well as to European Mystery plays and Autos (religious folk plays). Foreign to contemporary Hispano, Indian, and European cultures alike, the Matachines are favorites of the tourist media. Lamadrid says that the drama played "a central symbolic role in expressing spiritual bonds between [Spanish and Indian] cultures."

Picurís, of all the Matachine-dancing pueblos, was a good choice for Gandert's scrutiny, since it is geographically embedded in modern Hispano territory. Once one of the largest pueblos in northern New Mexico and now one of the smallest, Picurís was also known for its contact with the nomadic tribes. To this day the community remains proud of an indigenous cosmopolitanism that makes it seemingly more welcoming to outside influences than the more conservative pueblos.

Gandert has long been intent on reinserting Hispano history and culture back into the record, challenging myths of racial purity at the same time. Recently his search for a mostly buried legacy was personally justified; while attending a lecture on Indian slavery in the Spanish colonial days, he realized that Gertrudis Valdez, mentioned in relation to the genízaro communities of the San Luis Valley as a slave abducted from nomadic tribes, was his great-grandmother. Yet even as we celebrate New Mexico's original mestizaje, we may wonder what all the fuss is about. The Americas, north and south, have always been dense cultural mixtures. In North America, which celebrates the "melting pot" and "diversity" ad nauseam, why has "hybridity" become such an issue? Applied primarily to people of color, this fixation smacks of a kind of racism, perhaps engendered by envy from a would-be monocultural society that denies its own mestizaje. Little is made, for instance, of the mixing of those of Scots, German, Lebanese, or Czech ancestry.

The transformation of El Norte into the Southwest in the early twentieth century constituted a geographical inversion from looking north from one center to looking south and west from another, as Lamadrid has pointed out. After the Treaty of Guadalupe Hidalgo in 1848, which promised to respect the land and culture of Mexican (previously Spanish) citizens when the United States annexed New Mexico, laws were thrown to the wind, and communal grants were absorbed into private and government property. Those who were poor, uneducated, and/or non-English-speaking were shorn of their power, which lay in the land. In the process Spanish speakers were also de-historicized. One hundred and fifty years

later, these wounds still fester. Legislation is periodically proposed or promised to redress some of the historic wrongs. Now and then *La Gente* take things into their own hands. In the late 1980s, Gandert documented one such long-drawn-out struggle in Tierra Amarilla, Río Arriba County, scene of other violent confrontations in the late 1960s.

Land and culture/religion are at the core of all New Mexican history. For genízaros like some of Gandert's ancestors, who lost both, these dances may have been the sole contact with a sensed but unknown past. As he photographs specific ceremonies and events, Gandert is also incorporating the land where they literally take place. He is not a landscape photographer, but he documents the people's involvement with their history in place, their lifeways and traditions. Visually, the land is always in the background in Gandert's work, but the background permeates the foreground thanks to its significance in the general culture. Because of the serial or narrative nature of these photographs, context is provided in some images and passed on in spirit to those (such as portraits) that have none. The snowy dancing grounds, low adobe houses, ranch gates, crumbling sheds, and painted bar signs, the cars lined up around the plaza and processions along an acequia, all are integral but almost invisible parts of the final images. They are also implicit in the content, since often water and territory figure symbolically in the dances and dramas.

Miguel Gandert, who is both peripatetic and land-based, having photographed in tiny villages all over the state, describes *Nuevo México Profundo* as "art of a much larger exploration of culture along the Río Grande corridor. I look at the Río Grande as the bloodline for the Indo-Hispanic culture....My family still has land in the original community where people settled after coming from Spain. I can still go back to the house where my grandfather and father were born.... My grandfather...believed that land is the body and the ditches its soul or blood.... This is my reaffirmation, me learning about my roots.... I am of this place."

Like the events he photographs, Gandert's works are acts of cultural defiance. His stated goal is the reclamation of spirituality outside the church, unfettered by dogma and institutional conventions. Over the years he has sensed "a strong affirmation of ritual" in Nuevo Mexicano communities, because maintenance of tradition is how people affirm their lives. Now that this project is complete, he looks forward to coming back as an innocent bystander, although I suspect that the cultural tightrope extends into the future, and he will continue to walk it.

## Sources

Miguel Gandert, from conversations with the author and the following published interviews: Allen Rabinowitz, "Miguel Gandert's Photography Documents Indo-Hispanic Culture of Native New Mexico," *Photographer's Forum*, Nov. 1996; untitled interview,

*THE Magazine,* July 1998; Neery Melkonian, "Contested Territories: Miguel Gandert's Documentary Photography," *Afterimage*, Dec. 1991.

Roland Barthes, *Camera Lucida.* New York: Hill & Wang, 1981.

Flavia Waters Champe, *The Matachines Dance of the Upper Río Grande: History, Music, and Choreography.* Lincoln: University of Nebraska Press, 1983.

James C. Faris, On "Indigenous Media," unpublished lecture given at the Society for Photographic Education, Northeast Regional Conference, Nov. 5, 1994, University of Hartford.

_____, A Political Primer on Anthropology/Photography, in Elizabeth Edwards, ed., *Anthropology and Photography, 1860–1920.* New Haven: Yale University Press, 1992.

Suzanne Forrest, *The Preservation of the Village: New Mexico's Hispanics and the New Deal.* Albuquerque: University of New Mexico Press, 1989.

Elliott Kahn, Good Friday Pageant Rekindles Community Spirit in Tomé, *New Mexico Magazine*, April 1988.

Barbara Kirshenblatt-Gimblett, *Destination Culture: Tourism, Museums, and Heritage.* Berkeley: University of California Press, 1998.

Enrique Lamadrid, Entre Cíbolos Criado: Images of Native Americans in the Popular Culture of Colonial New Mexico, in Maria Herrera-Sobek, ed., *Reconstructing a Chicano/a Literary Heritage: Hispanic Colonial Literature of the Southwest.* Tucson: University of Arizona Press, 1993.

_____, Ig/noble Savages of New Mexico's Silent Cinema, 1912–1914, *Spectator* 13(1), Fall 1992.

Luke Lyon, Viva Guadalupe! Viva Tortugas!, *New Mexico Magazine*, Nov. 1976.

Chon Noriega, *From the West: Chicano Narrative Photography.* San Francisco: The Mexican Museum, 1995.

Sylvia Rodríguez, *The Matachines Dance: Ritual Symbolism and Interethnic Relations in the Upper Río Grande Valley.* Albuquerque: University of New Mexico Press, 1996.

Brenda Romero, *The Matachines Music and Dance in San Juan Pueblo and Alcalde, New Mexico: Contexts and Meanings.* Ann Arbor: University Microfilms, 1993.

Mela Sedillo, *Mexican and New Mexican Folk Dances.* Albuquerque: University of New Mexico Press, 1935.

Theron Marcos Trumbo, Montezuma's Children, *New Mexico Magazine*, Nov. 1949.

Marta Weigle and Peter White, *The Lore of New Mexico.* Albuquerque: University of New Mexico Press, 1988.

Betty Woods, Trip of the Month: Tortugas Fiesta, *New Mexico Magazine*, Dec. 1956.

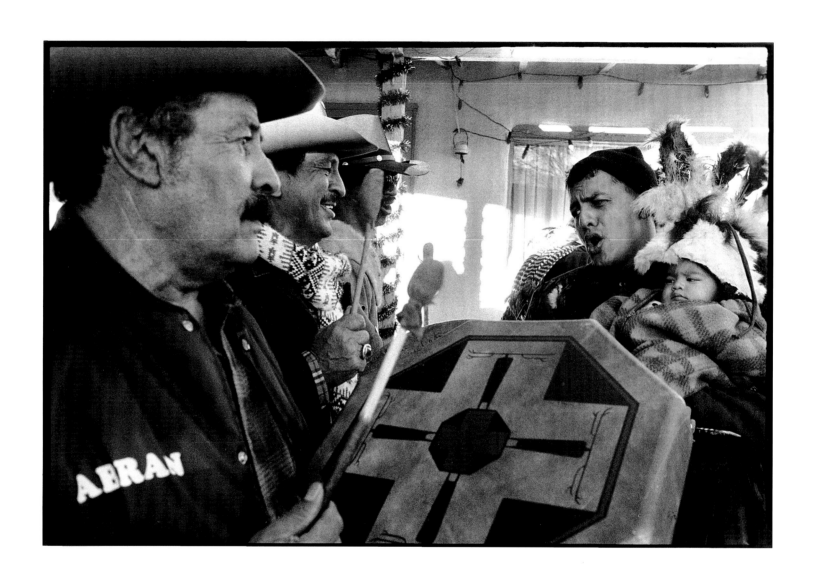

Tres Generaciones Cantando, Ranchos de Taos, 1997

# Dancing with a Camera

*Chris Wilson*

It's cold, overcast, and beginning to snow at about 9 a.m. on New Year's Day—the first morning of a new millennium. Miguel Gandert and I have the windows of his Subaru station wagon rolled down as we jostle down a dirt road in Ranchos de Taos. He is here to photograph the Comanche dancers of Talpa for the fifth time, as part of his ongoing documentation of Indo-Hispano ritual celebrations. I've come along to gather impressions of him at work and to enjoy our growing friendship. Soon we pick up the sound of Indian drumming and follow it to a cluster of pick-up trucks parked along a road north of town. In one practiced, continuous sequence, Miguel breaks to a stop, puts the car in park, turns off the engine, pockets his keys, reaches into the back seat for his camera bag and three cameras, slips them over his head, and is out the door.

We climb a gravel drive to the bare dirt yard beside a stucco brown, metal-roofed ranch house. I find my place at the end of a crescent formed by ten or so people watching a circle of dancers dressed in buckskins, moccasins, and brightly colored feather headdresses. Miguel heads straight for the three-man chorus headed by Francisco Gonzales, a former state legislator, nicknamed El Comanche. They smile and nod, their voices grow louder, their drum beat stronger as he steps within an arm's length and raises a camera. After a

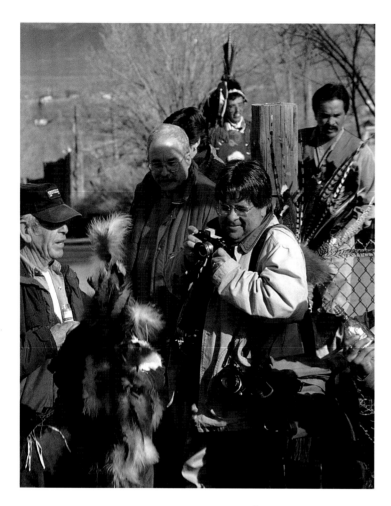

Miguel Gandert photographing
Comanches in Talpa, 1998
(Photo by Andrew Connors)

few minutes, this set ends when the dancers take the owners of this home, the Sandovals, captive and dance around them triumphantly. Then we're all invited in to a waiting spread of coffee, punch, cookies, cake, and mincemeat turnovers. ("This is the place with the really good empananitas," Miguel had confided as we drove up.) Back in his Subaru, he sheds his cameras into the back seat as fluidly as he put them on.

We spend the rest of the day winding through the contiguous villages of Ranchos and Talpa in a caravan of vehicles—three drummers, six to ten dancers, and a dozen or so supporters. At one house, when no one emerges after two songs, we move on. At others, one or two or five or ten people emerge to greet us, watch four or five dances, and take pictures with their Instamatics.

Forty-four years old, five-foot-seven, and dressed in a lightweight black jacket, jeans, and running shoes, Miguel Gandert stands at the edge of the crowd, arms folded, watching intently. At one stop, he scrambles up on a pickup to shoot an overview. At another, he goes down on both knees to get the best angle on a young dancer. Like a curious black bear come down off the Sangre de Cristo Mountains, he weaves in close to the dancers, hunched forward, camera raised to his eye, leading with his nose. (More than once he's been knocked senseless by a spinning dancer.) At another house, he focuses on a sixty-year-old woman with her infant grandchild bundled in her arms as the Comanches circle around.

About 11:30, snow squalls force an early break at the Armijos' for a lunch of ham, green chile stew, red chile and beans, posole, flour tortillas, cake, and pastelitos. We sit satisfied, talking in the living room. Miguel is handing out handsome 16-by-20-inch prints of photos taken in earlier years. As they pass from hand to hand around the room, someone explains, "Here's Luis Giron who was killed in a motorcycle accident."

"Mira. Look how serious you are in this one, Abrán."

"Come here, mija," a mother calls across the room. "Come see how little you were in this picture."

"Oh, this one's from when Miguel set up his big camera and took pictures under the portal at Francisco's."

"Here's old Manuel who died since last year. He always loved it when we came to dance at his house on his saint's day."

"I'm a real product of northern New Mexico," Gandert says as we drive back to Santa Fe in the dark. Although considered Hispanics by the U.S. Census, Gandert and his parents, like the Comanche dancers of Talpa, belong to the Spanish-speaking but largely mestizo enclave of northern New Mexico and southern Colorado known to geographers as the Hispano Homeland. Cultural cross-fertilization and intermarriage with Native Americans began soon after Spanish colonists arrived in the region in 1598. Their descendants, settled in land-grant villages on Mexico's far northern frontier, found themselves annexed to the United States following the U.S.-Mexican War of 1846. Deprived of most of their village common lands through legislative and judicial chicanery, they nevertheless insisted as early as the 1890s, through their thriving Spanish-language press, that they could be loyal U.S. citizens while also maintaining their culture and Catholicism. They were both Hispanic and American: *Hispano-Americanos*. From 140,000 Hispanos in 1900, their descendants in New Mexico and Colorado have grown to perhaps half a million today.

Miguel Gandert's mother, Cecilia Mondragón, grew up in Antonito, in the part of Anglo-dominated Colorado that tried to secede and rejoin New Mexico as recently as the 1960s. She attended high school in El Rito, New Mexico, before going on to Highlands University in Las Vegas. Miguel's great-grandfather, a German-born trader named William Gandert, moved in the 1860s from Taos east over the Sangre de Cristos to Mora, New Mexico, where he married Mariana de Jesús Vigil. In time, Gandert became recognized as a Hispanic name. After serving in the Army during World War II, Miguel's father, José, attended Highlands on the G.I. Bill. He was elected student body president, met Cecilia, and married her.

Miguel, the third of José and Cecilia's four children, was born in 1956, when José was teaching in Española. Three years later, José become a leader and lobbyist for the New Mexico National Education Association, and the Ganderts moved to Santa Fe. Like other middle-class Spanish-American families living in the flat-roofed, adobe style ranch houses of the Casa Solana subdivision, one of Santa Fe's first suburbs, the Ganderts chose not to speak Spanish with their children because they believed it was important for them to speak English without an accent to get ahead. But Miguel spent summers on his grandfather's farm in Mora, where he heard Spanish spoken every day.

He recalls the day in 1967 that he climbed the piñon-covered hills above Casa Solana to watch a National Guard convoy with cannons and a tank head north out of town. Land-grant activists demanding the return of stolen common lands had just declared their independence from the United States and raided the country courthouse at Tierra Amarilla. The troops were off to quell this, the last rural insurrection in U.S. history.

A not overly athletic twelve-year-old, Gandert was manager of the Young Junior High

basketball team when his science teacher, Doug Smith, loaned him a camera to take game pictures for the yearbook. It may be a cliché of personal narratives, but this was the event that changed his life: "I remember going into the darkroom and seeing my first picture coming up in the developer, and I was hooked. It's still like magic for me today. A photograph's a frozen moment, a memory you can hold and share." Through his school years, Gandert served on the newspaper and yearbook staffs. His father had begun working for the Agency for International Development, preparing Spanish language text books for use in Latin America, and in 1970, moved the family to the Ecuadorian capital of Quito, high in the Andes Mountains. While attending a Montessori-style international high school there, Miguel polished his Spanish.

At seventeen, in the fall of 1973, he returned to enroll at the University of New Mexico in Albuquerque. The University Studies program permitted him to create his own mix of honors classes, anthropology, sociology, philosophy, political science, and journalism. Although the intensity of the Chicano movement had peaked in the late 1960s, Gandert embraced its revisionist history of stolen grant lands and a mestizo heritage, encapsulated in New Mexico in the self-identification *Indo-Hispano*.

UNM had the foremost photo and photo history program in the country at that time, and Gandert took a full complement of undergraduate classes and graduate seminars from art historian Van Deren Coke, photographer Thomas Barrow, and Beaumont Newhall, the preeminent historian in the field. The first daguerreotypes of cathedrals and stiffly posed people, expeditionary photographs of pyramids and the Grand Canyon, Eugene Atget's deserted Paris streets, Wegee's tabloid newspaper crime shots, Walker Evans's sharecroppers, Dorothea Lange's Dust Bowl refugees, Auguste Sander's stern-faced Germans, Cartier-Bresson's beautifully composed "decisive moment" photographs—Gandert drank them all in.

Contemplating photographs of people who were once full of life, but are now long dead, can produce a disquieting sense of one's own mortality. That is inherent in photography. Gandert's comprehensive study of photo history deepened this experience into a permanent sensibility. Although he continued to work as a photojournalist during his undergraduate years, he also became a documentary photographer working for posterity, aware of his potential audience a generation or ever so many generations hence. As Gandert put it, he wanted to provide "a window onto the appearance of my time."

The older photographers in the graduate program at UNM during those years reveled in Edward Weston's *Daybooks,* the diary of a bohemian photographer willing to endure hunger and a lack of recognition in the pursuit of art. Meanwhile, Gandert emulated the legendary *Life* photojournalist W. Eugene Smith and most admired the hard-edged docu-

mentary photographers Mary Ellen Mark, Robert Frank, Josef Koudelka, Danny Lyon, and the lesser-known chronicler of New York's Puerto Rican barrios, Rene Gelpi. Gandert liked the intimacy Gelpi achieved with grainy black-and-white film and a wide-angle, 28mm lens that required him to get close to his subjects. Above all, he was transfixed by the way Gelpi's subjects stared proudly, sometimes defiantly back at the camera.

"Early in my career I was obsessed with people looking at the camera," Gandert recalled in a 1998 interview. "I wanted pictures that looked back at people so there was a dialogue and I became a surrogate." This was fifteen years before the anthropologist John Urry coined the term *the tourist gaze* to describe the way that tourists are allowed to stare at people who interest them, while those depicted in stereotypical tourist images avert their own eyes from the tourist gaze. Even then, Gandert was beginning to transform the romantic tourist image of Hispanic New Mexico with portraits that stared back.

As photo editor of the student newspaper, *The Daily Lobo*, Gandert shot everything from rock concerts to regents' meetings. His first coherent body of work emerged from a story on a student-sponsored boxing club in the Albuquerque barrio of San José. Exhibited soon after his graduation from UNM in 1977, *Two Corners of the Ring* includes shots of boxers exchanging blows and trainers working over their battered protégés between rounds, but consists primarily of portraits of boxers staring warily at the camera, their guard up against a possible punch.

Victor Romero, Albuquerque, 1977

"One boxer, a young man named Victor Romero, told me he thought I wanted to know what it is to be a boxer, and that I would never understand boxing until I got in the ring," recalled Gandert some years later, after Romero had died in a boxing accident. "In one of my favorite images, Victor in a hooded sweat suit appears as a monk, his fists held forward, and behind him like religious icons, a Coke sign and a clock with a dangling cord. …Looking at it I feel that at least a small part of the intensity of Victor Romero lives on."

Within months of his graduation, Gandert's journalism professor, the veteran newspaperman Tony Hillerman (only then writing his first mystery novels), recommended him for a cameraman job at KOAT, the local ABC affiliate. During fourteen years as cameraman and news producer at Channel 7, he also worked for CNN and ABC on assignment in Korea, Mexico, and Central America. "There's nothing that I did that's not really dated," he explains. "Nothing was ever really complete. You're always limited by time. Something that deserves two hours gets two minutes." So, on the side, Gandert took graduate courses in

photography at UNM and worked to complete larger bodies of documentary photography. "It's what kept me sane," he says.

For his 1983 master's thesis show, Gandert produced seventeen portraits of gang members who look directly into the eye of the camera. Black-and-white Converse high tops, pressed work pants, flannel shirts, sleeveless white undershirts and suspenders; bandannas positioned over eyebrows, baseball caps turned backwards, and wrap-around sun glasses; immaculately polished low riders; tattoos of girlfriends, dapper *vatos,* Jesus with a crown of thorns, or the Virgin of Guadalupe with her radiating *esplendor*—these constituted the means for creating individual personas within a shared subculture. Out of focus in the background of these portraits, functioning as a subconscious landscape, are silhouettes of utility wires and leafless trees, a neighbor watching from a distance, chain-link fences, an open dumpster, a pickup truck, tire tracks in the dirt.

The anthropologist Edward T. Hall, whose work Gandert first read about this time, pioneered the study of body language and proxemics (the culturally determined distancing between people). Hall argues that most human interactions take place in recurrent social settings—situational frames, he calls them—comprised of body language and proxemics, rhythms of interaction, a situational vocabulary, a characteristic physical setting, and, in some cases, specialized clothing, formal rituals, and rules of behavior. In an informal situation—an encounter with a friend on the street, for instance—we know without thinking how far apart to stand, whether to nod, extend a hand, or offer a hug, and what sort of pleasantries to exchange. A more formal situation such as a Catholic mass includes not only the prescribed liturgy but also our Sunday-best clothes, our hushed voices, and knowledge of where to sit in relation to other parishioners.

Posing for a family portrait in a photographer's studio is a relatively formal situational frame. Handing a camera to a stranger at a family picnic or a tourist stop so that she can take a group picture is a related, if less formal situation. We know to arrange ourselves shoulder to shoulder facing the stranger. The stranger knows to pause briefly after raising the camera and to ask us to say cheese, so we have a chance to compose ourselves. Gandert photographing a victorious boxer with a trophy clutched in his padded glove, or a cholo leaning against the door of his beloved lowrider, is a closely related social situation.

In his master's thesis, Gandert admits to being a bit of a voyeur and feeling some guilt for taking people's pictures. It helped that his work was addressing the dearth of Hispanos in history books and museum exhibits. It also helped that anyone roaming Albuquerque's barrios with a camera slung over his neck in those years (as I also happened to have been, working on a historic building survey) was regularly greeted by enthusiastic requests to take people's pictures. The camera meant attention and validation. One of Gandert's basic rules

became, "Never say no when someone asks to have their picture taken." He began giving away prints to everyone he photographed. (There are stacks of 5-by-7 prints of people he's been unable to locate stored in a metal cabinet in his UNM office.) Gandert also began to sell prints to collectors, museums, and archives to help pay the high cost of film, processing chemicals, and photo paper.

In 1982, Steve Yates, the curator of photography at the Museum of Fine Arts in Santa Fe, invited eleven veteran photographers to document the state's contemporary human landscape. Yates was so impressed with Gandert's thesis show that he delayed the publication of the photo survey to allow Gandert to refine his work. If he stayed at a medium distance in his earlier work out of deference to the conventions of portraiture, Gandert now moved in much closer, in the process inserting himself into other situational frames.

In one image taken for the survey in 1983—an image that has long been one of his best known—a lowrider is stopped at the side of a residential street. Friends lean in at both windows to socialize. It's a situation repeated a hundred times a day in the barrio. The difference here is that the person standing at the driver's window is Gandert, holding a camera. Perhaps his ready smile and unthreatening demeanor gained him access, or the car's occupants already knew him and had seen his photos. His wide-angle lens soaks in the chrome steering wheel and shiny vinyl within, as well as snatches of chain-link and nearby houses outside the windows. The driver and a young woman in a halter top, her elbow resting on the passenger's window, fix their eyes on the camera. Visible tattoos provide

Melissa Armijo, Eloy Montoya, Richard "El Wino" Madrid, Albuquerque, 1983

surrogate personas for each. It is a relatively informal situation, but the presence of Gandert's camera elicits their dignified composure and wary gazes that hold any inclination to romanticize at bay. As always, Gandert provides a visual frame by carefully printing the black edges of his negative—an indication that this is the original, uncropped image.

Published in 1985 as *The Essential Landscape,* the photographic survey was accompanied by nine essays probing New Mexico's vernacular cultures. Their author, J. B. Jackson, was considered by many the preeminent writer on American cultural landscapes. Of the pho-

tographers included in the book, Jackson was most interested in the work of Gandert, and commissioned him to make slides for use in his talks around the country. Gandert read Jackson's essays, and the two cruised through lesser known villages and neighborhoods talking about the physical landscape and the ways people make a living, socialize, and come

Juan's Auto Service, Albuquerque, 1985

together for community celebrations. In late 1985 and early 1986, Gandert made a series of slides for Jackson of the subterranean economy of roadside flea markets, mechanics working in driveways, and day laborers with their tools. In 1987, when Jackson, then in his late 70s, grew tired of escorting a PBS crew that was making a documentary about his vision of the landscape, he told them, "Go with Miguel. He knows what I see."

Throughout the 1980s, Gandert continued to make portraits of outsider subcultures—exotic dancers, remnant hippies, and the clientele of Okie's, a university area bar slated for demolition. Each September he geared up for an intense two weeks of photographing carnies at the state fair. And when the festering dispute over alienated common lands flared again in 1988, he produced a series entitled *Tierra O Muerte* (Land or Death) that includes shots of jailed land-grant activists and fortified encampments.

Gandert continued to photograph the lowrider subculture and also began to shoot their toddlers, parents, and grandparents, a traditional *matanza* (pig slaughter and roast), cemeteries, Matachines dancers, and the Fiesta de Nuestra Señora de Guadalupe. In one 1987 image, an eleven-year-old in her lacy white first communion dress poses in front of an unconventional backdrop of concrete block wall and graffiti-covered dumpster—a holdover, perhaps, from his earlier gang work. In another image, taken two years later during the Good Friday pilgrimage up Tomé Hill, an aged figure hoists a large crucifix up on his shoulder against a cloud-streaked sky. In the background, taking up half of the frame, is the sort of cultural landscape of irrigation ditches, fenced fields, and adobe houses that Jackson read as signs of hard work and human aspiration. Gandert's other long-term documentation projects include the Hispanic farms and ranches of the region, portraits of Southwestern artists and writers, and the hard street life of Juárez and its burgeoning *colonias*.

Some Hispanics object to Gandert's photos of Juárez prostitutes, as they did earlier to his barrio gang photos. Understandably concerned that these images might provide ammunition for bigots, they argue that they are not representative of Hispanic culture. But in the context of his larger body of work, these photos reveal Gandert's desire to include various segments of society and his commitment to afford every individual respect through the

opportunity to present him or herself to the world in a dignified manner.

During the 1980s Gandert taught occasionally at UNM, and in 1991 he was hired as a full-time professor in Communication and Journalism, a department that combines traditional newspaper and TV work with the study of intercultural communication. Although he has covered the full range of photo and broadcast journalism classes, Gandert most enjoys teaching "Introduction to Visual Communications" and "Intercultural Field Research." Students know him as a mellow, approachable, engaging professor who provides practical advice on camera technique and interacting with people, while also conveying substantial enthusiasm for his own work and his students' potential for contributing to the documentation of contemporary cultures.

Gandert has continued to exercise his journalistic license to explore corners of society that might otherwise be off-limits. He has photographed the first Mexican woman police chief in Tijuana for *People en Español*, the fiftieth anniversary of the Trinity Site for the *Los Angeles Times Magazine*, a survivor of the Truth or Consequences sex murders for *Maxxim Magazine*, and the control room of the Four Corners Power Plant for the annual report of the Public Service Company of New Mexico. In 1997, when Ken Burns asked him to produce a portfolio for the web site accompanying his PBS documentary, *The Pursuit of Happiness*, Gandert chose to spend his allotted two days photographing Pueblo Indian casinos populated by gamblers, dealers, cashiers, and security guards, as well as documenting the educational, environmental, and recreational programs made possible by casino income.

Diego "Lucy" Delgado, Juárez, México, 1992

Over the past decade, Gandert has dedicated the better part of his free time to the documentation of the ritual celebrations depicted in this book. (We can only imagine how much support and patience have come from his wife, Julie Newcomb, a writer and radio producer, and their daughters, Sonja, 14, and Yvonne, 10.) The rituals Gandert photographs are joyful and somber, poignant and profound, and, for me, ultimately unfathomable. So I will leave the interpretation of their origins and meaning to those historians, anthropologists, and folklorists who have studied them closely. What interests me most about Gandert's work

are the spatial dynamics of these community rituals and the modern situational frame of people interacting with the photographer and his camera.

We know from the Heisenberg uncertainty principle that the observation of a physical phenomenon unavoidably alters that phenomenon. The same holds true for social phenomena, which poses a dilemma for students of society. To minimize the impact of their presence, folklorists and anthropologists often stand back among the onlookers, using a telephoto lens to take pictures. Gandert does the opposite when he shoots with 21 and 28mm wide-angle lenses, weaving in as close to the action as decorum permits.

From a romantic perspective, such a forthright intrusion of modern technology undermines the authenticity of tradition. But these rituals are kept alive solely by people who live in the modern world. Each of the celebrations is photographed by community members, some by television crews; people with cameras have by now become customary participants. At a recent show of Gandert's work at the Albuquerque Museum, a sixty-five-year-old Hispanic woman thanked him by saying, "Finally we can see ourselves in the museums." Likewise, grown children who have had to move away to find work but come home to take part in community celebrations will take Gandert's prints back with them to hang on their dining room walls in Denver or Phoenix. Gandert and his photos thereby become part of the social, symbolic web that sustains community.

To record the physical and social context, Gandert stands back with his preferred, hand-held Leicas with wide-angle lenses. (He typically uses three cameras with different lenses so he won't have to change lenses in the middle of the action.) Some events, such as the Good Friday pilgrimages to Chimayó and up Tomé Hill, are linear and relatively solitary experiences. Religious processions, by comparison, are circular, generally originating at churches, winding through communities, and returning to their starting points, thereby projecting religious devotion throughout villages and urban neighborhoods. These routes down city streets, state highways, dirt roads, and paths alongside acequias are often lined with spectators. In the foothills of the Sandía and Manzano Mountains east of Albuquerque, where recent suburbanization has inundated old Tijeras, Cañoncito, San Antonio, and San Antonito, annual Matachines dances and religious processions reassert a Hispanic presence that dates back to the early 1800s. One developer who sought to close a little-traveled dirt road was surprised when he met with opposition because the road has served as a procession route for generations.

Gandert sometimes employs a panoramic camera to encompass church, plaza, and ritual dance in one long horizontal image, most notably at Alcalde and Ranchos de Taos. Buildings may be missing from the perimeter of the old plaza at Alcalde, but when the Matachines, Abuelos, and Malinche begin to dance, and a crowd gathers two and three deep

around them, it is easy to appreciate how the three — church, plaza, and ritual celebration —
intertwine as the primary modules of community organization. At the Tortugas church near
Las Cruces, evergreen trees, concrete block walls, and chain-link fences have been used to
define the perimeters of three dance grounds, one for each of the parish's dance groups. The
new Juárez colonia of Anapra may cling precariously to a raw hillside beside the interna-
tional border, but when its dancers take their places in front of their new concrete block
church, they too define both a plaza and a human community.

The Talpa Comanche dancers begin each New Year's Day soon after sunrise in the small
plaza in front of the Ranchos de Taos church. At house after house, the chorus typically
takes a place beside the residents in front of their home, while supporters who follow along
form a crescent facing them, with the dancers in between. At each stop, houses, outbuild-
ings, fences, and, sometimes, a trailer home define a space, thirty-five feet or so square —
a good size to accommodate this number of participants. Just as plaza spaces relate to the
scale of community ritual, residential compounds relate to the more modest scale of Talpa's

Comanches and to the size of extended
families. When the horseback skirmishes
between Los Españoles y Los Comanches
at Alcalde require a more ample space, the
action moves to open ground where pick-
up trucks define the perimeter of tempo-
rary *plazas de armas*.

Gandert moves to a middle distance to
record remarkably deep and wide swaths of
action, all of it in focus. To describe a sin-
gle image: we are standing on the side of a
street in Bernalillo. Directly in front of us,
a row of hooded Matachines wearing blue
jeans and running shoes face a row of girls
in their white communion dresses, who
carry *arcos*—arches perhaps four feet
across, decorated with flowers. On the oth-

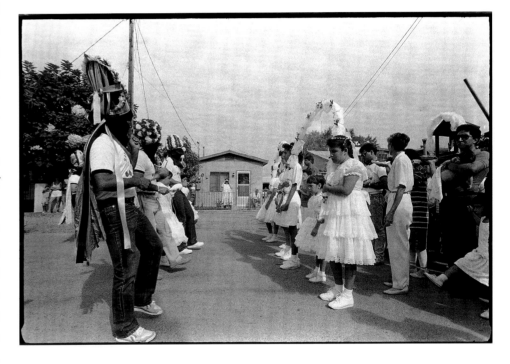

Arco de Triunfo, Bernalillo, 1991

er side of the street, a woman in her front yard aims an Instamatic camera back at the dancers
and us. Behind the girls, a man in sunglasses holds one handle of an *anda*, a litter bearing a
statue of San Lorenzo, while cradling an infant in his free arm. Meanwhile his young daugh-
ter, with her hand tucked in his pocket, mimics the dance step the older girls have just com-
pleted.

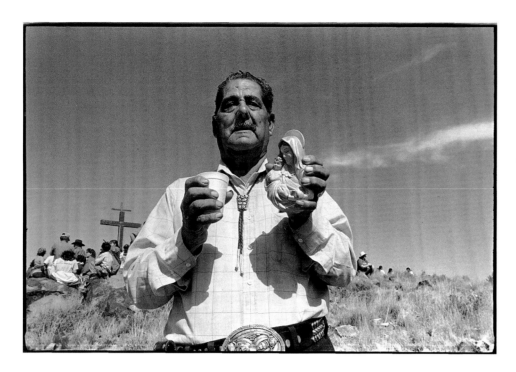

Agua de la Vida, Tomé, 1993

Who can resist becoming enthralled in the nuances of ritualized gesture and costume, the clothing and body language of attending family members, and the context of onlookers and surrounding cultural landscape so lovingly recorded in these photographs? "Because of the serial or narrative nature of these photographs," notes Lucy Lippard, "context is provided in some images and passed on in spirit to those (such as portraits) that have none." At the Bernalillo procession, telephone and power wires loop overhead like utilitarian festoons, while in others we glimpse barbed wire and chain-link fences, gas meters and TV antennas, brimming acequias and bone-dry hillsides.

Beyond simply documenting the ritual, Gandert also works to give us a sense of the experience of participants. Since he first leaned in at the window of a lowrider in 1983, part of his approach has been to insert himself directly into everyday situational frames. To echo Victor Romero's observation of years ago, Gandert wants to get into the ring. It helps to think of his close-in photographs not as picture windows through which to discretely view quaint customs, but rather as the chance to step vicariously into the spatial context of these celebrations.

One gauge of his relationship to each community is his physical distance from the ritual. He holds back at Picurís Pueblo, where the Abuelo in his grotesque rubber mask prodded Gandert with his whip one year and took mocking, imaginary photographs of him. Gandert hated this, he says, because photographers like to think they are invisible. "I'd like to just pull on my ear when I see something interesting and have film come out my mouth," he once told me. But his embarrassment lessened when he learned the Abuelo was a friend whose burlesque served to normalize Gandert's relationship to the community. At Talpa, he is warmly welcomed and circulates freely in among the dancers. At most other celebrations, he moves primarily in the spaces between onlookers and dancers.

On a pilgrimage trail he falls in line with others. In one photograph we are following a man using two canes as he climbs Tomé Hill on Good Friday at the moment when the sun comes up over the hill to shine directly in our eyes. Or we are in a Matachines procession at San Antonito, glancing back over our shoulder at a middle-aged couple carrying a large

crucifix. In another image, we are looking out over the crepe-paper decorations on the hood of a vehicle, following a similarly festooned flat-bed truck filled with children sitting at the feet of a girl dressed as the Virgin of Guadalupe, as we drive down a dirt road in Anapra lined with small, concrete-block houses.

Many photos of the dances gain experiential immediacy from a slightly out-of-focus fragment of a dancer's knuckles, the neck of a guitar, or a Matachin's three-pronged wand, which intervenes between us and the larger scene. At the corner of one photo taken in the bar at Alcalde, the horn of the Bull nearly gores us as he lunges to avoid the whip of the Abuelo in the middle distance. Or we catch a blurred glimpse of feathers and buckskin fringe, which seem to brush our cheeks as we look beyond to similarly dressed dancers. In other images, the tilt of the frame suggests the view seen by a dancer, who dips first one shoulder, then the other, rather than that of a photographer squaring up his camera.

Gandert and participants also pause now and then in the flow of celebration and revert to the most traditional of photographic situational frames—posing for the camera. One year at Talpa, Gandert set up a tripod and old Crown Graphics newspaper camera to take formal portraits of Los Comanches (an ironic commentary on Edward S. Curtis's exclusionary definition of what makes an authentic Indian). Other times, Gandert appears to have just been recruited to take a group snapshot, as in the photo of elderly Comanches posing in front of the altar of the Alameda church.

In another type of portrait, a man steps to the side of the Tomé pilgrimage path, faces the camera, and holds up a styrofoam coffee cup in one hand and a grapefruit-sized Madonna and child in the other. The mid-morning sunlight falling from above bestows equal vibrancy to the creases in his face, the folds of the Virgin's cloak, and the nails of his fingers. Inside the Santuario de Chimayó, a mother steadies her toddler with one hand for the photographer. The child, who has an oxygen tube across her nostrils, is too young to "say cheese" and instead gives a "wave bye-bye" response. On the *plaza mayor* in Juárez, a woman of perhaps twenty, dressed in a white blouse, fringed sash, and shiny black vinyl skirt, with a bandanna across her forehead, addresses the camera with a placid gaze reminiscent of Gandert's earliest portraits of boxers and cholos. To pose for the camera is to adopt a stance toward the modern world outside one's everyday community.

Some dancers pose for the camera in full ritual regalia—the family of four Abuelos in fur hoods at Amalia, for instance. In another photo, a teenage boy at the end of a line of Matachines in front of the San Antonito church, the gauzy scarf over his cheeks sucked in over his lips, stares at the camera through a veil of fringe. But those individuals most absorbed in the measured steps and prescribed gestures of the ritual appear oblivious to onlookers and camera alike. Meanwhile, adults walking in religious processions uphold the solemnity of the occasion by consciously ignoring the camera. These are people able to

inhabit centuries-old rituals, but they also know how to respond to the camera. Rooted in a regional culture, they are as modern as any one of us. They are Hispano-Americanos, or in the case of Juárez, perhaps, Indios-Mexicanos.

Also scattered throughout these images are children, ten or twelve years old, who pause to cast a perturbed or fierce or benign gaze directly at the camera. Beside the water-filled Atrisco acequia, Matachines escort a Malinche, who absent-mindedly fingers the skirt of her satin dress as she turns to face us with a look of serene comprehension. "Witnesses to the crime," Gandert calls these children, with a faint smile. The crime, I suppose, is voyeurism. And to the extent that we become absorbed in these images, we too are implicated. But might something else account for the looks on their faces—not a crime, but rather an emerging awareness of their own fading innocence? The challenge of making one's way in the modern world? The passing of time? The fleeting poignancy of life itself?

In this, his largest body of photographs to date, Miguel Gandert immerses us in the ritual celebrations of Indo-Hispano New Mexico—the dancers' costumes, the spectators' clothing, the way people move, where they stand in relation to each other, how their dance grounds are physically framed, the mundane details of their hardscrabble landscape, a feeling of being inside the experience, and the various ways they choose to face the camera. Gandert is a dedicated artist delving as deeply as he knows how below the surface of our assumptions about this American region. His photographs, like the gatherings they record, not only celebrate a mixed Spanish and Native heritage, they also affirm the possibility of sustaining human communities—season after season, generation to generation—through rituals enacted by individuals who are themselves mortal.

Outside again after lunch on that blustery New Year's Day in Talpa, Francisco Gonzales calls us together in a circle to join hands. He offers thanks for all the wonderful people who have come to celebrate the Feast of Emmanuel, for these dances in honor of Jesus, for those who once danced but are now gone, for the dedication and spirit of the young dancers, and for the hospitality and love shown by the Armijo family. We walk to the next stop, where a girl of about sixteen and an unsteady, stoop-shouldered old man emerge from a trailer home. As he falls easily in step with the dancers, others try unsuccessfully to coax his painfully embarrassed granddaughter to join in. Miguel comes to the end of a roll, hurries to change film—and the moment is gone.

The sun sits low in the southwest as we walk to the last stop of the day. Four generations of an extended family, sixteen people in all, are waiting to see one of their own, a thirteen-year-old girl who has danced joyously at stop after stop throughout the day. When the dancers take her great-grandfather captive, he too knows the steps. Interspersed with the

Indian and Spanish chant, Gonzales leads the chorus in a new refrain: "Oh we love you grandfather. Yes we love you grandfather. You know we love you grandfather." Encircled by dancers, drummers, relatives, and a few remaining supporters, the daughter and great-grandfather are dancing together, grinning. With a bitter wind bearing down on us off the snow-covered Sangre de Cristos, some brush tears from their eyes.

I didn't notice whether Miguel was standing and watching, or had gone in among the dancers, down on one knee perhaps, working to get a better angle.

## Sources

Thanks to Miguel Gandert, Joanne O'Hare, Helen Lucero, and Anne Boynton for editorial suggestions.

In addition to interviews with Miguel in January, March, and April of 2000, and the loan of his career portfolio, this essay draws on the following:

Van Deren Coke, *Three Generations of Hispanic Photographers Working in New Mexico.* Taos: Harwood Museum, 1993.

Guy Cross, Interview with Miguel Gandert, *THE Magazine,* July 1998.

Miguel Gandert, Appearances within My Own Time, or A Formal Exploration of People Pretending to Be. Master's thesis, University of New Mexico, 1983.

Edward T. Hall, *Beyond Culture.* Garden City, N.Y.: Anchor/Doubleday, 1976.

Neery Melkonian, Contested Territories: Miguel Gandert's Documentary Photography, *Afterimage,* Dec. 1991.

Pablo O. Monasterio, ed., Nuevo México, *Luna Córnea* 7 (1995), special issue on photography in New Mexico.

Richard L. Nostrand, *The Hispano Homeland.* Norman: University of Oklahoma Press, 1992.

V. B. Price, *Albuquerque by Six.* The Albuquerque Museum, 1989.

Public Broadcasting System, The Pursuit of Happiness, web site (www.pbs.org/jefferson/pursuit/), 1997.

Allen Rabinowitz, Miguel Gandert's Photography Documents Indo-Hispanic Culture of Native New Mexico, *Photographer's Forum,* Nov. 1996.

Sylvia Rodríguez, *The Matachines Dance: Ritual Symbolism and Interethnic Relations in the Upper Río Grande Valley.* Albuquerque: University of New Mexico Press, 1996.

Chris Wilson, *The Myth of Santa Fe: Creating a Modern Regional Tradition.* Albuquerque: University of New Mexico Press, 1997.

Steve Yates, ed., *The Essential Landscape.* Albuquerque: University of New Mexico Press, 1985.

# CONTRIBUTORS

**MIGUEL GANDERT** has been photographing the social rituals, people, and landscapes of his native New Mexico for twenty years. His photographs have been exhibited widely in museums and galleries throughout the world, including the Whitney Museum of American Art and the Smithsonian Institution's National Museum of American History. He is an associate professor in the Department of Communication and Journalism at the University of New Mexico.

**ENRIQUE R. LAMADRID** teaches Southwest Hispanic ethnopoetics, folklore, folk music, cultural studies, Chicano literature, and contemporary Mexican poetry at the University of New Mexico. He has conducted field work in New Mexico, Chihuahua, Michoacan, Colombia, and Ecuador. His inquiries into the Indo-Hispanic traditions of New Mexico chart the influence of indigenous cultures on the Spanish language and imagination.

**RAMÓN A. GUTIÉRREZ** is a professor of Ethnic Studies and History at the University of California, San Diego, and founder and director of the Center for the Study of Race and Ethnicity. He is the author of *When Jesus Came the Corn Mothers Went Away: Marriage, Sexuality and Power in New Mexico, 1500–1846* (Stanford University Press, 1991).

**LUCY R. LIPPARD** is a writer and cultural critic who lives in Galisteo, New Mexico. She is the author or editor of more than twenty books on contemporary art, including *Mixed Blessings: New Art in a Multicultural America* (Pantheon, 1992; New Press, 2000) and *Partial Recall: Photographs of Native North Americans* (New Press, 1992).

**CHRIS WILSON** is J. B. Jackson Professor of Cultural Landscape Studies at the University of New Mexico School of Architecture. He studied the history of the photograph at the university in the early 1980s. He is the author of *The Myth of Santa Fe: Creating a Modern Regional Tradition* (University of New Mexico Press, 1997).

**NUEVO MÉXICO PROFUNDO**

Project Editor: Joanne O'Hare

Designer: Kristina Kachele

Art Director: David Skolkin

Copyeditor: Jo Ann Baldinger

Cartographer: Deborah Reade

Text set in Monotype Garamond with FF Meta Sans display

Tritone separations by C&C Offset Printing Company, Ltd., Hong Kong

Printed on 150 gsm MultiArt matt paper by C&C Offset Printing Company, Ltd., Hong Kong

Bound by C&C Offset Printing Company, Ltd., Hong Kong